A CHARMED COUPLE

The Art and Life of

Walter and Matilda Gay

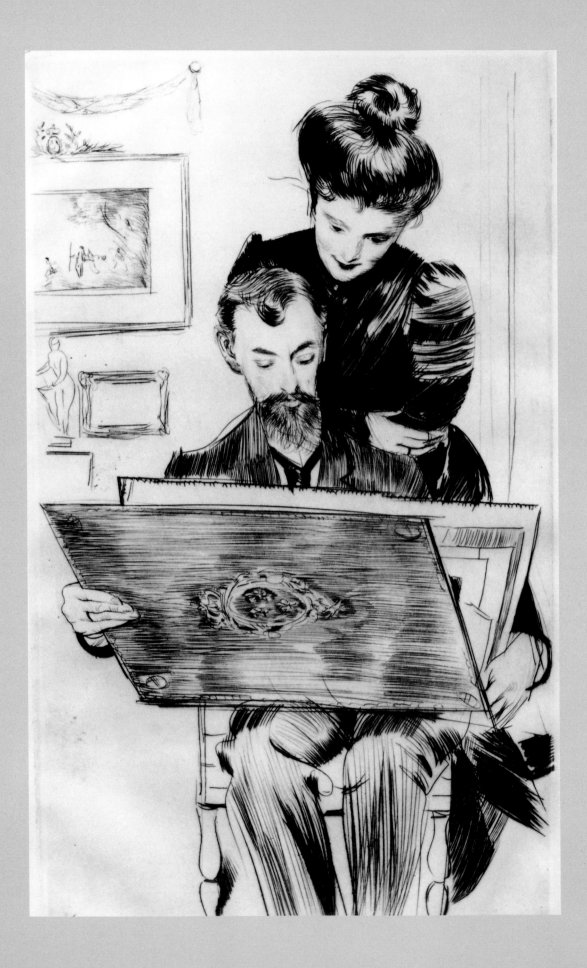

A Charmed Couple

❈

The Art and Life of Walter and Matilda Gay

❈

WILLIAM RIEDER

HARRY N. ABRAMS, INC., PUBLISHERS

Editor: *Barbara Burn*
Designer: *Darilyn Lowe Carnes*

Library of Congress Cataloging-in-Publication Data

Rieder, William.
 A charmed couple : the art and life of Walter and Matilda Gay / William Rieder.
 p. cm.
 Includes bibliographical references and index.
 ISBN 0–8109–4561–4
 1. Gay, Walter, 1856–1937. 2. Painters—United States—Biography.
 3. Gay, Matilda, b. 1855. 4. Painters' spouses—United States—Biography.
 5. Expatriate painters—France—Biography. I. Title.

ND237.G32 R53 2000
759.13—dc21
[B] 00–26627

Frontispiece: Paul-César Helleu. *Walter and Matilda Gay.* Drypoint etching.
Private collection

Printed and bound in Japan

 Harry N. Abrams, Inc.
100 Fifth Avenue
New York, N.Y. 10011
www.abramsbooks.com

Contents

Introduction

WHEN WATER GAY DIED IN 1937, HE WAS DESCRIBED BY THE *NEW York Times* as the "Dean of American Painters in France." He had begun in Boston painting flower pictures, and after moving to France in 1876 at the age of twenty, he took up genre subjects: eighteenth-century costume pieces and realistic scenes of peasant life in Brittany. About 1895 Walter developed an interest in interiors ("I was searching for the spirit of empty rooms," he wrote), many of them in the Paris apartment and the château near Fontainebleau that he and his wife, Matilda, had filled with French furniture and works of art, rooms that were far from empty.

These and the other interiors he painted were inhabited by people who lived in easy company with works of art: French furniture, sculpture, tapestries, mounted porcelain, old-master paintings and drawings, and small decorative objects that were referred to as "bibelots." The Gays and their friends shared an intense interest in and knowledge of these works, as well as a passion for old houses ("A new house never has any human quality," Matilda wrote) and a sense of continuity with the past. "Walter Gay and I were made for traditional countries: it is the 'sense of the past' within our veins."

Walter's paintings were acquired by a number of American museums and by a small group of socially prominent collectors whose drawing rooms looked not unlike the pictures and indeed were sometimes depicted in them. However, when several exhibitions of his work were held in New York after his death, it was increasingly out of sync with the times. One visitor to his posthumous exhibition at the Metropolitan Museum of Art in 1938 felt as though a fashionable guest had been delivered by his chauffeur to the wrong party. In the introduction to the catalogue of the Gay exhibition at Wildenstein's in 1945, the art critic and painter Albert Gallatin wrote, "The pictures of Walter Gay are beautifully painted, and possess style and distinction. His technical equipment was that of an accomplished and gifted artist. That, of course, is where their value lies, but in addition, today, when vulgarity and brutality are so much in evidence, when contemporary painting has sunk to an all time low, people of taste should derive pleasure from communing with these souvenirs of a civilized and cultivated epoch."

In 1980 a retrospective exhibition in New York at the Grey Art Gallery at New York University brought his work to a new audience, including a critic from the *New York Times,* Grace Glueck, who hated it, and a curator from the Metropolitan Museum of Art, who was delighted by it. I still am, particularly by the interiors, although I am well aware that Walter Gay was a minor artist who had many good days and quite a few bad ones.

This is a book not about Walter Gay's art, which has been well covered in all its phases by Gary Reynolds in the 1980 exhibition catalogue and subsequent articles, but about the fashionable and fascinating life led by Walter and his outspoken wife, Matilda, much of it told in their own words and illustrated by his interior views, many of which have never been published.

The Gays believed in keeping a record. Matilda wrote a remarkable diary, only recently discovered, in which she recorded with candor and delicious wit the people and events of their life. Covering the years 1904 to 1934, the diary contains more than three thousand typed pages and is one of the most compelling accounts of the period. Many of her friends would not have been pleased by her comments. Walter recorded his own version far more concisely in seventy-six pages in his *Memoirs,* published privately in 1930 for his friends, all of whom were delighted.

Prologue. May 1945

T HE OLIVE DRAB military car passed slowly through the tall iron gates flanked by mansard-roofed pavilions and proceeded on the cobbled drive through an overgrown park to the broad weedy forecourt, where it pulled up to the steps at the center of the imposing château.

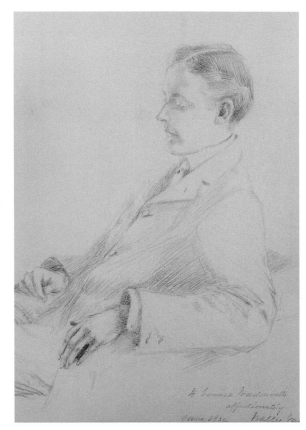

Out stepped United States Congressman James W. Wadsworth to inspect this property in the French countryside, which he had recently inherited from his favorite aunt, Matilda Gay. He had first visited the house in 1911, still "boyish-looking in spite of his 33 years," Matilda wrote. "It was a triumph to see the dear boy at Le Bréau, where I had waited so many years for his visit, and compiled his archives, following his life and its development from afar." She was pleased to see that he had changed little since Walter had drawn James's pencil portrait in 1902 (fig. 1). Both uncle and aunt had grown enormously fond of James Wadsworth. Matilda had taken particular pride in his political career, first in the Senate and then the House of Representatives, and she had always visited him on her regular trips to Washington, where she stayed with her sister Louisa Wadsworth, James's mother.

In France with a Congressional delegation, James had requested that the military order members of his family to report to Paris for a family reunion. His younger son, Reverdy, a combat veteran and captain in the Tenth Armored

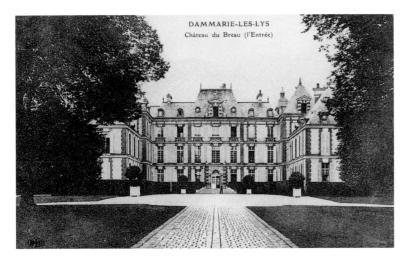

2. Forecourt, Château du Bréau. Photo: Collection of
The New-York Historical Society

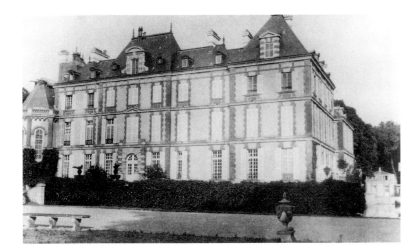

3. Rear side and moat, Château du Bréau. Photo: Collection of
The New-York Historical Society

Division billeted in Oberammergau, and his grandson, Stuart Symington, Jr., stationed with the infantry in Compiègne, had joined him at the Hôtel Raphaël. From there they set off on the hour-and-a-half drive to have lunch at the Château du Bréau (figs. 2, 3).

As they waited at the door, James looked across the forecourt to the walled gardens, which had once been so well maintained. The English and Italian gardens, formerly at their best in May, had been the pride and joy of châtelaine Matilda, but after Walter's death in 1937, she abandoned the gardens and the park and retreated to the house. She died there during the war in 1943.

After what seemed an interminable time, the door was slowly opened by Armand, the ancient stooped butler. Today Symington recalls the occasion vividly: "Aunt Tillie's aged retainers did the best they could for us. Food was scarce. I remember a dish of *petits pois*, served on one set of plates, followed by one poached egg, served on another. The napkins were the size of pillow cases." It was perhaps just as well that the Gays were no longer there. However scarce the food, they would have been horrified at the thought of a lunch of only *petits pois* and one poached egg.

During their brief tour of the four-storied château, most of whose rooms had been shut for years, the visitors had only enough time in the salon to glance at thirteen leather-bound volumes of Matilda Gay's typed diary sitting on a table. The first volume began in 1904, but the event that had set the story in motion and ultimately brought James to this room had taken place seventeen years earlier.

9

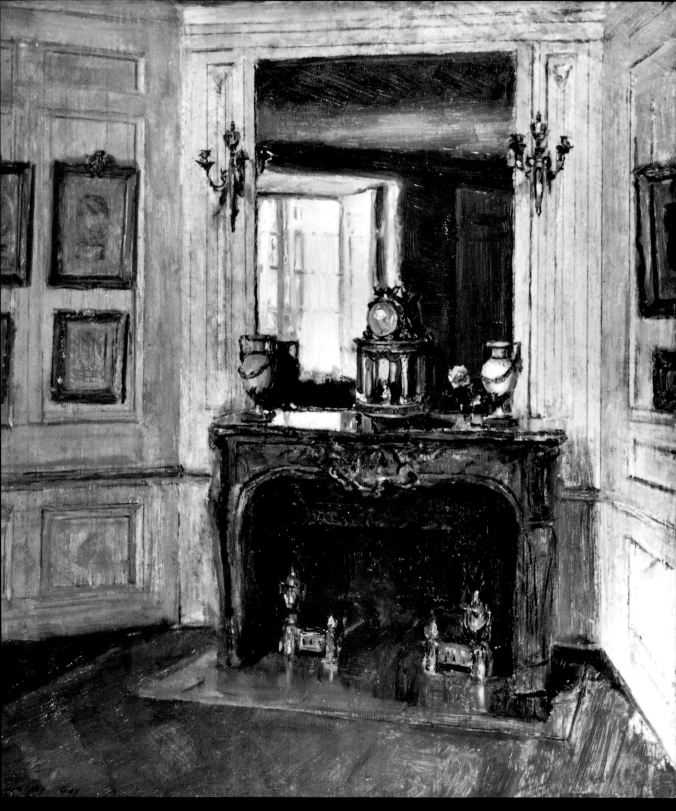

4. Walter Gay. *Interior, 73, rue Ampère.* Oil on panel, 18 x 22". Pyms Gallery, London

Part One.

WALTER AND MATILDA GAY

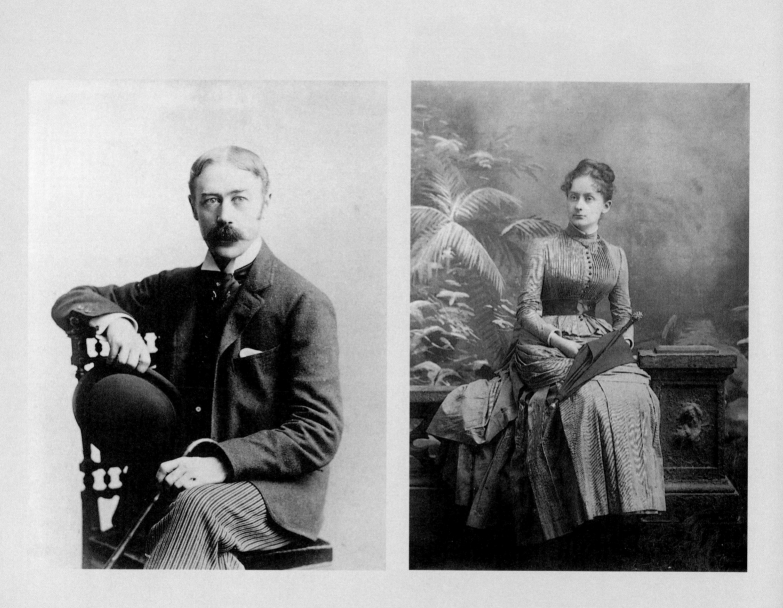

1. Matilda Travers and Walter Gay

MATILDA TRAVERS HAD BEEN LIVING FOR THREE YEARS IN PARIS when she met Walter Gay in 1887. Realizing that close proximity and a certain amount of subterfuge would be required if she were to achieve her goal, she asked if he would consider giving her lessons in drawing and painting. The ploy worked, and the following year Matilda informed her mother in New York that she was engaged to be married. An obscure and no doubt penniless American artist in Paris was not, however, what Mrs. William R. Travers had in mind for her strong-willed and no-longer-young daughter (Matilda was thirty-three). Mrs. Travers arrived on the spot soon thereafter to take Matilda on a trip anywhere away from Paris, but during their extended sojourn through Europe it became clear that Matilda was going to marry Walter Gay whether her mother liked it or not.

This was not the first sign of independence that Matilda had displayed. Born in 1855, she grew up in a large family with four sisters and three brothers in considerable comfort in New York City. William R. Travers, a successful Wall Street financier, had started with almost nothing and on his death in 1887 left a fortune of three million dollars. A great wit and bon vivant, he belonged to twenty-seven clubs and supported five domestic establishments, as well as a house in Bermuda. The family was frequently on the move; summers were spent sailing on the Travers yacht off Newport, Rhode Island, where they had a large house on Narragansett Avenue. "During Mr. Travers's lifetime the red house was the center of the Newport gayeties," reported his neighbor and friend Mrs. John King van Rensselaer. "There was seldom a moment during the season when the house was not filled with a gay, pleasure-loving crowd, and receptions, dinners, dances, etc., followed in lively successions." Matilda, however, never liked Newport. "[It] was always distasteful to me; and I have no regrets for my old home," Matilda later wrote. An old Newport friend, on seeing the Gays' Château du Bréau for the first time, said to Matilda, "This is a long way from Narragansett Avenue, isn't it?" "I am grateful that it is," responded the châtelaine. She retained an even greater distaste for New York, where as a young woman she had felt like a European exile—even before she ever saw Europe.

OPPOSITE LEFT:
5. Walter Gay, c. 1880. Photo: Collection Arthur T. Garrity, Jr.

OPPOSITE RIGHT:
6. Matilda Travers, c. 1880. Photo: Collection Arthur T. Garrity, Jr.

13

At the age of twenty, Matilda became a Catholic, to the puzzled astonishment of her family "among whom Catholicism was looked upon as a Celtic superstition wholly inappropriate to people of quality," as her distant relative and close friend Daisy Chanler reported. Matilda must have been a considerable trial to her genial and kind-natured father, whom she nonetheless adored. Over the years she often met friends of her father who spoke of him with great admiration. "These tributes to the remarkable man who was my father are of frequent occurrence, nor does the impression of his wonderful charm grow dim."

Matilda and Walter decided to get married in London, perhaps because they both regarded England as the Mother Country. Matilda's maternal grandfather, Reverdy Johnson, had been United States minister to England during the administration of Andrew Johnson, and Walter, although a fourth-generation New Englander, was always intrigued by his English ancestors.

On the sunny spring morning of April 27, 1889, the young couple walked together in London's Green Park, and Walter tried to kiss Matilda behind her sunshade. That afternoon they were married at the Catholic Church of the Assumption in Warwick Street. Walter described the small wedding party: "Besides Mr. Junius Morgan, father of Mr. Pierpont Morgan, an old friend of my wife's parents, there was only a gathering of the family, many of whom had crossed the ocean to be present. There were present my wife's mother, her brother William R. Travers, Mrs. George R. Fearing, Mr. and Mrs. William A. Duer, my brother Harry Gay, and my cousins, the Frank Blake family of London." The reception was at Brown's Hotel. For Walter his marriage to Matilda was quite simply the happiest day of his life.

The church became a place of pilgrimage that they never failed to visit on subsequent trips to London. "July 16th, 1909. To mass with W. G. at the Church of the Assumption where 20 years ago our life journey began. The little place of worship is modest and poor. But it is full of ghosts for me, when I think that, of all that sympathetic wedding party, only one [her sister Harriet Fearing of Boston] survives."

As wedding presents they received mostly checks from relatives and friends. "This wise form of gift enabled us to exercise our own taste, so we formed a collection of old English silver, to be had at that time at reasonable prices. At Oxford we picked up a complete set of blue-and-white china, so our table was furnished with souvenirs of family and friends," Walter wrote in his *Memoirs*. For many years they celebrated their wedding anniversary with two rituals: Walter would present Matilda with a bridal bouquet of white roses, and

later lilies of the valley, picked that day in the park at Le Bréau; and Matilda would always wear her wedding dress. On their twenty-sixth anniversary in 1915, she wrote in her diary: "Who were those strangers—Walter Gay and Matilda Travers, who were married in London more than a quarter of a century ago? Have we anything that resembles them at all, in opinions, sentiments, or prejudices? Yes, one thing has lasted—our affection for each other. How many couples can say the same?"

They took their honeymoon trip to Canterbury and explored the countryside in Kent, which Matilda embraced. "When the sun shines, can anything be sweeter than English landscape?" For a moment they even considered settling in England. "But we decided to live in France, and we have never regretted the choice," Walter wrote. He had by then been in Paris for thirteen years and felt at home there, having made many friends among the young artists who took studios together and frequented the same cafés. Matilda brought her own circle of friends to the marriage, mostly Americans from New York and Newport whom she had known for years and who were now visiting or living in Paris. In addition, both had relatives who often came to France in the summer and needed to be entertained.

In the neighborhood where Walter had occupied several studios, the 17th arrondissement, the quarter north of what is now the Place Charles-de-Gaulle, the Gays rented a four-story house with a studio and large garden at no. 73, rue Ampère, which remained their Paris residence for the next twenty years. They called it their "little box in the Rue Ampère" (figs. 4, 7).

7. 73, rue Ampère. Photo reproduced from Grey Art Gallery and Study Center, New York University. *Walter Gay: A Retrospective*, 1980

15

2. Walter Gay, Genre Painter

WALTER GAY MAY HAVE SEEMED TO HIS NEW MOTHER-IN-LAW AN obscure, impoverished artist, but in fact he was already enjoying considerable success at the time he married Matilda Travers. One of four brothers, Walter was born in Hingham, Massachusetts, in 1856. His father, Ebenezer Gay, was a lawyer who had graduated from Harvard and was elected in 1862 to the Massachusetts Senate. Walter was always closer to his mother, Ellen, and

8. Walter Gay. Two still lifes: *Daisies* and *Goldenrod.* Both oil on panel, 25 x 8". Beacon Hill Fine Art, New York

16

was deeply saddened when she died in 1917 at the age of eighty-six. His feelings for his three brothers, all of whom had successful business careers, were best described by Matilda, who wrote: "The family feeling is very strong, and beautiful to see, but in sentiment and ideas we are as far removed from them as though we were Chinese."

As far back as Walter could remember, he had wanted to be an artist and to live in France. During his childhood in Hingham, he was close to his uncle, the landscape painter Winckworth Allan Gay. "[My uncle] had gone to Paris in 1848, and I learned much from him, sitting by his side while he painted and hearing him talk about France, whither I longed to go," Walter wrote. "From this old uncle, I got something which the schools never gave me in after life." At the age of nine, he moved with his family to Dorchester, near Boston. At the Roxbury Latin School, Walter covered his copybooks with drawings rather than the work assigned. "I grew up thinking a great deal about art."

In 1872 at the age of sixteen, feeling rather at loose ends, he accepted the invitation of another uncle, Charles Blake, to join him in starting a ranch in Nebraska, which was still a wilderness of Indians and buffalo. "I jumped at the chance. My occupation was to herd cattle, and it was there that I learned to ride and shoot, sports from which I have profited all my life. . . . I left the ranch with much regret, after the year had expired. My uncle wanted me to remain, at least to try another year, when he would have given me an interest in the business, but I had made up my mind to become an artist, and if possible go abroad." He devoted fully a third of his *Memoirs* to that one year in Nebraska and always thought of the experience as one of the three great events of his life, the other two being his move to France and his marriage to Matilda Travers.

On his return to Boston, Walter began painting still lifes, which he exhibited at the Williams and Everett Gallery where they attracted favorable notice. Early in 1876 a newspaper reviewer commented: "Walter Gay . . . has for some years been making a speciality of flower pieces, in which he has attained to merit distinction. While strikingly true to nature, his flower groups have an idealistic grace which commends them to amateurs. . . . They are well worthy of the attention of all persons friendly to art; for, if we may judge from the promise shown by Mr. Gay, they will be more valuable five years hence than they are now" (fig. 8).

Walter attended a night class at the Lowell Institute for Drawing, and during the day he shared a studio with the landscape painter John Bernard Johnston, whose teacher William Morris Hunt would drop in to give advice to the two young artists. Hunt and Winckworth Gay both thought that Walter

should continue his studies in Paris, and they must have conveyed that advice to Ebenezer and Ellen, who promised to help support Walter for three years of study. In April 1876 Walter sailed for France.

Without knowing a soul and speaking no French, he arrived in Paris and settled into a small hotel on the Left Bank, only a few hundred yards from the apartment in the rue de l'Université where he and Matilda would later live. During an afternoon stroll through the neighborhood on their wedding anniversary in 1913, "[Walter] showed me his first quarters in Paris, the Grand Hotel de Tours, a squalid inn on the rue Jacob, no. 15," she wrote. "He pointed out his mansard window, where he paid a franc a day for his room, a happy, penniless, enthusiastic boy, fresh from Dorchester and Boston, intoxicated with the fascination of Paris and its artistic atmosphere."

Walter spent his first three weeks going every day to the Louvre, "having made up my mind to know it thoroughly." He had planned to meet up with his friend Johnston, who had preceded him to Paris, but Johnston had gone to Auvers-sur-Oise, where Walter joined him for several weeks, at times in company with the French painter Charles-François Daubigny. Walter soon moved on to Barbizon in order to meet the American expatriate painter William P. Babcock, "who had known or seen all the great painters of his period, knew more about the old masters and had more tradition than almost anyone I have ever met; he was a link with the past."

In 1877 Walter moved to Montmartre and entered the atelier of Léon Bonnat, where he remained for the next three years. Bonnat, who had studied in Paris with Léon Cogniet, was one of the most popular and respected painters of the time. A regular exhibitor at the annual Salon exhibitions, he specialized in large pictures of religious and historical subjects and genre scenes of Italian life and the Near East. He also achieved international renown as a portraitist. An influential teacher, Bonnat counted among his students Gustave Caillebotte, Raoul Dufy, and Henri de Toulouse-Lautrec. The many Americans who studied in his atelier included Thomas Eakins, John Singer Sargent, and Charles Sprague Pearce. Bonnat was a liberal teacher who "stressed simplicity in art above high academic finish, as well as overall effect rather than detail. He encouraged strong chiaroscuro and heavy modeling as well as careful drawing, the hallmarks of his own work."

An artist who studied with Bonnat shortly after Walter did was the American Barclay Day, who wrote a vivid description of the atelier: "The usual way of gaining admission to the studio is to call on M. Bonnat with one or two specimens of work, and ask permission to attend his 'Atelier d'Élèves,' and then

18

to go straight to the studio, which is situated in the Impasse Hélène in the Avenue Clichy, not very far from Montmartre, and present oneself to the *massier,* and pay one's subscription and entrance fee."

Work began at 7:30 A.M. in the summer and an hour later in the winter. A new model was posed every Monday morning, and each day the sitting lasted four hours, with intervals of rest for the model. "Modesty, energy, and straightforward frankness are indeed our 'patron's' chief characteristics," Day wrote. "In person he is not tall, but well built and muscular, with a firm step, clear, earnest eyes, and features rather of the Spanish than the French type. His method of teaching is as simple and decided as his appearance. We were left entirely to our own devices during the first day of the week; on the second the 'patron' came round to see how we had blocked in our studies, and again on the last to see what we had made of them. His plan was to leave each pupil absolutely free to follow his own inclination in all matters pertaining to choice of subject, method of work, and material. . . . His attention was always directed to the study as a whole, and he was a cheery and encouraging critic—always praising when he conscientiously could, but always telling us very decidedly what was bad in our work." Each pupil got an average of four or five minutes at each visit. "He was very particular that the gesture of the figure should be true, and that the type and character of face and form should be emphasized, even if ugly in nature. . . . Unless exceptionally good or bad, he took scarcely any notice of details, wishing his pupils to devote all their energy to get their studies of form right as a whole." Bonnat's visits lasted from an hour to an hour and a half. "Then, with a simple 'Bonjour, Messieurs!' on his part, as he reached the door, and a general rising on ours, he was gone; the pipes and cigarettes that had been allowed to go out were relighted, and tongues wagged louder than ever."

The Gays continued to see Bonnat socially for many years. In 1909 Matilda described him at a dinner: "Bonnat sat opposite and is a wonderful old gentleman, well over seventy [he was seventy-six], but unchanged in appearance since the last 20 years. He ate and drank like a young man—how could one call him old?—and was very affectionate to his 'élève Walter Gay,' whose painting has fortunately never resembled that of his master."

In the afternoon, Walter and his fellow students would walk over to the nearby Café de la Rochefoucauld, where they saw Puvis de Chavannes, Manet, Boldini, George Moore, and other artists. Walter also met Edgar Degas at this time. "I went to his studio, and he was even good enough to come to mine and gave me much good advice. I saw a good deal of him in those first few years."

But Degas was difficult and the friendship waned. Matilda elaborated, "Degas is a *sauvage*, full of wit, but also of bitterness. This great but very disagreeable painter lives alone with his mistress-cook Zoë, who reads the newspapers to him. He is wildly *Nationaliste* and would like to hang all strangers domiciled in France to lamp-posts."

Degas's pastels had a strong impact on Walter Gay's work. "I remember the little color shop of Ray and Perraud, on the corner of the Notre Dame de Lorette, where we used to go for our painting materials and where there were often pastels by Degas, which we artists were all crazy about, but which nobody would buy. They were offered for 1,000 francs [\$200, or about \$3,300 today] and some even for 500. But none of us had any money."

At Bonnat's suggestion, Walter traveled in 1878 to Madrid, where he spent a month at the Prado copying the work of Velázquez, which was a revelation. During this trip he realized that he needed more training in drawing, and he decided to return to Bonnat's for another year. "Bonnat, whatever he might have been as a colorist, was a strong draughtsman, and insisted on drawing being the foundation of all art," Walter later wrote.

At this point, Walter's parents decided that it was time to end their modest support. "On this, my third year, letters began to come from America warning me that it was time for me to go back," he wrote. "As I had been promised three years, I thought this very hard. Then came a final letter, which informed me that the cheque (a small one) enclosed would be my last, and that I *must* go back. This was a great shock, a really serious state of things, for I had few friends, and these latter as poor as myself. I hadn't begun to go into the world at this time and I knew nobody who could help me. I made up my mind, in spite of all this, *not* to go home."

Walter's early work reflects the French academic training he received in Bonnat's studio. He began to paint small, realistic genre pictures of eighteenth-century subjects strongly influenced by Jean Meissonier and the Spanish painter Mariano Fortuny. Each year Walter submitted a few of these to the Salon, the annual exhibition in Paris, which opened on the first of May. On the average about six thousand pictures were submitted, from which the jury selected about half. Walter made his debut in the Salon of 1879 with a picture that was well received by the critics. The Paris correspondent for the *Boston Herald* wrote: "The surprise of the year among Americans is Walter Gay's little picture which he calls *A Fencing Lesson*. His picture represents the interior of a great garden filled with luxuriant vegetation. An old master is fencing with a youth in the centre, and groups of ladies and gentlemen, seated on either side,

9. Walter Gay in his studio at 11, rue Daubigny, 1885. Photo: Walter Gay Papers, Archives of American Art, Smithsonian Institution

chat or languidly watch the game. It is a marvellously fine piece of work. . . . The little figures are drawn with a master's skill, and painted with great *finesse* and dexterity. . . . Mr. Gay has, without question, the best success of any of his compatriots this year, and he is to be congratulated on his great progress."

After sharing a studio for several years with his friend Stanley Mortimer, Walter moved to no. 75, boulevard de Clichy, where he took a studio on the same floor as the American artists Frederick Bridgman, Edwin Blashfield, Walter Blackman, and Charles Sprague Pearce. "The large and spacious edifice, the rooms of which are thoroughly well adapted to the uses to which they are put, is almost an American art colony," wrote the critic Lucy H. Hooper, who attended a reception there in 1880 held by the artists to show their pictures to their friends before they were forwarded to the Salon. "Young as Mr. Gay is, he has already gone far, and I venture to predict that he will go still farther," she wrote. "In all my Parisian experience I have seen no more brilliant an art debut."

From this point on, Walter showed his pictures regularly at the annual exhibitions and managed to support himself by painting, although he admitted that there were long periods when he didn't sell a picture. By 1885 he had taken yet another studio, this one in the rue Daubigny (fig. 9), where he was visited that year by the artists Benjamin Tupper Newman and Ralph Clarkson. Newman wrote to his wife: "We went over to see Walter Gay's studio. Our knock was answered by himself. We had interrupted him in the operation of shaving and his face was lathered with soap. He excused himself and completed the operation while we looked about the studio. A number of paintings were on easels unfinished. One of an old school master seated at a desk with his scholars before him was excellent. He had many fine sketches made in Switzerland last summer. He is a short, rather fine-looking fellow and has pleasant manners. . . . Gay got a mention in this year's salon and most of his friends think it should have been something more than that, but it is hard for a foreigner to get a

medal. His studio is finely fitted up with antique furniture, rugs, and draperies. An old harp stood in one corner, its gilded woodwork making a picturesque effect against the dark of a carved cabinet. Gay was soon ready to go out with us to play lawn tennis."

In the mid-1880s, as a result of summer trips to Brittany and Barbizon, Walter shifted to a larger format and painted scenes of peasant life strongly influenced by the work of Jules Breton and Léon Lhermitte. His picture of a Breton peasant woman entitled *The Weaver*, now at the Museum of Fine Arts in Boston, is a typical example.

La Bénédicité (fig. 10), which depicts a woman saying grace, was shown at the Salon of 1889 and purchased by the French government for the Luxembourg Museum in Paris, then the museum of contemporary art. One critic admired its "symphony of grays of infinite delicacy as they pass from the depth of airy transparent shadow to the softness of *demi-teinte* and the complete intensity of full light," but he thought that with this picture of a "gray old woman returning thanks for a meager meal" Gay had painted enough old women.

Walter Gay's reputation was clearly growing, as he modestly described in his *Memoirs*: "My pictures were beginning to be known. I painted large pictures then, of figures, and they were exhibited not only in Paris, but in Munich, Berlin, Antwerp, and elsewhere, receiving medals." In fact, he received gold medals in those cities as well as in Vienna, plus a silver medal in Budapest. These awards stimulated commissions from English, French, Belgian, and German art dealers for more pictures. He also exhibited at the two Expositions Universelles of 1893 and 1900 in Paris and at the World's Columbian Exposition in Chicago in 1893.

Walter joined the Société des Peintres et des Sculpteurs (also called the Société Nouvelle), the Société de la Peinture à l'Eau, and the Brussels Royal Society of Water Colorists. The Luxembourg Museum asked him to join a friends' committee. Significant recognition of his contribution to art in France came in 1894, when he was made a Chevalier of the Légion d'Honneur. Although he spent little time in America, Walter was elected to the National Institute of Arts and Letters and became an associate member of the National Academy of Design. *La Bénédicité* eventually ended up in a museum in Amiens ("in honorable retirement," said Matilda), where the Gays saw it in 1930. "Though hung a little too high, it holds its own. It is interesting to visit provincial museums, those tombs of fashion in art," she wrote, realizing perfectly well what she was saying about Walter's early genre pictures.

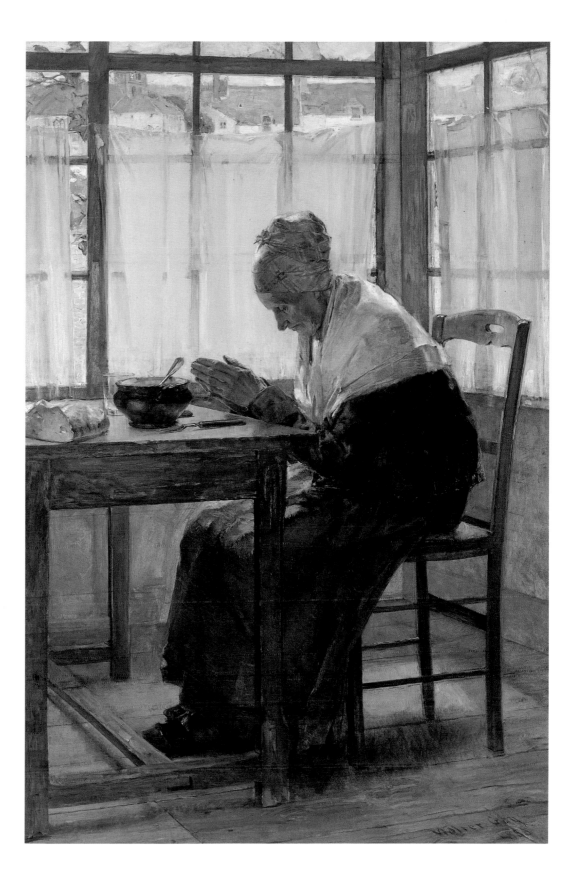

10. Walter Gay. *La Bénédicité*, 1888. Oil on canvas. Musée de Picardie, Amiens

3. Walter Gay, Painter of Interiors

IN ABOUT 1895, WALTER TIRED OF PAINTING LARGE FIGURE PICTURES, which he referred to as "pot-boilers." "Medals and honours were all very well, but to obtain them I was obliged to make too many concessions to the public in the way of subject and of treatment. Besides I felt that I could be more personal in small ones. Added to this I had a sentiment for the past: it meant much to me."

His first interior view was painted at the small summer house that the Gays rented in 1895 at Magnanville, west of Paris near Mantes. "It was a little old manor house, very inconvenient and dilapidated, but it had old *boiseries* [wooden paneling] and was paintable," Walter wrote. Two years later they took a larger house, the Château de Fortoiseau, a nineteenth-century château near the village of Dammarie-les-Lys, about three miles southwest of Melun. Here Walter began to concentrate on interiors: "I painted many studies at the Château de Fortoiseau, without exhibiting them, showing them only to sympathetic people who could understand what I was trying to do."

One of those sympathetic people was Matilda's friend Daisy Chanler, who later described these early interiors, "Walter had exquisite taste and appreciation of beautiful things; he found himself when the poetry of the old château in which they lived entered his soul. He began to paint pictures of their salon, their dining room. He knew how to give a room an intimate sense of life, to make you feel that charming people had just left it, and that rooms and furniture had belonged to other charming people long ago. He is now so famous for these interiors that it seems idle and presumptuous to praise his most delicate art, but one may always offer a sprig of laurel where laurel is due."

There had been a long tradition in Europe of painting interiors, usually by artists commissioned to make accurate renderings of architecture and furnishings. But Walter's views came from a different direction: pictures that captured the mood of a room in a particular light. Perhaps the best known precedents in this vein were J. M. W. Turner's famous views of light-flooded rooms at Petworth, the West Sussex home of the Earl of Egremont, painted during the 1830s and now exhibited at Petworth and at the Tate Gallery in London. Later in the century a number of artists, including Adolf von Menzel

and Gaston La Touche, became interested in the theme of the empty room. Degas and John Singer Sargent also did a few pictures of interiors without people that may have influenced Walter. Sargent's view of his own dining room in Paris, painted in the mid-1880s and now in the Smith College Museum of Art, and another interior in a private collection, *The Hotel Room,* are strikingly similar to some of Walter's early interiors.

Pictorial accuracy was not Walter's priority, except in commissioned pictures, and even then he often deviated from a literal record of the room. Some of his interiors are more like vignettes, with a few carefully placed objects and pieces of furniture assembled in a corner or against a wall as though in a still life. In the interest of pictorial composition he felt free to alter the details, inserting objects and furniture that might or might not have been there, to achieve the picture he wanted, although by and large his interiors depict the actual contents of the rooms.

Matilda called these pictures "poèmes d'intérieurs." A comparison of two views of the so-called Ghost Room at Fortoiseau (the ghosts didn't seem to bother the Gays) shows both the aptness of her description and the problems of viewing Walter's interiors too literally (figs. 11, 12). Did the room have both of these chimneypieces? Probably not. Which of the two was actually in the room? There is simply no way of knowing, although the dark chimneypiece with the small opening appears in another view of the room and the lighter, yellow-and-gray veined version happens to be a Louis XV type that Walter particularly liked and creates a more attractive balance with the Rococo overmantel, which suggests the answer.

Although Walter wrote in his *Memoirs* that he showed his interiors of Fortoiseau only to sympathetic friends and did not exhibit them, it was not very long before he did start to display them in public. Two views of Fortoiseau were shown in the Sixth Annual International Exhibition in 1901 at the Carnegie Institute in Pittsburgh, where they were bought by Mrs. Henry Kirke Porter, whose daughter gave them to the museum in 1942 (figs. 11, 26). From 1897 until his death, Walter exhibited thirty-three of his works in sixteen Carnegie Internationals.

At the annual exhibition in 1903 at the Pennsylvania Academy of the Fine Arts in Philadelphia, he displayed some interiors of the house in the rue Ampère and of a house of his friend, the artist Paul Helleu (see figs. 55, 99). Walter also began to exhibit his pictures at the Société Nationale des Beaux-Arts in Paris and in 1904 sold his first interior to the French state, a view entitled *Blue and White,* showing the dining room in the Boston house of their

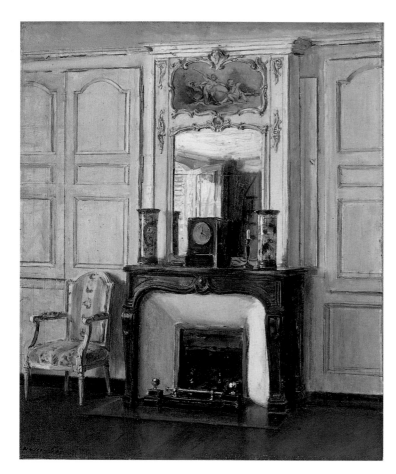

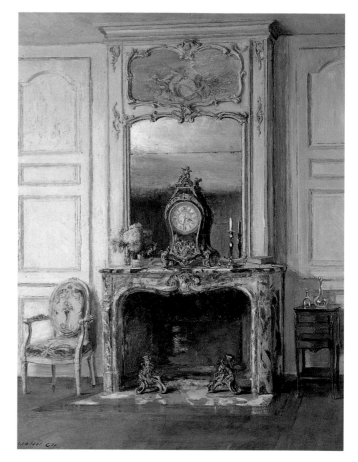

ABOVE LEFT:

11. Walter Gay. *The Old Fireplace* (Château de Fortoiseau). Oil on canvas, 21¾ x 18¼". Carnegie Museum of Art, Pittsburgh. Gift of Miss Annie-May Hegeman from the collection of her mother, Mrs. Henry Kirke Porter. 42.5.5

ABOVE RIGHT:

12. Walter Gay. *The Ghost Room* (Château de Fortoiseau). Oil on panel, 23½ x 18⅛". Collection Edward Lee Cave

OPPOSITE:

13. Walter Gay. *Blue and White.* Oil on canvas, 23¹⁄₁₆ x 18¾". Musée d'Orsay, Paris. R.F. 1977–440

friend Mrs. Joseph Bradlee (fig. 13). Soon he was doing interiors everywhere he went: at the châteaux of friends, at Fontainebleau and Versailles, at the Musée des Arts Décoratifs and the Musée Carnavalet, at apartments and houses in Paris, and on trips to England and America.

By 1905 Walter had accumulated enough interiors for a one-man exhibition at the Galerie Georges Petit, "the tidiest little showroom in Paris," thought Matilda. "Invitations were sent to every world, artists, duchesses, dentists, etc., and most of them turned up at the inauguration," she reported. Of the eighty-one pictures and sketches, about twenty were lent by clients, including Lord Ribblesdale in London, and by neighbors and friends in France, including the Marquise de Ganay at Courances and the Comtesse de Béarn at the Château Fleury. "The pictures look like a collection of rare jewels—beautifully lighted and presented. Enthusiasm on all sides—very gratifying for him, who works so hard, and for me, who have helped him do it," she beamed. "The French are so much more appreciative of my husband's work than his compatriots—the Americans have not yet 'caught on.'"

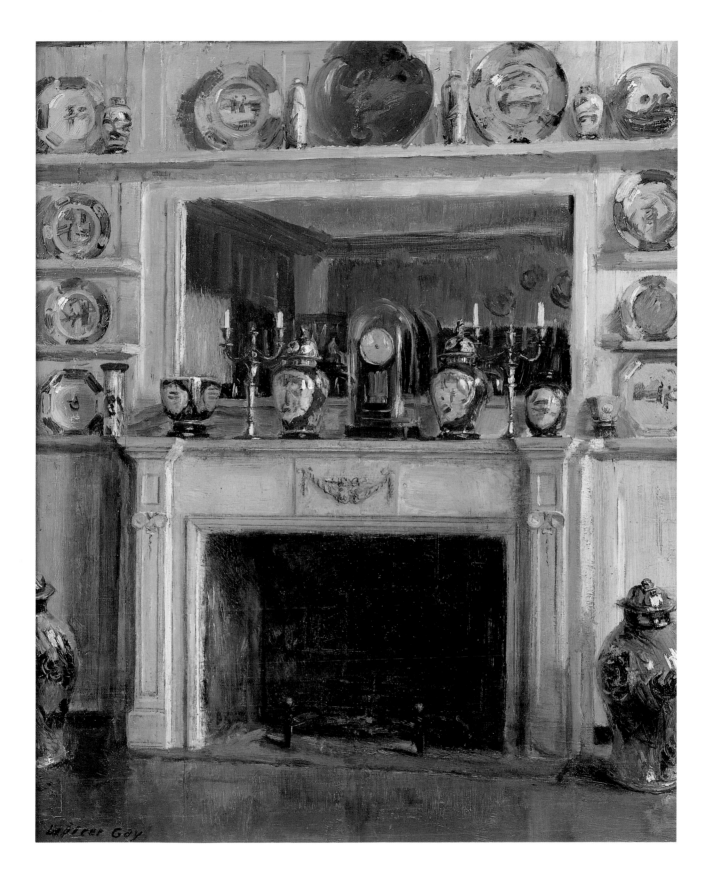

The exhibition was a great success. Seventeen pictures were sold for a total of 30,000 francs [$6,000, or about $100,000 today] and Walter received eighteen new commissions. "These interiors of his have founded an epoch in French art—he has a number of imitators, but none of them get the same subtle *esprit*," Matilda wrote. "Without either diplomacy or wire-pulling, he has established his place . . . solely by his talent and industry. It is significant that Walter Gay is the only American artist whose exhibition has ever created a 'furore' in Paris." With the proceeds, he was able to go shopping. "W. G. came back with a beautiful frame under his arm, for which his mouth has been watering for 18 months—and his recent exhibition's success has enabled him to get it."

The exhibition also created new commissions, but as Walter soon discovered, painting on commission was not always a straightforward matter. The Gays' new friend Geordie Stafford and his mother, the Duchess of Sutherland, came to see them in 1907. Matilda reported, "They went up to the studio, and the Duchess asked Walter Gay to paint an interior of her sitting-room in Stafford House. She is beautiful, gracious and winning—and would be infinitely more lovely if she did not artificialize her face." On his next trip to London, Walter reported back to Matilda: "I've had my first sitting at Stafford House. When I arrived at half-past nine I found no one up, of course, but was shown upstairs to the Duchess's boudoir, where I was expected to paint. After looking at it well, I made up my mind that it was utterly hopeless to try to do anything there, so boldly took my things to another part of the house, without asking anyone's permission. There I started a large study of the ballroom, one very long room opening into another, with arches and gilding and an *enfilade* of pictures, the sort of thing that I can do well. I made a good start, and as I saw no one the whole morning, was not disturbed. I think I can finish it quickly—the end of the week will see it nearly done. I am afraid that the dear Duchess, when she finds out that I am not painting her room, will be disappointed, but I can't help that—and, after all, they didn't order it. She said, however, that when the Duke saw it he would perhaps decide to take it, but one can't count on that sort of thing."

"The only way to repeat a successful exhibition is to have one still more successful," Matilda wrote. And so they decided to have another in 1908 at the same gallery. A writer friend agreed to write the foreword to the catalogue. "Henri Lavedan came in the afternoon, and read us the subtle and poetic article he has written for W. G.'s catalogue. It is a good send-off, to be described so happily by such a master of language. When I thanked Lavedan for his warm cooperation in my husband's coming exhibition, he merely said: 'Le sujet

m'était sympathique; j'ai fait mon petit Walter Gay' [I liked the subject; I made my own little Walter Gay]"

In the days before the opening Walter was naturally preoccupied. "W. G. is much absorbed in preparations for his exhibition on Wednesday; over-fatigue and excitement will be his portion for the next fortnight. 'Il faut payer la gloire' [One must pay for glory]." Matilda reported on the installation: "The 70 interiors really look charming in their variety of tone and subject, and the gallery has been cleverly furnished in antique furniture, and terra-cotta statuary, which sets off the pictures quite happily."

The Gays were thrilled by the first sale. "The Secrétaire des Beaux-Arts, M. Dujardin-Beaumetz, arrived early and immediately acquired for the State the interior of the petit salon of the Bréau, with the Gramont portraits—one of W. G.'s very best." (One of Matilda's few muddles: this picture [fig. 14] entered the Luxembourg Museum in 1911; the one bought in 1908 was a view of the salon at Le Bréau entitled *Les Médaillons* [fig.15].) "With this happy 'send-off,' the success of the day was assured. People poured in, and I received compliments on every side from all kinds: the connoisseurs, the ignorant, the serious, the flippant, the good-natured, the cross-grained, the fast, the slow, the sincere, the treacherous, the young, the old—the world, in short, was well represented." In general Matilda was leery of exhibition openings. "No assembly of people is more dangerous (for social pitfalls) than those to be found at picture exhibitions."

Edith Wharton, a childhood friend of Matilda's, came to see the show at the gallery and several days later wrote to Walter: "I must send a line to tell you what a deep & varied impression I received from seeing all your pictures together undisturbed by jarring elements and setting each other off like the flowers in some delicately chosen bouquet. One felt keenly from the repetition of the impression, your wonderful sensitiveness to colour & the happy & harmonious effects you get from it. . . . My warmest congratulations to you both."

Another friend at the opening was Mrs. William K. Vanderbilt, who added another to her collection of Walter's pictures. Anne Rutherfurd was the second wife of William Vanderbilt and one of Matilda's closest friends in Paris. "There is a deep vibration between Anne and myself."

Matilda left at five o'clock, "fagged out, W. G. still escorting people about the room, tasting the sweets of success—and always modest and unassuming. . . . A well deserved tribute to the talent and industry of my dear husband. . . . The biggest day we ever had in all our married life—but a very happy one."

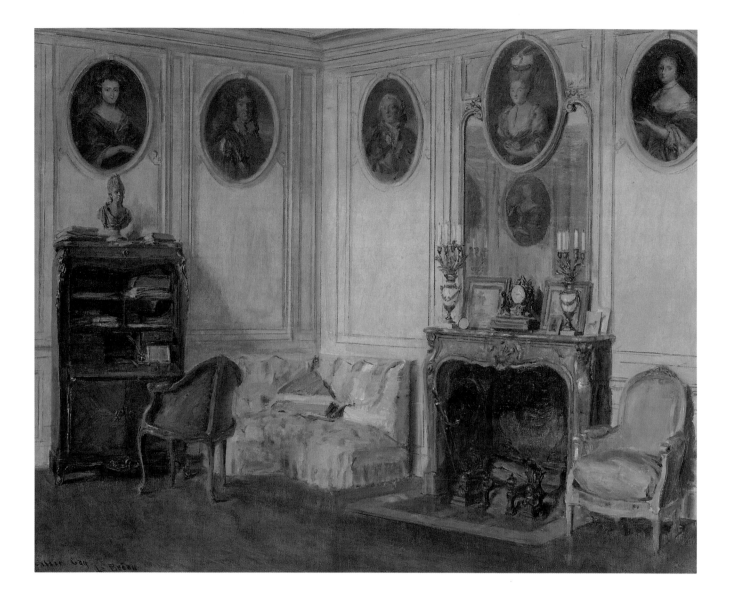

14. Walter Gay. *Petit Salon, Bréau.* Oil on canvas, 20 x 24".
Musée d'Orsay, Paris, on deposit
at the Musée de la coopération
franco-américaine, Blérancourt.
Gift of Georges Eugène Bertin to
the Musée Luxembourg, 1911.
R.F.1977–441

During her several visits, Matilda sometimes wrote as if *she* had paint-ed the pictures. "Then to W. G.'s exhibition, where I sat receiving congratula-tions and inhaling bad air for two hours." Both artist and wife thought the exhibition was a tremendous success. "In the afternoon to W. G.'s show which closed today, after having been a *succès fou*, artistically as well as financially. All Paris has flocked there during the last 15 days; the aristocracy, the connois-seurs, the artists, the dealers, the *littérateurs*, the bourgeoisie, the tradespeople, and our household of servants both in town and country, all sorts and conditions of men. . . . The appreciation of the public of his work increases—witness the far greater enthusiasm over this exhibition as compared with the last, three years ago, successful as the latter was." But they were glad to have it finished.

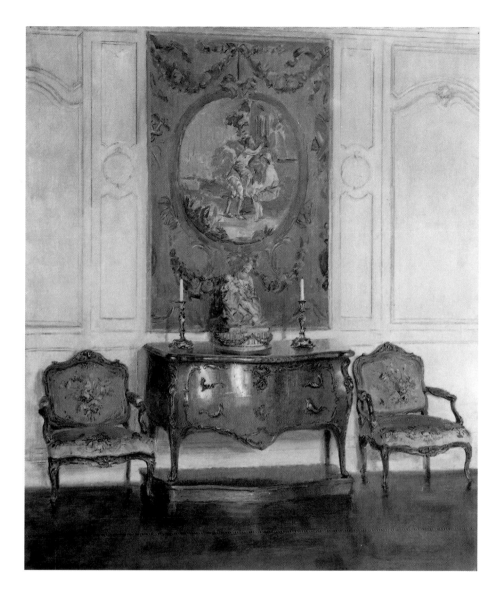

15. Walter Gay. *Les Médaillons*.
Oil on canvas, 25½ x 21¼".
Musée d'Orsay, Paris.
R.F.1977–443

"This one has lasted long enough, W. G. is worn out with excitement and fatigue—and it is a relief to have it all over, pleasant as the experience has been."

Two years later at the Salon, Walter sold another picture to the Luxembourg Museum, a view of the library at the Château Courances (see fig. 95). Matilda reported proudly: "This makes his fifth picture bought by the State. Today he went to the Salon to be present at the President's visit, who stopped before his picture, shook hands with him, and congratulated the happy artist." The next day the Gays went again to the exhibition "where W. G. guided me to his own panel of pictures, in the middle of which was the interior of the library at Courances with the precious label on it, 'Acquis par l'État.'" All in all, nine

16. Walter Gay. *Petit Trianon, Versailles*. Oil on canvas, 21³/₄ x 18¹/₄". Museum of Art, Rhode Island School of Design, Providence. Gift of Mrs. Gustav Radeke. 12.034

of Gay's pictures were purchased by the State. Most of these were displayed in the Jeu de Paume in the Tuileries, which was then an annex of the Luxembourg Museum.

In 1911 Walter exhibited several pictures at the Exposition des Peintres et Sculpteurs, known as the Rodin exhibition. "W. G.'s things have their usual distinction, but they lose by not being hung together," Matilda wrote. "They are too delicate and subtle to be scattered in a big gallery, surrounded by strong, loosely painted things."

Later that same year Walter painted an interior of the Petit Trianon in the park at Versailles, which at first did not go smoothly (fig. 16). "W. G. painted at the Petit Trianon, but came back depressed as his sketch had not turned out well. Painting is such a lottery." But after a few days he returned to continue work on it while Matilda spent the morning nearby in the gardens of the Grand Trianon. He exhibited the picture at the Galerie Georges Petit in a group show organized each year by the Société Nouvelle, an exhibition that then traveled to Chicago, Saint Louis, and Buffalo. At the Albright Art Gallery in Buffalo the painting was seen by Mrs. Gustav Radeke from Providence, who bought it for 4,000 francs [then $800] and gave it to the museum at the Rhode Island School of Design, of which she subsequently became president. The picture is in some ways typical of the museum views Walter Gay painted at this time, in which he focused on a small group of objects, in this case a console table supporting a bust of Louis XV by Augustin Pajou. Walter altered and simplified the elaborate *boiserie*, as was his habit, and to flank the table added two chairs that were never at the Petit Trianon.

One of Walter's regular venues in Paris was the Cercle de l'Épatant in the rue Boissy-d'Anglas. When he exhibited several pictures there in 1912, Matilda, as usual, thought they were the best in the show. "As they almost always are, at that show, and indeed at many others."

Walter's next exhibition was in March 1913 at the Fifth Avenue galleries of Gimpel & Wildenstein in New York, where fifty-nine pictures were shown. The essay in the catalogue was a translation of Henri Lavedan's 1908 foreword, one sample of which suffices to give the flavor: "[Walter Gay] understood that inanimate things and especially those, which, owing to their great age have more memories, are possessed of a little soul of their own, of whose furtive fluttering he tries to give us a glimpse." Matilda reported, "The New York mail brings good news of Walter Gay's exhibition over there. He is having a real success. . . . It makes us both very happy that he should be so appreciated in his own country. It seems a pity that he is not there to enjoy the pleasure that he is giving."

Once again a number of pictures in the exhibition were loans. The French government lent *Blue and White* from the Luxembourg Museum, and the Metropolitan Museum of Art lent *The Green Salon*. Other pictures were lent by their friends Anne Vanderbilt in Paris, the Marchioness of Ripon and the Duke of Sutherland in London, Thomas F. Ryan and Archer M. Huntington in New York, and the Gays' country neighbors the Comtesse de Beauchamp and the Marquise de Ganay.

Archer M. Huntington was one of several American millionaires who became important patrons of Walter Gay and luckily never read Matilda's diary: "Archer Huntington is a brilliant, erratic creature. He hides a certain embarrassment under a mask of buffoonery—it is often the small talk of brilliant men. Mrs. Huntington's real passion is social ambition—it stiffens the feathers of her hat. She is, I believe, an authoress of limp novels."

One of Matilda's oldest friends, Bessie Marbury, visited the Gays at Le Bréau in May of 1913 and "told Walter Gay all about the success of his New York exhibition, and how she had made the 'article' for him, first by her purchase of one of the most charming of the pictures, *Les Persiennes fermées*" (fig. 17). The purchase may in fact have been made by Bessie's companion, the decorator Elsie de Wolfe, for Walter wrote to Wildenstein, "Miss Wolfe is a very good person to have bought a picture, as she has influence in New York with people of taste." The same picture had been admired by the president of Boston's Museum of Fine Arts, J. T. Coolidge, Sr., who wrote to Walter, "The quality of reserved and refreshing coolness, the summer heat kept out yet

amply suggested in the Bréau room, delighted me." Other views of the same room in the exhibition seen by the Gays' New York friend Eliot Gregory made him homesick for Le Bréau, where he had visited for years. ("He seemed to be part of the enchanting season, like the flowers," Matilda wrote. "He was a man who had stepped out of a memoir, and had a flavor rare in an American.")

At the same time as Gay's pictures were on view at Gimpel & Wildenstein, an exhibition of a rather different nature was causing an uproar in New York. The famous Armory Show, one of the first exhibitions of modern art in America, included works by Cézanne, Gauguin, Picasso, Braque, Matisse, Kandinsky, and Duchamp, artists who did not find great favor in Walter Gay's circle. His friends could not resist comparisons. Edith Wharton's sister-in-law, Mrs. Cadwalader Jones, wrote to Walter: "Your exhibition here is entirely delightful. They all look very well, and their coming is well timed, for the public is supping full of Cubist and Post-Impressionist horrors at another big exhibition, and the distinction, charm, and *science* of your work makes an excellent contrast, which discriminating people are not slow to notice." A friend of Matilda's, Mrs. Peixotto, expressed it more vividly: "Mr. Gay's exhibition coming now when there is so much excitement over the pictures of the Futurists and the Cubists, is, to me, like the approach of the aristocratic white peacock in a noisy courtyard."

That sort of comment from friends was to be expected, but the letter Walter received from the director of the Metropolitan Museum of Art, Edward Robinson, was quite another matter: "I must take a minute from a busy day to congratulate you upon the exhibition at Gimpel & Wildenstein's, which makes a very bright and attractive appearance—especially sympathetic after one has come away from one remarkable exhibition of MM. les Cubistes, les Futuristes, and the other sons of affliction."

While these sentiments are disconcerting coming from the director of the Metropolitan Museum, which was then and still is devoted to the art of the present as well as the past, they were not at all disconcerting to the Gays, who, with a few exceptions, were not greatly interested in the art of the present ("The note of present-day painting is superficiality and slap-dash," wrote Walter) and most particularly not in the turbulent currents of modernism. For example, Matisse: "There is a certain force in his things, but they are shocking in color, in drawing, and in subject. Diseased art," pronounced Matilda. Her judgment of living artists was often flawed. "Albert Besnard is the biggest man of our time: he has the tradition of the old masters, and there is something Michelangelesque in his drawings, the same fearless purity in the nudes." If most contemporary art was distasteful to the Gays, that of the nineteenth cen-

tury did not fare much better. Empire: "The Bonapartes mean nothing to me, and the First Empire style was icy, stiff, and tasteless," she wrote. Louis-Philippe: "That gaudy, bourgeois epoch." Second Empire: "That blight of bad taste." Impressionism: "What is amusing is that the wild impressionists try to trace their inspiration from Ingres and admire him reverently; I wonder what he would say to them?" Art Nouveau: "A modern atrocity—when it is endurable, it is based on Byzantine influences; when it is wholly original, it is rather dreadful." The past that the Gays so often talked about loving included, for the most part, Gothic cathedrals and European art from the Renaissance to the end of the eighteenth century, parameters that were not uncommon in their particular sphere. Cultivated and refined though their tastes were in many areas, they were not without limitations.

17. Walter Gay. *Persiennes fermées* (Closed shutters). Oil on canvas, 29 x 33". Elsie de Wolfe Foundation, Los Angeles

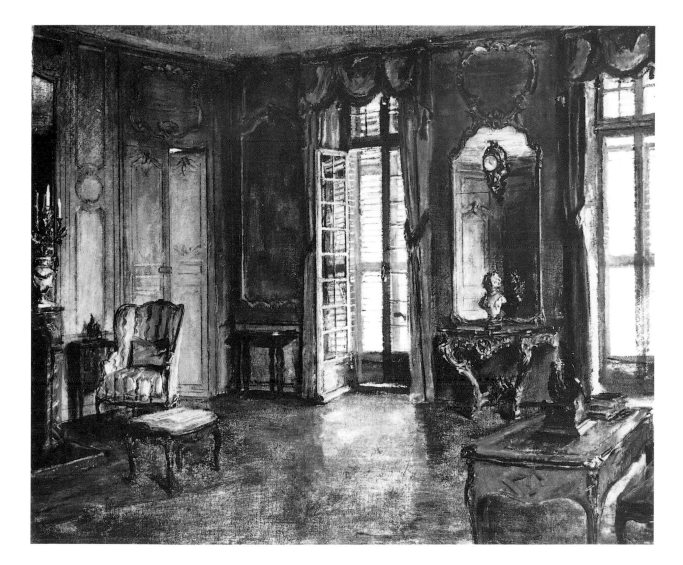

35

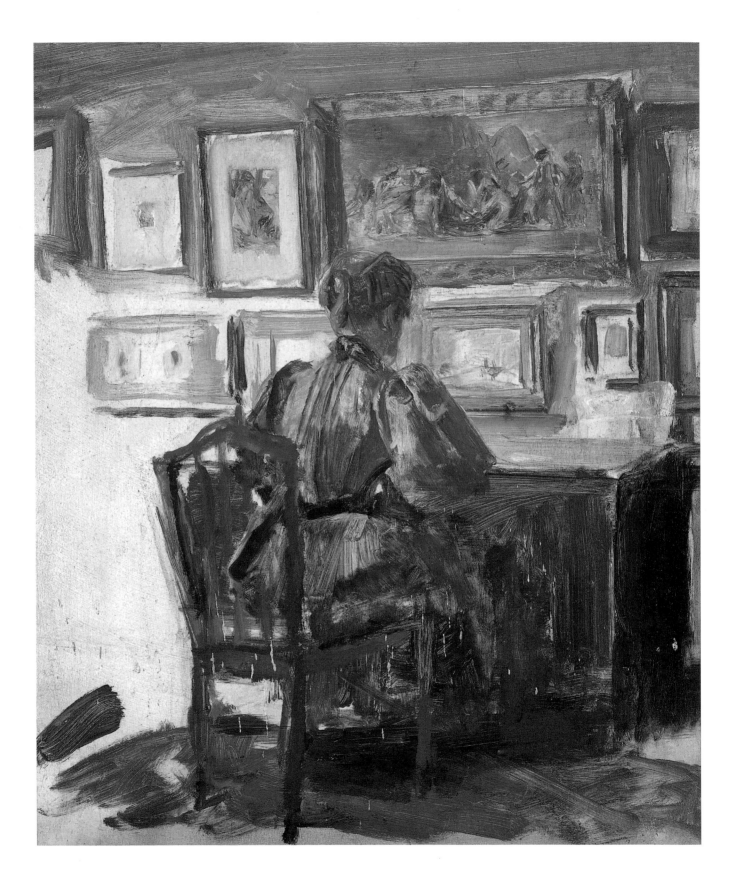

4. Matilda Gay, Diarist, Hostess, Wife

MATILDA GAY BEGAN HER DIARY ON FEBRUARY 28, 1904, AT THE suggestion of an American friend, Johnny Livingston. "[He] dined here last night and urged me to keep a diary—said that he and wife had done so ever since their marriage. Though somewhat late in the day, I promised to begin." She did not stop until 1934, although the last thirteen years cover only the Gays' travel (fig. 18).

Matilda had an extraordinary eye and memory for detail. For most of the dinners the Gays attended, and the Gays attended a great many dinners during this period, she included the names of every person present, who sat on her right and left, what was said, what she thought of what was said, and what she thought of who said it. And the dinners occupy only a part of each day's entry, often a small part. Some of the entries cover several typed pages. (A young clerk from Brentano's in Paris came in periodically to type the diary and Matilda's correspondence.) The factual aspect of the record, important though that is, is often of less interest than her opinions of the events and people that made up her world. And there was very little about which Matilda did not have a colorful and perceptive opinion. Given the hours that she must have devoted to this carefully written diary, it is surprising that she had time to do anything else. But, as the thirteen volumes make abundantly clear, Matilda Gay was a very busy woman.

Managing two residences, one in Paris and one in the country, both of considerable size, with a total staff of about twenty servants, was by no means an easy task. They had to be hired, directed, encouraged, soothed, and sometimes fired. Some of these retainers stayed on far too long. François, the butler, had been with the Gays for eleven years when they finally got around to discharging him. "He was faithful, devoted, and honest, but incapable and, as so frequently happens in his class, he has become an unconscious inebriate, never quite drunk, but almost never quite sober. After several years' impatient endurance of this grave defect, we resolved to send him away, in spite of his good qualities."

Matilda's maid Gabrielle remained for twenty-four years, during which time she managed to quarrel with everyone in the household. "Final interview

OPPOSITE:

18. Walter Gay. *Matilda Gay in the Study, 11, rue de l'Université.* Oil on canvas. Private collection

with my faithful old servant Gabrielle. She retires on a pension most unwill-ingly. But in the long run an ungovernable temper will prevail over years of devotion and fidelity to duty. She touchingly asked my pardon for the annoy-ances she has occasioned in all these 24 years. . . . It is such a mistake to keep servants too long; one unconsciously spoils them. They become impossible and we get angry with them for the result of our own weakness, or laziness, or both," Matilda concluded. "These are the pleasures of housekeeping—our mas-ters below stairs make life difficult sometimes." But firing them was never easy. "How disagreeable it is to send away servants, even unworthy ones. It tries severely W. G.'s sensitive nature. My Anglo-Saxon brutality is always aroused at such moments and makes me talk louder than anyone else."

Matilda often wondered just how much the staff inflated the house-hold accounts. "Paid all the house bills. It always puts me in a bad humour to do this. I seem to be making presents to the servants—perhaps I am!" Occa-sionally the Gays took a vacation primarily to get away from the servants, but this did not entirely solve the problem, as they required the chauffeur and a maid or two when traveling domestically. (Trips abroad could be managed with only one maid.)

Days at home fell into a pleasant routine. Once household matters had been attended to and menus decided for the day, Matilda would go for her morning promenade with Walter in the Pré Catelan, her pet spot in the Bois de Boulogne on the west side of the lake near the end of the Avenue Foch. Then it was time for lunch.

Giving and attending lunches, teas, and dinners occupied a significant portion of Matilda's life. Rare indeed was the day when she was alone at any one of these functions. Shortly after her marriage, she moved into full swing as a hostess, inviting to the house in the rue Ampère their rapidly expanding cir-cles of friends in the artistic, intellectual, and social worlds of Paris, as well as visiting relatives from America. When the weather was good, they lunched in the garden. Meals were judged a success when "everybody knew and liked everybody else," which, thanks to Matilda's skill in these matters, happened quite often. She had several rules of thumb to ensure that parties went well. The first was the age-old balance between men and women. "Extra men are never amiss, but extra women are a burden." The reason for this was her odd belief that men were better talkers. "It is always more agreeable to have men, because they will talk generally, and many women will not."

Then there was the delicate issue of interesting men with boring wives and vice versa. "The society of literary men is very agreeable—only the wives

are nearly always uninteresting, and not on a level with the husbands, unlike the *gens du monde* [gentlemen], where the wives have so frequently the superiority." Mixing respectable society with the *demi-monde* was a mistake. "I confess that I do not care for the fusion of *monde* and *demi-monde*—I know it is the fashion—but a bad one, not to be followed." A few intellectuals were useful, but not too many. "The *intellectuels* should always be in the minority, as they are the seasoning of the feast; and they love to meet the smart people as much as the latter are graciously flattered by meeting them." Diplomats were generally good at dinners; military men almost never. "The military type is an exceedingly difficult one to talk to. I have only three quarters of an hour conversation for an officer—when the colloquy lasts over 45 minutes, my small talk gives out." It lasted only slightly longer with civilians at dinners she did not enjoy. "Dined at La Muette, that picturesque remnant of an earlier time. A heavy dinner of 24 people, more or less assorted. We were two hours at table, so my stock of platitudes, which only last one hour and a quarter, ran dry." When Matilda liked the company, she was clearly wonderful company, and when not, not. "To lunch with Mrs. Thomson (née Parsons). A gathering of 24 people—about 18 of whom I had been avoiding for 20 years. I sat next to a man whom I had been trying not to ask to dine for a long time." Her habit of behaving with unconcealed icy disapproval when displeased must not have endeared her to many.

Whereas some hostesses were nervous wrecks at their own dinner parties ("Generally the hostess is sacrificed to the exigencies of social life"), Matilda thoroughly enjoyed hers, at least until the women had to retire. At Walter's insistence, the Gays followed the English custom of separating the men and women for an hour after dinner, a custom that Matilda loathed. "I must talk trivialities and personalities to the women, while the men are saying things I should like to record. . . . That is always an awful hour—that hour with the women!"

When the Gays were not giving large dinners, they were attending those of friends, on the average, four or five nights a week. "These giant dinners destroy all relations between host and guest—it is like dining at a restaurant," Matilda complained while writing a thank-you note for the previous dinner and preparing for the next.

On nights when they did not entertain or dine out with friends, the Gays were either at the theater or at evening parties, of which those on the embassy circuit were the most challenging. Embassies were perilous places rife with bores, "snags," and unknowns ("the usual embassy fiends"). Matilda

perfected a method of dealing with another category, those who did not want to see her. "I saw several people who pretended not to see me, but I had already anticipated them; so their fun was spoilt. It is the 'shoot first' principle, and is practiced in every social gathering in every corner of the world." This technique, in combination with Matilda's glacial stare, had the effect of keeping many at a distance, particularly men. "Men don't talk to me much at soirées, unless they are about to dine at our house, or have just done so. I seem to get on better with women of all ages." The goal at embassies was to make a quick, clean escape, but this was rarely achieved. "Dined quietly with W. G. and then went at eleven o'clock to a soirée at the Belgian Embassy. . . . There was a tremendous crowd, and, as usual, the *départ* was a hopeless confusion. We spent 20 minutes in the salons, and one hour waiting in the antechamber for the carriage. It seemed so little worthwhile."

The evenings that the Gays both regarded as their happiest were those spent entirely by themselves at home, quietly reading or playing checkers. Unhappily, such evenings were exceptionally rare.

Although Matilda did not drink tea, she soon discovered its advantages. "How much easier it is to give a tea than a dinner, and oh! how blessedly cheap!" For an intimate tea (*goûter intime*), she would invite about thirty friends. "Everyone knew everyone else and it was all very cosy." A more ambitious tea would number between fifty and sixty, but that usually proved a little tiring. "I was very glad to see them all—and not in the least sorry when they went away." Her own teas were only one side of the coin. On a good day she could zip around Paris and attend several teas. "Three teas in one afternoon means a good deal of senseless chattering, but I found pleasant people everywhere." There were, however, two types of teas that she avoided. "Went to a *thé*-bridge at Madame de Belleseize's. I don't drink tea, and I don't play bridge, so after talking to two elderly bores, I fled." The other was "old ladies' teas," even when, in due course, she became one of them. "Being an old lady myself, I do not enjoy the society of my contemporaries. I love the young."

In addition to the teas, there were afternoon lectures, receptions, concerts, language lessons, reading hours with friends (she read all of Shakespeare), and, not least, the ongoing business of paying and receiving calls. "Nothing more fatiguing than an afternoon of gadding calls, like these—and yet one must see one's friends." Receiving calls could be tiresome, especially unwelcome ones. "Madame d'Orfeuil came to see me in the afternoon. I always have the ill luck to be at home when this lady calls, and she seems to divine that I am sorry to see her." When not in the mood to receive, Matilda did her best

19. Matilda Gay. Photo: Collection Arthur T. Garrity, Jr.

to conceal it. "I don't always feel like receiving, but I hope I hide it when I'm not "*en train.*"

Not surprisingly, by the end of the spring, Matilda was ready to escape Paris for the country. "I am glad to leave the Paris season, with its rush, and that peculiar imbecility that comes over even the most intelligent during the season." She had by this time had enough of "le grand monde élégant" of Paris: "and very ugly and inelegant some of them are. I wonder if they are as tired of my face as I am of theirs?" she asked. "Probably," she answered.

She was then often so exhausted that she would go off by herself for a rest cure, either in Switzerland or at Châtel-Guyon near Clermont-Ferrand. "The waters may be efficacious, but I doubt if they can eradicate or even attenuate my three incurable maladies: neurasthenia, bad temper, and old age. However, I obey the family physician. Châtel-Guyon is the usual hideous watering place, cheap trashy shops and expensive barracks of hotels which look as though they were made of paste-board."

Matilda was not beautiful and knew it. "Women like myself, who have never been beautiful, have their innings after 40. We cannot lose what we never possessed, and as we have always sought more substantial pleasures than admiration, the harvest is a rich one." She did, however, like compliments. "I like people to say nice things about me when I am not there—for when I am, I have to pretend to believe that I don't agree with them." Saying nice things about

others, on the other hand, was not always her strongest suit. With the exception of her husband, about whom she never wrote and seems never to have uttered a critical word. Walter never painted a picture that she didn't like, and whenever his works were exhibited in group shows, they were, as far as Matilda was concerned, the stars.

She did not share his passion for shooting. "I am always glad when [the shoots] are over, for I am not a sportsman, though I appreciate the value of the open air exercise it gives. Still, I hate the taking of life for pleasure." But she never complained about the entertaining that went with it: the shooting breakfasts, lunches, and teas.

The one underlying sadness in their marriage was their failure to have children. "Why is it that everyone has nice children but me?" Matilda wondered. A friend tried to console her when she complained of being childless by saying that children were a great blessing, "and likewise a dearly bought one sometimes. For when they were unhappy, you suffered more than they did, and when they were happy, they did not need you. There is a large part of truth in this philosophy. But it is better to have had the joy, with all its corresponding sorrow: I would rather be a widow than an old maid." When friends and relatives came with their children to stay at Le Bréau, Matilda was thrilled. Her nephew Billy Coster and his wife often parked their two daughters there while they went off on a child-free vacation. While Matilda loved well-mannered children, her descriptions of babies make it very difficult to imagine her as a mother. On first seeing the little grandson of her friend the Duchesse de Trévise, she wrote, "Saw the baby, 3 weeks old. What strange lumps of humanity we are when we come into the world. This one looked like a lobster, with huge dark eyes. It is wonderful to think that this grotesque and rather repulsive little object will be a man some day—and probably a handsome one, like his father."

There is not the slightest indication that Walter was ever unfaithful. On this subject, Matilda held the common French view that there were "*infidélités qui ne comptaient pas* [infidelities that did not matter], that a wife must bide her time, for the husband wearies sooner of his little *caprices* than of his legitimate tie," as she expounded one night at dinner with their friend and neighbor, the artist François Flameng. "As Flameng's married life has been a series of *caprices*, he applauded my philosophy and wished that all women thought as I did, and first of all Madame Flameng."

Matilda wrote that life had but half its meaning for her when Walter was away. But the remaining half contained a strong note of self-sufficiency. "How heartily I enjoy my own society, when I don't have too much of it."

5. Paris

WALTER AND MATILDA LIVED FOR FIFTEEN YEARS IN THE RUE Ampère before the first signs of discontent with the place began to surface. In response to praise of the house, Matilda grew noticeably more captious. "Monsieur et Madame de Montgermont called—they thought our little hôtel was 'ravishing.' Their own in the rue Pierre Charron is large and hideous." Matilda's complaints about the neighborhood became increasingly vocal. "This quarter has no memories for me. My only association is with people whose friendship I have avoided, and whose acquaintance was only an *écueil* [obstacle]."

She told Walter that she never went to the Left Bank without longing to live there. "Shall I ever realize my dream of mouldering away on the 'Rive Gauche'?" she wondered. With that the die was cast and they began to search for a suitable residence in the Faubourg Saint-Germain, where, it now developed, Matilda had wanted to live all along.

When they finally left the rue Ampère in 1909, Matilda could find nothing good to say either about the house or the neighborhood, and she wondered how they had stood it for so many years. "I leave this comfortless little hôtel without a pang. It has been so distasteful to me for so long, and it is ugly and bourgeois, like the quarter, where we have always lived as strangers and never had any friends."

They rather naively thought that they would quickly find a house or large apartment on a quiet street with a garden and light-filled rooms with enough wall space for their now sizeable collection of pictures and drawings. These were difficult requirements in a neighborhood where many of the old houses had small, airless rooms with the musty smell of bad plumbing—a survival, Matilda speculated, of the more pungent odors of the eighteenth century. Although these places had a certain historic atmosphere, of course they simply would not do.

While she loved the neighborhood, Matilda had very mixed feelings about its aristocratic inhabitants. "Oh me! how dowdy they are, and how common-looking, until you speak to them, and their beautiful manners atone for their shortcomings in dress and appearance." A typical example was the old Marquise d'Etampes, whom she went to see in 1906, "a visit I have postponed

43

for eight years. Found just what I had expected—a dowdy, *distinguée*, deaf old lady, with the usual moth-eaten air of the Faubourg." But in the end it was the aristocratic grace, distinction, and great simplicity of the residents that were so appealing, what she called "the real Faubourg Saint-Germain."

Distinction was one of the qualities that most attracted the Gays, but it was not easily defined. "Distinction belongs to every class, and therefore to no one, like snobbishness," Matilda wrote. One of the most refined women she knew was the wife of their farmer in the country. The appeal of the Faubourg was clearly not without an element of snobbism, but not of the conventional social variety. "It is a vexed question," she wrote. "A general rule is that I always call people snobs who don't treat me well. But they've a perfect right to avoid me if they think me uninteresting or unprofitable."

20. Walter Gay. *Library, 11, rue de l'Université.* Oil on board, 21 x 25 ½". The Art Institute of Chicago. Anonymous loan. 301.1996

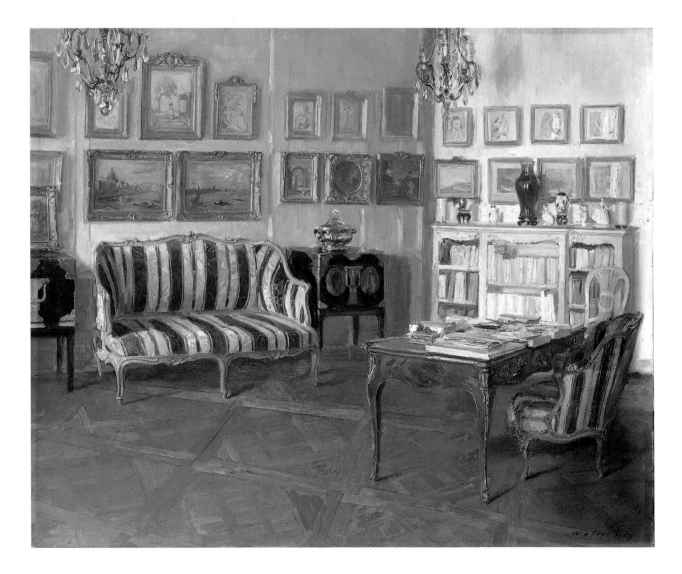

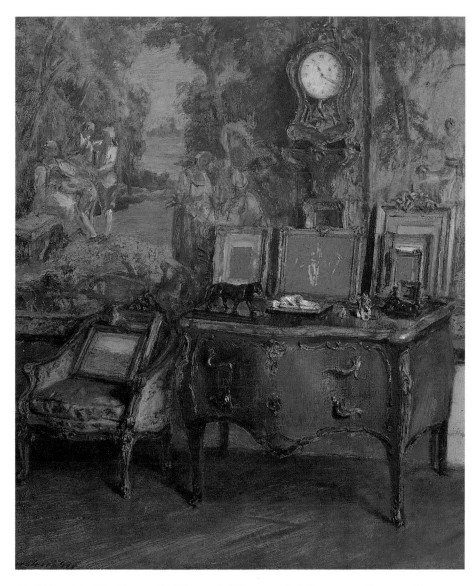

21. Walter Gay. *The Commode (11, rue de l'Université)*. Oil on canvas. Private collection

Finally in May 1909 they found an apartment with most of the essentials at no. 11, rue de l'Université, the former Hôtel de Chaulnes, at the corner of the rue de Pré-aux-Clercs. With large, high-ceilinged rooms, the apartment offered ample space for works of art. The one feature it lacked was access to a garden, but at least it overlooked one. Located on the interior of the building on the second floor, *entre cour et jardin*, the place was blissfully quiet, while in the very throb of Paris. "May 17th, 1909. Eventful day. Signed the lease of the apartment where we are to settle for six years—a serious step which I hope we will not regret. But the first sight of the place attracted me. . . . The rue de l'Université is our frame, and the new apartment will be a cheerful grave." It remained their Paris frame for the rest of their lives. While the Gays stayed at a nearby hotel, the servants moved their household goods, aided by five strong men. "It is in rather a hopeless stage, nothing fits, and yet there is far too much. I felt like Marius sitting amid the ruins of Carthage," Matilda wrote in January 1910.

No sooner had they settled in than the Seine overflowed its banks and flooded the neighborhood, forcing the tenants on the ground floor below them to leave the building. "I think I would rather be wet in the rue de l'Université than dry in the little house in the rue Ampère, which I hated for so many years," Matilda wrote to her sister Louisa Wadsworth in Washington. "Meantime, our

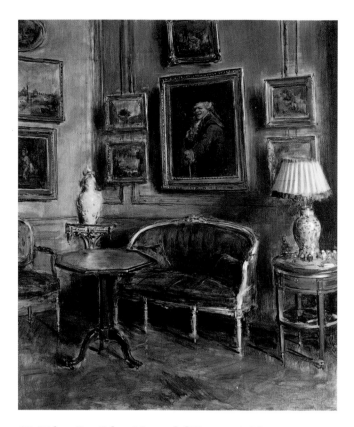

22. Walter Gay. *Salon, 11, rue de l'Université*. Oil on canvas, 28¾ x 23¾". The Pennsylvania Academy of the Fine Arts, Philadelphia. Gift of James P. and Ruth Marshall Magill. 1954.24.1

apartment is going very slowly, on account of the stoppage of circulation and closing of so many shops. It is, however, very successful, as far as we have been able to arrange it. One room is in order, the salon and my bedroom. They both look charmingly." She reveled in the modern bathrooms. "To have one of my own is a luxury I have not had these 25 years."

By March things were back to normal and their friends began to visit. "They [are] all enchanted with our new quarters, and I foresee that we shall continue our role of curators of our new museum." Matilda had always envied museum curators, who seemed to have the ideal occupation, and indeed, since cataloguing Walter's drawings the previous year, she felt that she already was one.

A museum is what some of the rooms resembled, with pictures double- and even triple-hung on every available wall (figs. 20–22). But the overspill of drawings and pictures stacked on commodes and the clocks mounted over tapestries reflected a style of display not found in museums (fig. 23). The mantels could hardly contain the clutter. Walter's views of the apartment show that it experienced the same frequent shifting about of pictures and furniture as their house in the country. When a new acquisition appeared, if it was to be hung and not just added to the nearest stack, a whole wall of pictures was reorganized to accommodate it. But for all the frequent changes, this was a traditional apartment, which looked as though it had always been that way and would always stay that way, exactly how the Gays wanted it to look. "How I love the little old-fashioned apartment with its high ceilings and its wide fireplaces!" Matilda exclaimed. She was soon able to resume entertaining, now on a larger scale than had been possible in the rue Ampère. Full capacity in the dining room was fourteen. Smaller meals for four or fewer were served in the study (fig. 24).

In a neighborhood full of antique shops, the apartment was ideally situated. "Prowled in bric-a-brac shops. Bought a beautiful console, and one lovely armchair," Matilda wrote. "It does one good to buy pretty things." When two dealers came to visit and were fooled by a piece of furniture, Matilda was almost gleeful. "Mme. Guirand and her son, the antiquity dealers, came to visit

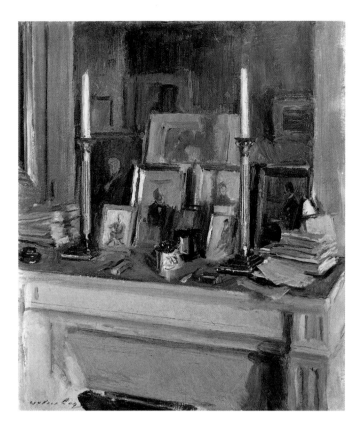

23. Walter Gay. *La Cheminée (11, rue de l'Université)*, c. 1909. Oil on canvas, 21¾ x 18". Museum of Fine Arts, Boston. Gift of Mrs. Walter Gay. 39.735

our collection and were very complimentary, most gratifying from people of their experience. The son, who doubted one or two of our chairs, was completely taken in on the authenticity of a console, which is more than half modern. *"Tout le monde se trompe!* [Everyone is mistaken!], even sharp dealers."

Antiquing was one of the Gays' favorite activities but could be awkward when pursued with friends. On one occasion, they went with their downstairs neighbor, Roffredo Caetani, Prince di Bassiano ("He is exquisite in his distinction, but there is always something moribund about a scion of an ancient historic family"), to visit the famous antiquarian Madame Langwell, who specialized in Oriental art. "Madame Langwell herself is a character, or *type* as they say in French, of an excellent *commerçante*, self-respecting, dignified. She does the honors of her collection so well that one forgets it is a shop. The jades, the porcelains, the vases . . . the lacquer furniture, and last, but foremost in temptation, were the magnificent Coromandel screens." One of these screens Matilda coveted. "[It is] covered with scenes of domestic life: a series of *intérieurs* by some Japanese Walter Gay. But alas! we've no place for such treasures. . . . When one loves these beautiful things passionately, one does not need to buy them. The memory is the best possession of which no one can rob you."

Five days later the Gays went downstairs to visit the Bassianos, "who showed us a Coromandel screen, the very one I wanted so hard at Madame Langwell's the other day." That one did not need to buy beautiful things suddenly seemed less true. "As long as I can't have it, I am very glad that they can," Matilda tried to persuade herself. But in fact she wasn't glad at all, and she continued to think longingly about the beautiful coromandel screen in the apartment below her feet. When the Bassianos moved several years later, the Gays offered to take care of some of their precious things, including, as it happened, the coromandel screen, until their friends were settled in a new apartment. Although there had been no place for such a treasure before, a place was found for it, actually quite a prominent place in one of the salons, where, once

47

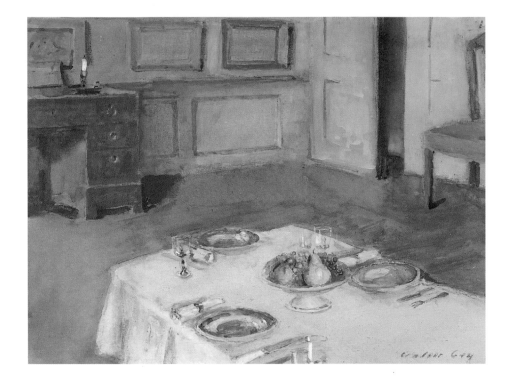

installed, it stayed (fig. 25). Their friendship with the Bassianos survived. "They are so *sympathique*, so comprehending. Roffredo is the quintessence of subtlety—an Italian of the Renaissance," Matilda hymned, now that she had the coromandel screen.

Other pieces of furniture, such as a Louis XV sofa and armchair with original upholstery of striped red-and-cream-colored velvet (fig. 20), came from the apartments of friends (in this case, that of the novelist and playwright Pierre Decourcelle; see fig. 105), but through the more straightforward channel of the auction room. However full the rooms became, there was always space for more furniture, which sometimes arrived on birthdays. "W. G. gave me a lovely pair of Louis XVI andirons for my bedroom in the apartment followed up by a bunch of red roses."

During the summer and autumn, the Gays occasionally came in from the country for the day and, feeling like naughty children hiding, called no one. "To Paris with W. G. where we lunched quietly in our apartment, never so attractive as in the height of the dead season, free from our curtains, carpets, and social obligations. . . . It is delightful to be incognito in Paris at this season—and so safe, between a court and a garden." They loved being back at their nest in the rue de l'Université, "our snug little corner of old Paris," especially when no one knew they were in town.

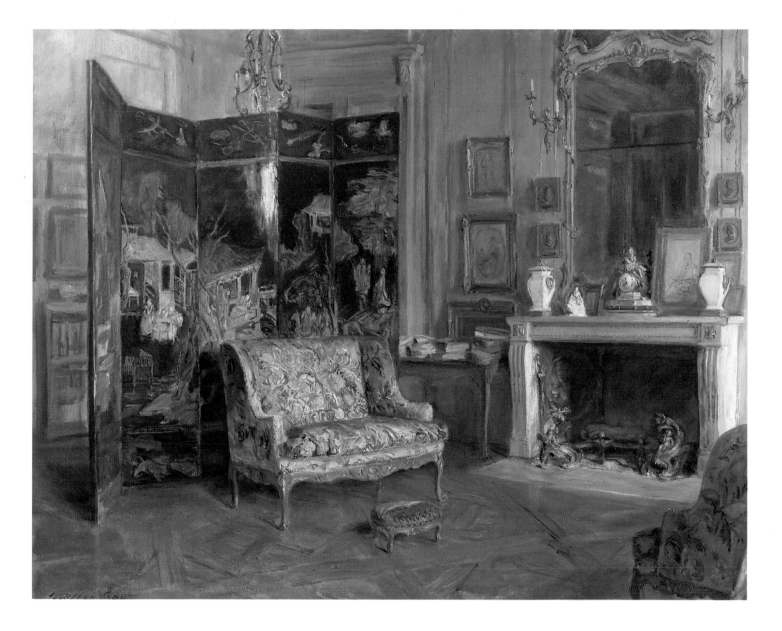

6. The Country

AFTER THEIR FIRST SUMMER HOUSE AT MAGNANVILLE IN 1895, THE Gays took another house the following season at Sandricourt on the Seine, which turned out to be completely unsatisfactory, as it was both uncomfortable *and* unpaintable. Matilda thought that its only redeeming feature was its position on the river. "I like the Seine as a baby more than in its full maturity. This happens to mankind as well as to rivers." They concluded that summer rentals were not for them and decided they needed a year-round country house.

For the next nine years they rented the Château de Fortoiseau from Baron d'Astier de la Vigerie. Because the dwelling had cachet, that elusive quality the Gays always sought, the lack of running water and electricity did not particularly bother them. They even forgave its Louis Philippe ugliness. They furnished the house with a combination of eighteenth- and nineteenth-century French furniture and Japanese porcelain (figs. 26, 27), restlessly reshuffling the arrangements, and moving things from one room to another, from Paris to the country and back. The sofa on which Matilda reclines in the portrait Walter painted of her at Fortoiseau (fig. 28) appears in another picture of the study in their house on the rue Ampère (see fig. 56).

In the spring the air was perfumed by the violets that filled the small park surrounding the château. Matilda built a little summer house in the garden, where she enjoyed reading Dante. She did not, however, enjoy the gardener, whom she considered stupid, stubborn, and sly. "Were it not for his nice young wife, I think I should send him away," she wrote.

In December 1904 two events took place that would bring their stay at Fortoiseau to an end. The d'Astiers informed them that they would not renew

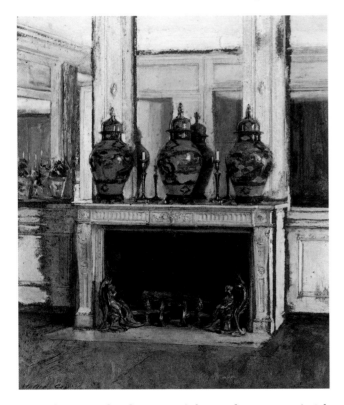

26. Walter Gay. *The Three Vases* (Château de Fortoiseau). Oil on canvas, 21³⁄₄ x 18¹⁄₄". Carnegie Museum of Art, Pittsburgh. Gift of Miss Annie-May Hegeman from the collection of her mother, Mrs. Henry Kirke Porter. 42.5.6

27. Walter Gay. *Château de Fortoiseau*. Gouache on board. Collection Edward Lee Cave

28. Walter Gay. *Matilda Gay Reclining on a* Lit de Repos (Château de Fortoiseau). Oil on panel, 17 x 21". Private collection

the Gays' lease on March 1, 1906, as they intended to reoccupy the house themselves. And Matilda's much beloved sister Susan, who had visited several times, died suddenly in America, a shock that Matilda was never able to dissociate from the place where she heard the news. It was as though the château was now poisoned for them. Clearly, they would have to search for another house in the country.

Their last night at Fortoiseau—October 30, 1905—was not a happy one. "The memories of our nine years in the old house are crowding before me," Matilda wrote. "The dead sit in the chairs, and their voices ring in my ears—there are too many vanished faces here." The face she would always miss the most was that of her favorite sister.

From time to time the Gays were invited back to Fortoiseau, but they deplored the pretentious modernization made by the d'Astiers. "I feel like my own ghost when I go back to Fortoiseau. . . . I can't believe that I ever lived [there]—it is so changed, both in furniture and atmosphere. I always get away from it as soon as I can. . . . There is nothing left of our dear old Fortoiseau in this over-furnished villa, where social ambition has its sway." As bad as the house was the noisy and tiresome Madame d'Astier. "Madame d'Astier paid her duty call today, to announce her arrival in the country. She is more exuberant, boastful, and snobbish than ever—but really not a bad sort of person to see once a year."

29. Walter Gay. *Château du Bréau*. Oil on canvas,
21¼ x 25½". Private collection

30. Walter Gay. *The Open Window, Bréau*, c. 1915.
Watercolor on paper, 21½ x 17½". Dumbarton Oaks,
Washington, D.C. D.19.2(WC)

31. Walter Gay. *The French Garden, Bréau*. Watercolor.
Inscribed: "à Mademoiselle Marthe de Vogüé, hommage
de Walter Gay." Private collection

The d'Astiers stayed only five years, after which Walter and Matilda went for one more visit. "Bénard, our old keeper, showed us over the house and place haunted by so many memories. It is to let again. The house is full of ugly furniture; it is cleaner and more modern than when we had it, but it has wholly lost the little *cachet* that we gave it with our furniture and W. G.'s pictures. . . . But the place is profaned, and it is no pleasure to return to the familiar corners." The château passed through several subsequent occupants, none of whom the Gays much liked, until World War II, when it was used for the storage of ammunition by the Germans, who blew it up on their retreat.

The château closest to Fortoiseau was the Château du Bréau, which belonged to the Comtesse de Gramont d'Aster, who happened to be seeking a new tenant at just the moment when the Gays were looking for another house. Her previous tenant, Prince Louis de Broglie, had just informed her that he would be leaving at the end of his lease. A friend of the Gays' who knew Le Bréau well, Madame Alfred Sommier of Vaux-le-Vicomte, thought that it might be just right for them. They went to have a look and were enchanted: "[It is] a beautiful place, and a fine house handsomely furnished with authentic 18th century furniture," Matilda reported. It was, however, much larger than Fortoiseau, and Matilda initially could not quite imagine living there. Madame de Gramont indicated that she would be willing to rent it for 15,000 francs a year [about $50,000 today], a sum that seemed reasonable but could still be improved by negotiation, which continued into the spring. The following July the Gays signed a three-year lease. "July 28th, 1905. W. G. and I went to the notary's to sign the lease of the Bréau. I wonder whether we shall regret it or not?" They moved in on October 31 and never moved out. "The charm of this lovely place holds me fast, after passing only 24 hours here—it is a dreamy spot, full of old-time memories. I wish someone would write a story here."

The Château du Bréau was set in a three-hundred-acre walled park filled with privet and handsome old poplars and surrounded by two hundred additional acres of woods and fields bordering the Fontainebleau forest. There was more land outside the park available for partridge shooting. The four-storied brick-and-stone house had a mansard roof, projecting wings, a wide forecourt framed with orange trees in traditional tubs, and broad terraces shaded by linden trees overlooking the moat at the rear and on both sides (figs. 29, 30). Built in 1705 on the foundations of an earlier house, the château was later expanded to include two ranges of gabled outbuildings for stables and carriages behind the twin entrance pavilions, which housed the concierge and the groundskeeper. On one side of the stables were the gardener's house and three

large walled gardens, one of them English, one Italian, and a kitchen garden. On the south side of the house was a formal French garden designed by a pupil of Le Nôtre named Duchesne featuring a semicircle of chestnut trees and a tall dovecote (fig. 31). The Seine was a comfortable afternoon's walk away by way of the village of Vosves.

The house had a colorful history. During the eighteenth century it had been owned by the Comte de Chateauvillard, who was said to have amused himself by tormenting his wife. "Once when she was returning from Paris, he hired some men to stop the carriage, rifle her trunks, and tear her jewels from her neck and ears," Matilda recounted. "Another time, during one of her short absences, he caused the facade of Le Bréau (then a small house) to be hung in funeral black, painted with large white tears. At the grille Madame de Chateauvillard was informed that her very trying husband had died suddenly. The mischievous author of this trick stood watching at the window to see the effect produced on his wife by the news. Instead of being relieved, the poor woman was greatly overcome, which was just what her husband wanted. As it turned out, she died first, and he married a young Italian girl, about the age of his own son—and the latter fell in love with his stepmother: the story of Phè-dre enacted at Le Bréau."

The Gays' friend, the Comte Cahen d'Anvers, who lived nearby at the Château de Champs, remembered Le Bréau as a typical structure of its type before it was bought in 1884 and renovated by the Gramonts, who enlarged the demesne, added to the house, and made numerous changes, including the installation of Louis XV-style *boiseries* in the principal rooms on the ground floor. They furnished the house with eighteenth-century furniture, which joined with their ancestral portraits to give the impression of a family seat. Neighbors recalled the pleasant dinners and parties held during the time of the Gramonts, who filled the place with their friends. Despite the fact that more than half of the interior was what Matilda called a "reconstitution," it had a quality that the Gays prized above all others in a house, a "parfum du passé."

Everyone agreed that there was something magical about Le Bréau, and few of their friends failed to comment on its beauty. One, Randolph Mordecai, well-meaning but unskilled in the art of praise, described it as an "indigestion of beauty." But it was the atmosphere, the mood of the place that was most striking. Following a visit in 1905, Matilda's friend Margaret Terry Chanler wrote to her: "The memory of Le Bréau haunts and soothes me—as of something very lovely and calm and complete." Another friend, the writer

Gabriel de Mun, expressed it well: "Enfin Le Bréau est le pays des rêves!" [In short, Le Bréau is the land of dreams!].

A frequent visitor was Edith Wharton, who had known Matilda since their childhood in Newport and New York, although Edith was seven years younger. In her novel *The Reef*, one of the most beautifully portrayed houses in all of her fiction, the Château Givré, is strikingly like Le Bréau: "An old high-roofed house which enclosed in its long expanse of brick and yellowish stone the breadth of a grassy court filled with the shadow and sound of limes. . . . So prolonged yet delicate had been the friction of time upon its bricks that certain expanses had the bloom and texture of old red velvet, and the patches of gold lichen spreading over them looked like the last traces of a dim embroidery." Nowhere is the fine patina of age on the soft-hued facade of Le Bréau better described. In the mellow silence of Givré, Wharton so perfectly captured the quiet, dreamlike quality of Le Bréau that it hardly matters if her fictional château may have been a composite of the many houses she knew.

The large marble-floored entrance hall with walls of Caen stone passed straight through the house from the arched front door (fig. 32) to the back opening onto the rear terrace. On the left two terra-cotta sculptural groups flanked the red-carpeted stairs (fig. 33). Nearby were handsome carved wood urns on pedestals and busts on brackets.

The main salon was actually two interconnecting rooms paneled with cream-colored Rococo-inspired *boiserie* (figs. 34, 35). Walter painted many interiors of the salon in a widely varying range of light, color, angle, and mood—from the nearly monochromatic gouache-and-brown-wash study of the pier table with a vase of flowers (fig. 36) to the vividly colored view of a commode supporting a portrait

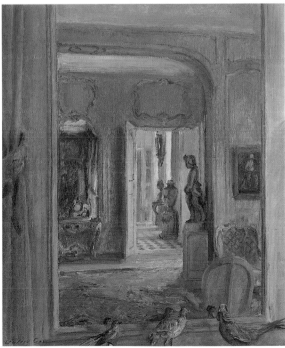

bust (fig. 37). Few of these pictures show the same furnishings because furniture, pictures, sculptures, and porcelain were added and moved about at Le Bréau at a rate that belied the "calm and complete" effect so admired by their friends. Some of these views were given as presents to neighbors, such as Hubert de Ganay at Courances and the Duc de Trévise at the Château Livry, and many were shown at his exhibitions. Walter's favorite subject in the salon was a Louis XV commode supporting a still-life arrangement of blue-and-white

37. Walter Gay. *The Salon, Bréau.*
Oil on canvas. Private collection

porcelain that he arranged and rearranged in various positions and combinations with a chair or table nearby (see fig. 73).

The Gays paid considerable attention to upholstery: some of the chairs were covered with yellow silk to blend with the new yellow curtains added below the old, faded red pelmets. But reupholstering the furniture did not always work as anticipated. The delicate harmony of faded *boiseries*, worn parquet floors, and what Edith Wharton called "soft hangings and old dim pictures" was easily disturbed, and despite Walter's keen sense of color and pattern, he occasionally disturbed it. "The sofas and chairs in the parlor are a very great success, with their covering of silk with a green stripe," he reported

38. Walter Gay. *Les Tableaux, Bréau*. Oil on canvas, 17½ x 21". Dumbarton Oaks, Washington, D.C. P.36.36

OPPOSITE:
39. Walter Gay. *The Library, Bréau*. Oil on canvas. Private collection

to Matilda in 1914. "Those in the petit salon less so. They are covered with a strong yellow and a stronger green stripe—too strong for the room. In fact, I don't remember having chosen it. They are also too dark in color."

The petit salon was the adjacent small room with oval portraits of the Gramonts inserted into the paneling high on the walls. The room was first used as a study, when Walter painted a view that was bought by his friend Georges Bertin and given to the Luxembourg Museum in 1911, but it seemed unsatisfactory in that state, so he converted it into a studio and added at eye level a complementary series of oval pictures of sculpture in the park at Bréau, painted the same size as the portraits. In one view a chair upholstered with the too-strong green stripe material sits next to a table holding his palette in front of an easel that supports a framed interior of Edith Wharton's drawing room at the Pavillon Colombe (fig. 38).

The library at Le Bréau was paneled with *boiserie* of similar design to that in the salon. On the chimneypiece of *brèche d'Alep* marble was a Louis XV green-lacquer clock flanked by porcelain birds and nearby a deep and extremely comfortable-looking Victorian tufted armchair (fig. 39). The mixture of eighteenth- and nineteenth-century furniture at Le Bréau was Matilda's

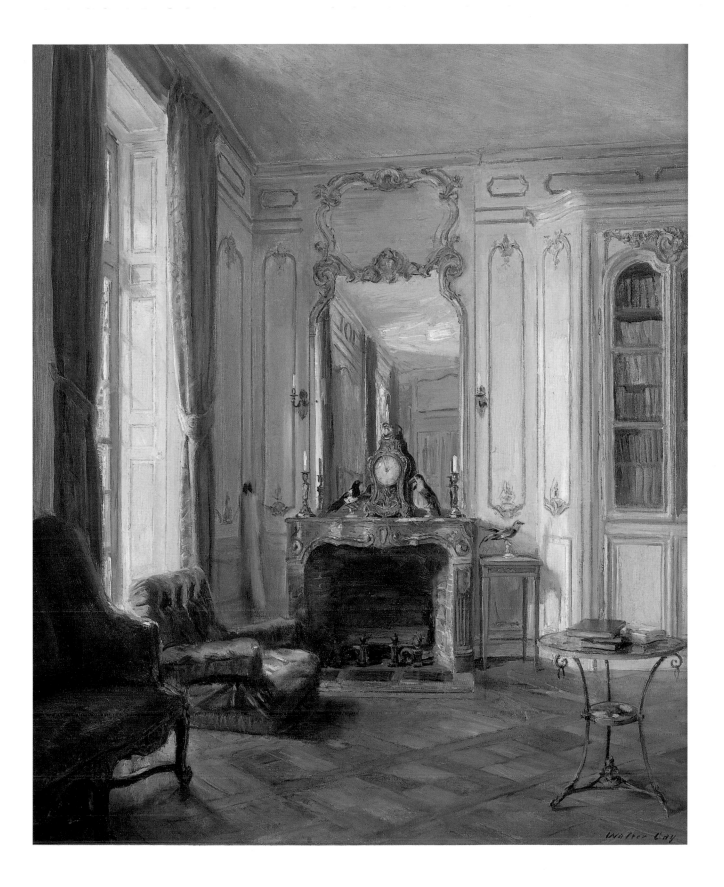

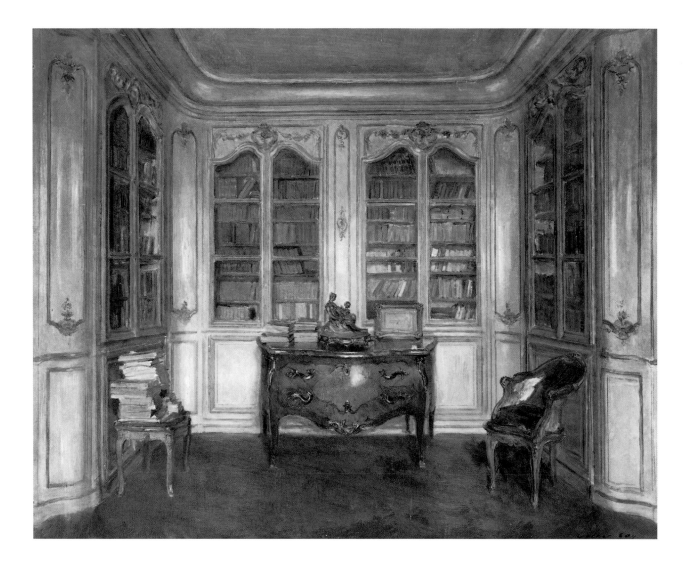

40. Walter Gay. *The Library, Bréau*. Oil on canvas, 21¼ x 25½". Smith College Museum of Art, Northampton. Gift of Archer M. Huntington

doing, a reflection of her frequent complaint about the period formality in French houses: "Why are French houses nearly always icy? There is never a cosy confusion." There was certainly no lack of cosy confusion in the library. Books were left casually piled on tables, commodes, and footstools and were hardly more orderly on the shelves. A painting of one part of the Gays' library (fig. 40) was hung on the arched opening in the salon (fig. 34), where, although clearly too large for the space, it remained until it was bought by Archer M. Huntington, who gave it to Smith College in 1925. There were several other paneled rooms in the château: a circular room with mirrored panels and a radiating inlaid floor (fig. 41), an oak-paneled room shown in a watercolor bought by the Museum of Fine Arts in Boston (fig. 42), and another circular room with green-painted *boiserie* (fig. 43).

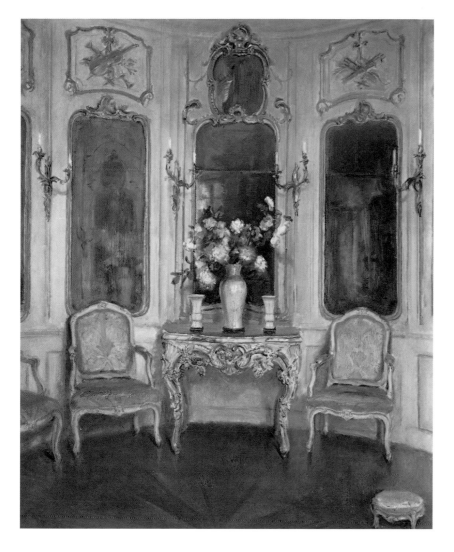

41. Walter Gay. *Mirror Room, Bréau*. Oil on canvas, 25⅝ x 21¼".
Museum of Fine Arts, Boston. Bequest of Helen S. Coolidge. 63.172

BELOW:
42. Walter Gay. *La Chaise-longue, Bréau*. Watercolor, 10¼ x 15¼".
Museum of Fine Arts, Boston. The Hayden Collection. Charles Henry Hayden. 30.446

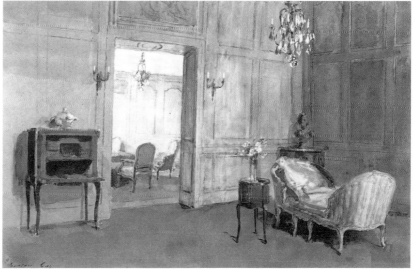

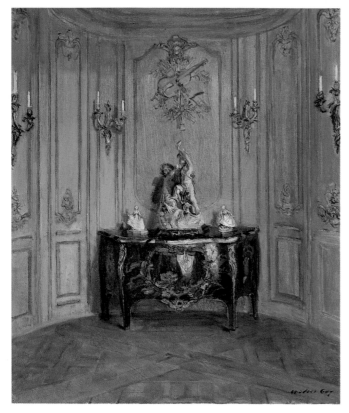

On the ground floor of the north wing was a suite of rooms that served as a summer apartment, which was refurnished in 1913 after an expensive visit to Buvelot's, a luxury shop in Paris on the quai Voltaire. Matilda's diary entry for that day reads: "How delightful it is to order pretty things. And how dreary it is when the bill comes in!" The suite included a room whose walls were upholstered with pink-and-cream *toile de Jouy* (fig. 44). Walter chose yellow fabric for the Directoire chairs in his bedroom, this time with more success than in the petit salon. "They are perfectly killing in their yellow covering with a design, which is exactly right," he reported proudly to Matilda.

In October the Gays reluctantly moved from the summer apartment to their winter quarters on the second floor of the south wing overlooking the French garden. "It always depresses us to leave the

43. Walter Gay. *The Green Salon* (Château du Bréau). Oil on canvas, 25 ½ x 21½". The Metropolitan Museum of Art, New York. Rogers Fund, 1912. 12.193

RIGHT:
44. Walter Gay. *The Pink Room, Bréau.* Oil on canvas, 21 x 17½". Raydon Gallery, New York

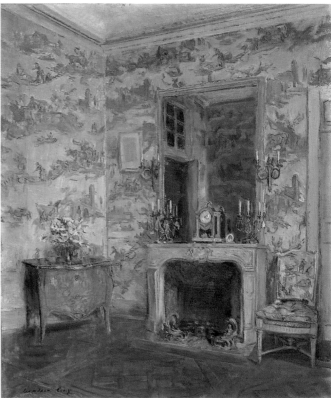

ground floor summer quarters—it is the passing of the season, symbolic of our own disappearance," wrote Matilda, for whom thoughts about mortality were never far from the surface.

All three of the principal floors at Le Bréau had guest bedrooms. In general French friends were lodged on the ground floor, Americans on the second, and children and servants of guests on the third. The reason for this, Matilda explained, was that "the French had a horror of stairs and our compatriots a horror of dampness, also that a sunny exposure was much more necessary for our comfort than for theirs. No doubt our tissues are dried up by our fierce sun and dry climate, so that European humidity chills our marrow." Their neighbor Madame de Ségur admitted that she lived on the ground floor from choice, and Madame Sommier at Vaux-le-Vicomte said that she would if she could. As for dampness, one could always make fires.

The beds, furniture, and walls were covered with the same fabric in several of the bedrooms, which were named after the predominant color of the material (blue, yellow, green) and were painted by Walter in a series of pictures that are among his most charming (figs. 45, 46, 48).

The one part of Le Bréau that Walter never painted and where he spent as little time as possible was the chapel, to the consternation of his pious wife. Located at the northwest corner, the chapel looked nothing like the rest of the house, as Daisy Chanler described in her autobiography: "The chapel was redecorated by a previous owner in the Viollet-le-Duc period, with Neo-Gothic stencilings in muddy colors and quite hideous stained-glass windows. The contrast between the chapel and the rest of the house is so surprising that I could not help asking my hostess if she had ever thought of changing it." Matilda responded that she had learned to pray in the ugly Catholic churches of old New York and did not care for religious aestheticism; she felt that she prayed better in unsightly surroundings among crude modern objects. The chapel served as the parish church to the local community of tenants and retainers, whose attendance or lack of it Matilda rarely failed to note. Immersion in prayer did not prevent her from counting and recording the exact number of communicants at mass.

Guests invited for lunch at Le Bréau were often late, as the drive from Paris was rarely completed without a flat tire or mechanical breakdown. Because this happened frequently to the Gays, they never could understand why visitors didn't make allowances for it. A delayed lunch did not get things off to a good start. "When people are late like this, it is always the result of a selfish thoughtlessness—it spoils everyone's temper for the rest of the day,

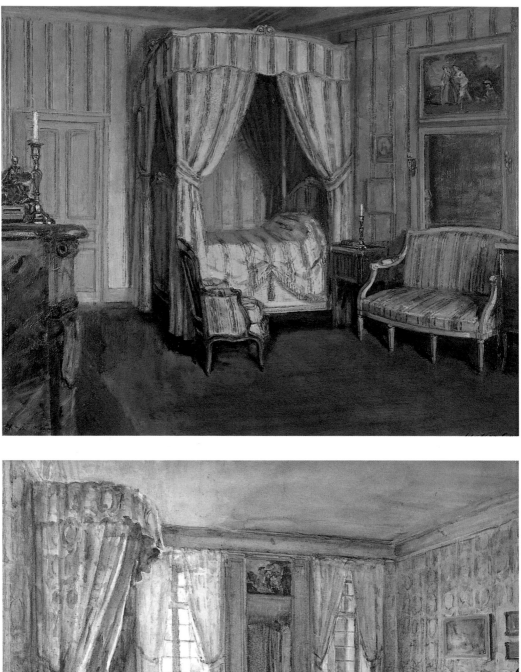

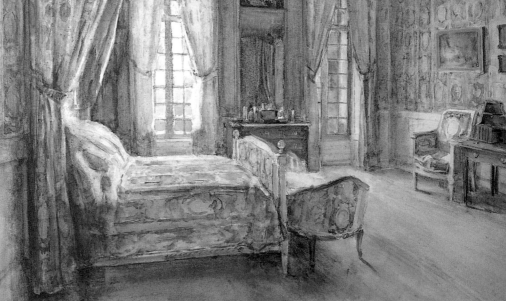

more particularly W. G.'s, who is thoughtful himself and expects everyone else to be," Matilda complained, gently suggesting that it was mostly Walter's issue. In fact, it annoyed her just as much. "I don't know why a retarded mid-day meal upsets one so—it must be gastric." A fairly typical example was the visit of the George Vanderbilts in October of 1907. "[They] were an hour late, as so frequently happens when our friends come down by motor. They never allow for *pannes* [breakdowns], and they always have them." If the hosts were feeling impatient, they went ahead and ate lunch on schedule at one o'clock, and guests had to make due with heated-up remnants of food whenever they arrived. In rare cases when friends were stranded en route, the Gays were obliged to send their own car to collect them.

Depending on the weather, lunch was served either on the terrace beside the moat in the shade of the linden trees or in the large dining room, which was paneled with *boiserie* decorated with palm trees. One of their first purchases for the house was silver for the dining room. "Went yesterday morning to hunt up old silver—had much trouble in finding what we wanted. The prices have risen enormously of late years. After spending 50 pounds on spoons and forks that would have cost 25 or 30 pounds 15 years ago, we came back feeling very poor and depressed."

In the summer they took as many meals as possible out of doors and particularly enjoyed dinner on the terrace by the light of the harvest moon. After lunch, came the house tour for those who had not already seen it, and then walks in the park and the woods, or excursions to nearby houses, most often to Courances and Vaux-le-Vicomte.

To friends who came for lunch or for the weekend, Matilda enjoyed showing the house. "Comtesse Joachim Murat went into raptures over the Bréau, and had a different adjective for each room—an inexhaustible vocabulary, that enviable French gift, which enables one to say the same thing over and over again without being a bore." But Le Bréau soon acquired such a wide reputation as a showpiece, "un château à visiter," that many came who were merely friends of friends or who hardly knew the Gays at all. These Matilda divided into two categories: cultivated people of taste, who knew what to admire and displayed their appreciation, and the others, who "admired everything and saw nothing."

The latter group was by far the larger of the two and included some surprising members, such as the famous aesthete Comte Robert de Montesquiou, who as it happened was also a first cousin of Madame de Gramont (fig. 47). "This gifted, brilliant, extraordinary, and somewhat uncomfortable

personage crossed the threshold of Le Bréau for the first time," Matilda wrote in her diary on November 22, 1908. "For four hours we listened to his torrent of eloquence and witticism, which never flagged—nor did our interest. He is tall, striking-looking, with a large, fine head and flashing black eyes—his thick hair and waxed moustache dyed carefully, and I detected a very adroit *maquillage* [makeup]. In speaking of our neighbours he quickly made mincemeat of them all—and some of his wicked thrusts were merited. He is a *fin lettré* [refined man of letters] and a very talented man, but not a man of taste, as he considers himself and is considered, for he admired the wrong things at the Bréau and did not see the beautiful ones. Our house is our shibboleth." Judging visitors on their ability to distinguish good works of art from the merely decorative was not perhaps the most generous of approaches, but that is the test that was given and many were found wanting.

As word spread about the appeal of Le Bréau, Matilda soon began to complain about her role as tour guide. Those who showed interest in the Gays solely because of their château did not get very far. One such was Madame de La Chapelle, whom Matilda encountered in Paris in 1907. "This excellent lady showed but a languid interest in us until she heard we lived at Le Bréau. Then a sudden enthusiasm flamed into her voice and manner. I am not flattered by such appreciation."

Robert de Montesquiou was not alone in making mincemeat of the Gays' neighbors. Matilda herself was only slightly less critical: "Some tiresome neighbors dropped in to mar an otherwise quiet happy day. Why are country neighbors nearly always bores? I know of only four exceptions in our well populated neighborhood." The exceptions were the Sommiers at Vaux-le-Vicomte, the Ganays at Courances, the Trévises at the Château Livry, and the Gontauts in Dammarie. Otherwise, the Dammariens, as Matilda called them, were on the whole well-bred, dreary, narrow, and prejudiced. "[I] am such a bad neighbor and never pay visits—save to those whom I care to see—and there are mighty few, among our numerous neighbors." At local social events, such as hunts, Matilda tended to see the same old faces: a few friends "and the remainder, the *crampons* [bores] of the neighborhood, who ask me why I don't go to see them, which they never seem to guess: because I don't want to." Most of these turned up at the Fontainebleau races. "I hate races, and only go to them as a duty, to uphold the institutions of the county. But the Fontainebleau races are particularly uninviting as I am always sure to encounter my unpaid social bills—unreturned visits, or dropped acquaintances. I meet cold or frowning faces with the same unruffled calmness." Matilda did not suffer fools gladly.

47. Comte Robert de Montesquiou, photographed by Paul Nadar. Caisse nationale des monuments historiques et des sites © Arch. Phot. Paris

"Talked to the usual familiar faces, some of them glad to see me, others mad. I am grateful to the first and amused at the second category."

When Walter concluded his *Memoirs* in 1930 by writing: "We have lived twenty-three years at the Bréau in the most delightful of surroundings, having made many warm and enduring friendships among the neighbours," he made two mistakes. In 1930, they had lived there for twenty-five years, and, in truth, their warm and enduring friendships among the neighbors would have to be accurately described as few in number.

Le Bréau was run with a core staff of about twenty servants. Inside were the housekeeper, butler, footman, valet, Matilda's maid, housemaid, cook, and kitchen maid. Outside were the caretaker, chauffeur, groom, stable boy, carpenter, the gamekeeper and his assistants, and the gardener with his helpers. After seeing this large and well-staffed house, the Gays' friends and others, not surprisingly, concluded that they must be vastly rich. But they weren't, at least not vastly. Edith Wharton told Matilda a story of having met Lord and Lady Craven, who spoke to her about Walter Gay and his painting. Lady Craven said: "The Walter Gays are very rich, and yet he goes on painting all the same." "Why the devil does he do it?" wondered Lord Craven. The Gays thought that Le Bréau gave the appearance of costing more than it actually did, which was no doubt true, but their periodic complaints of poverty, usually following the purchase of an expensive work of art, are not convincing. Two sizeable establishments, one in Paris and the other in the country, a distinguished art collection, frequent travel, and constant entertaining were not accomplished on small resources.

The economies exercised by the Gays sometimes reached the outer edge of eccentricity, a phenomenon not uncommon among the rich. From the Ritz in London, Walter once wrote to Matilda on the subject of comparison shopping for a footscraper, the metal bar attached to a doorstep used for cleaning mud from the bottoms of shoes: "I went to Maples. They told me they had exactly the same footscrapers in Paris. These in London are a guinea each—brass tops. You might, when you are in Paris, ask the price there, and if the difference is worth it I will get them here, if not in Paris."

When Walter stayed alone at the Ritz in London, he always felt the need to justify it to Matilda: "It doesn't matter about a few shillings more expense when I am there for such a short time, and I am sure to meet people that I know, so that I am less lonely."

The Gays became very fond of Madame de Gramont. "As I sat and looked at her beautiful, classic face, dainty dress, and exquisite distinction, I felt

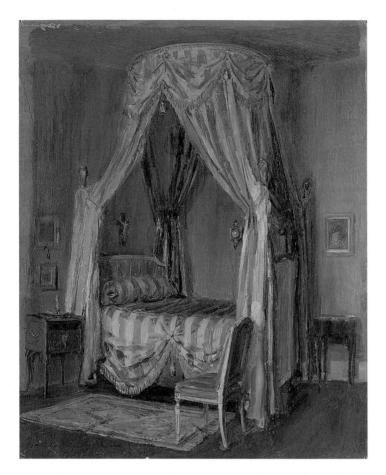

48. Walter Gay. *The Green Bedroom, Bréau*. Oil on panel. Inscribed: "à Mme La Comtesse de Gramont d'Aster . . . hommage de Walter Gay." Private collection

how far and away above almost anyone else is the *allure* of this great French lady," Matilda wrote. "One seems to be taking a bath of refinement in her atmosphere." The great lady loved Walter's interiors of Le Bréau, one of which, a view of the green bedroom, he painted as a gift (fig. 48). "We almost felt like her heirs, and in a sense we have inherited the fruits of her taste and efforts to express it. Madame de Gramont herself is worthy of such an interior as the beautiful Bréau—handsome as an old portrait, with white hair, flashing eyes, and regular features, clever, gifted, and what is still rarer, good: spending her life and large fortune in good works."

Perhaps too much of her fortune was spent in good works, because in 1907 she decided that she had to sell Le Bréau, which presented the Gays with a situation that would make a serious dent in *their* fortune. "[We] talk seriously about buying the Bréau . . . and yet we both dread the responsibility of owning a country place in France." Within two weeks they made up their minds to proceed. "We have taken the serious decision of buying Le Bréau; there was only the choice of quitting or of becoming proprietors. So [the lawyer] M. Aubergé came to breakfast today, and we three went by appointment to Madame de Gramont's. We found her, like ourselves, rather moved—but evidently well pleased that her place is to pass into our hands. She sells it to us for 550,000 francs [$110,000; the equivalent of about $1,800,000 today], including everything but the furniture, which we shall buy separately. M. Aubergé considers the property very cheap at this price." Which indeed it was in view of the fact that the Comte de Gramont had bought it twenty-five years before for 750,000 francs and had spent another three million francs on various improvements. The estate produced a revenue of 11,000 francs per year, which would cover the taxes and the most urgent repairs. "It is one of the ironies of life that for 18 years we have been asserting vehemently that nothing would

ever induce us to own property in France—and lo! we end by doing the very thing against which we have protested. This sarcasm of destiny seems to be part of the common experience. We returned from Madame de Gramont's with the impression of having done something very serious indeed—and no doubt this purchase will have the effect of rooting us more than ever to the soil of France, but we are already fast stuck in."

Still to be decided was the matter of the furniture. "Madame de Gramont wrote us the price of the furniture at Le Bréau. The sum total was a blow—it seems such a large amount for us to sink. We went to see her about it, and managed to come to a better understanding. She was an angel—and of such is the kingdom of heaven. It must be rare, in any country, such a type of high-minded disinterestedness, and *such* a grande dame. We finally agreed to pay 165,000 francs [$33,000] for everything *en bloc*." This did not include a large statue of Hercules in the park in exchange for which Walter painted for her another picture of the house. "This will bring the cost of the Bréau, with furniture, statues, house, lands, etc. to 765,000 francs—a small sum for the value, but a big one for our pockets—and we feel very poor and depressed. It may after all be a good investment, or at least we shall lose nothing. And certain it is that we shall become fonder of the place, now that we own it. . . . It will certainly be a lovely place to end one's days in." They entered the house for the first time as its owners on May 31, 1907.

Shortly thereafter Henry Adams came to stay for a weekend, which he recounted to their mutual friend Elizabeth Cameron, "Le Bréau was more than ever Gay. . . . I stayed over till Monday alone, and Mrs. Gay took me to see Courances. . . . After it, Le Bréau seemed harmony itself, even in Yankee hands. Mme la Comtesse Gay du Bréau was in very good form and excellent health, and they obviously enjoy their new rank and position in the country. But it is curious:—Vaux, Courances, Le Bréau, the three great houses, all in hands that one flatters in calling new. [Alfred Sommier had owned Vaux-le-Vicomte since 1875, and the Marquis de Ganay had acquired Courances in 1895.] The corridor of Ritz's can scarcely beat the pace."

Had he tried, Adams could not have struck a more tender nerve than to compare Le Bréau with the Ritz Hotel in Paris, the one place in the world Matilda most loathed and an establishment very different from its counterpart in London. As luck would have it, the Ritz was where the Gays' friends and relatives almost invariably stayed when in Paris and where, as a consequence, the Gays often found themselves having a meal, but never without subsequent fulminations from Matilda. A more or less typical example: "Motored to Paris to

lunch with Cousin Nellie at the Ritz. The restaurant was crowded, a perfect Pandemonium, bad air, bad service, jammed with people I didn't know or didn't care to see, all gazing at and gossiping about each other—an American institution, this restaurant life, which crushes colour and charm out of any place where it is to be found, vulgarizes life, and irritates me." She spent most of the following day reading and walking in the park alone *"pour me rincer l'oeil* [rinse my eyes] *de l'Hôtel Ritz."* On another occasion: "Lunch at the Ritz. Met the usual number of overdressed, underbred American women there. I choke in that atmosphere." Had she known that Adams thought of Le Bréau as one of a trio of country Ritzes, she would very likely not have asked him back.

But in fact he had a point. Le Bréau was so French in one way and, thought Matilda in an ungenerous moment, so un-French in another, being clean, well aired, and comfortable. "The Anglo-Saxons clean up the dilapidated châteaux of France—their presence is always denoted by a certain neatness." Even their French friends acknowledged that Le Bréau lacked entirely the French discomfort so striking in most châteaux. "They admire our house so much—why don't they reform their own?" Three years after buying Le Bréau, Matilda was complaining that it still looked as it had under the Gramont dynasty and that pictures and bibelots were much needed, but this was certainly not apparent in the view of the salon, painted before 1911, when it was acquired by the Albright Art Gallery (fig. 34).

Comfortable as Le Bréau was, it could be made more so with new plumbing and more bathrooms, which were added in 1912. "The Gramonts beautified the place, and we must make it habitable, according to American tastes, so our successors will benefit from us, as we benefitted from the former owners. But oh! how costly!" 58,000 francs [$11,600], to be exact, most of which they hoped to pay out of income, as they both hated to dig into capital. "Pipes, sacks of cement, great yawning ditches are everywhere. It looks as though the place had been irretrievably ruined by an earthquake. But this is the inevitable stage of modern improvements, so highly necessary at Le Bréau," Matilda reported in February. After a visit in March, when it seemed as though all the water in the moat could never wash the house clean, they wisely stayed away until May, when there was light at the end of the tunnel. Finally, in July, the job was complete and they could return to the newly Americanized Bréau. "We were so glad to see the work finished—modern plumbing in an old house, the perfect union of past and present . . . There is nothing more complete than an old frame containing modern comforts: sentiment and bathrooms combined—a happy union of soul and body, or spiritual and material."

They continued to look for furniture in Paris and on their travels. "Prowled in a bric-à-brac shop with W. G., and after much haggling, bought a lovely clock for Le Bréau. The subject is Diana watching the hounds bring down the deer—in terra cotta and full of vivacity." Walter had been looking for the right desk for the library for years when he wrote to Matilda in 1914, "I haven't bought the little desk yet, as by hunting a little longer I may find one that is a trifle larger, but this one would almost do, and it is so cheap—550 francs. I found it at the corner shop in the rue St. Thomas d'Acquinas, the shop on the corner of the Boul. St. Germain, where they have good things." Matilda complained frequently about the high prices of antiques and hated to pay the bills.

Improvements were not limited to the house. There were always changes in the gardens to consider and room for more sculpture in the park. "June 24th, 1913. A stone group, the dancing girls of Clodion, arrived and was placed in the Park, to the wild delight and excitement of W. G., shared by our retainers." Another Clodion-style group of putti with a dolphin was placed next to the moat, where it was painted by Walter.

In 1913 he had a new canal built to attract wild ducks and reported to Matilda on its progress, trying to calm her concern over the expense. "[It] is being dug (all by one man), will be over 80 yards long, and will be more effective than the [other] pond, though it cost very little to dig. It is almost done, and the two hundred ducks will soon disport themselves in it. We think they will desert their former pond for the new one, as it is to be quite shallow and ever so much larger. I think it will be a great success." When she saw it, she agreed. "It is such fun to make a pond—why is water always so amusing?"

The following year there were yet more improvements, both inside and out, which Walter supervised while Matilda was away on a rest cure. "In the day time I am absorbed with work: with painting, with looking after the workmen on the place; today there have been *vidangers, maçons,* and *marbiers* [cesspool drainers, masons, marble workers], the two latter under my direct supervision. I spent the entire morning superintending them in the hot sunlight and enjoyed every minute of it."

It was not until the end of 1926 that the Gays finally got around to installing electricity, as Walter recounted in a letter to their friend Mildred Bliss in Washington. "The last event here was the putting in of electricity, which is a great success, particularly as it is not visible and in the dining room nothing has been done at all, and we shall still have our candles and lamps."

An essential part of château life as lived by the Gays and their friends

was the automobile, although over the years cars and chauffeurs caused them considerable trouble. In 1910 the Gays bought a new Mercedes: "The *mécanicien* looks well in his new clothes, and the Mercedes has been all shined up," Matilda wrote. She told Edith Wharton that it had "the power of forty horses, but of course I don't allow our chauffeur to make use of them all." During World War I, when the Mercedes was requisitioned by the government, the chauffeur drove the Gays about in his own, humbler car, not always skillfully, as Matilda noted crossly in 1916 after an accident from which she luckily escaped with only an injured nose. The next time it was Walter's turn in 1925, when the succeeding chauffeur, Rive, flattened their new Panhard against a tree on an icy road. Walter walked away with only minor scratches; Rive lost an arm. The final comment on the subject came from their friend Rosa de Fitz-James: "Les automobiles sont un grand danger et les chauffeurs n'ont pas appris la prudence."

The Gays usually moved from Paris to the country in May, in some years not until June, although Matilda would gladly have done so earlier. "April 22nd, 1911. To Le Bréau for the day. The place looked heavenly in its April clothes of tender green, and pink and white blossoms. What idiots we are to spend the spring in Paris. But I can't drag W. G. to the country, even to his beloved Bréau, at this season. And it would be a mitigated delight to live there with an angry man."

He did, however, like to go there for the day in the winter and spring to shoot rabbits and pick flowers for Matilda. In January the woods were full of holly, and in some years the first jonquils came as early as February. In mid-March they often went out together for a day. "March 14th, 1915. Picked crocuses, primroses, and periwinkles in the park. The bushes are sprouting tiny leaves everywhere. W. G. shot 7 rabbits and a pigeon. Heavenly day." In April the park was a bed of violets and anemones and the fruit trees burst into bloom: apple, wild cherry, and hawthorn blossoms scented the air. Matilda loved to visit in April, take the sun in the English garden, and gather wildflowers. "April 16, 1915. Found Le Bréau in its marvelous April gown, something new and strange budding every minute. Picked the beautiful blackthorn, ill-named at this season, for the blossoms are a snowy white." Occasionally it was not from the blossoms that the fruit trees were snowy white in April; one year, 1919, late in the month, they were covered with real snow.

The gardens and forest were a source of enormous pleasure, but they could also provide comfort in times of tragedy. When the news about the *Titanic* reached them on April 20, 1912, the Gays went to Le Bréau "to efface the sadness of this disaster by refreshing our eyes with Nature's eternal resurrection.

Picked wild flowers in the woods with W. G. and the keeper, consoled by the sights, the sounds, and the perfumes of the Spring."

May of course was the glorious month: Matilda called it the "Fête des Fleurs" when her favorite lilies of the valley grew wild in the park, mingling their fragrance with the acacias. "The park is redolent of the perfumes of Araby." Wisteria hung from the chapel wall, and in the garden the air was heavy with the sweetness of lilacs, horse chestnuts, and laburnum. In the forest the Gays picked yellow broom and gorse.

Matilda thought she was doing well when she succeeded in moving her household to the country by the second week of May. "May 10th, 1913. With W. G. to Le Bréau, to settle ourselves for the season, a very *rococo* thing to do in the eyes of our mundane friends, who prefer to spend this most enchanting time of the year in the dust, noise, and crowd of Paris, entertaining each other." During the spring move, the Gays stayed at the Hôtel de France in Fontaine-bleau while the servants prepared the house, hanging curtains and laying carpets. "It is lovely here at Fontainebleau in this most luxurious and expensive of hotels—and it does me good to get away from the servants." Then there was a settling-in period of arranging books and furniture and getting the house in order. Shortly thereafter Walter would return to Paris to bring down pictures and bibelots, which, Matilda thought, "made a 'Walter Gay' of Le Bréau." This particular conceit could be taken a bit too far, as it was by one guest who wrote to thank them for a weekend during which he felt as if he had inhabited a "Walter Gay." When Matilda was away, as she was in May of 1914 on another rest cure, Walter wrote her regularly to report on the changes of the season: "Everything is going on smoothly here. . . . I wish you could have some of the delicious strawberries and haricots verts that we have now. The wisteria is over, but *en revanche* [in return] the lindens are coming on apace to welcome you back when you arrive."

Once settled, the Gays couldn't imagine why they had waited so long to move. When in Paris they thought of Le Bréau as a very expensive luxury, but at Le Bréau they felt it was a necessity. In June the house was deliciously fragrant with elderberry picked in the forest, roses from the garden, and the scent of the orange and lime trees on the terrace and forecourt wafting in through the French windows. The park was a mass of wildflowers, honeysuckle, and privet.

During the summer family and friends came in ever greater numbers. Meals on the terrace were as often for fourteen as for four. Tea was served in a little kiosk summer house in the garden by the fountain. Matilda particularly

enjoyed having young children about splashing in the fountain, feeding the swans, and shouting with joy when she took them rowing on the moat. "A country house must have a romping child about to set it off."

But it often seemed that their happiest days in the country were spent by themselves. "Lovely day all alone with W. G. and [their dog] Jet. In the afternoon we sat among the wheat sheaves in the fields, and drank in their blond colour, the blue of the sky, the deep green of the park, and the château in the distance, looking like an illustration for a story-book. . . . These are golden days, the days when we are by ourselves."

Jet, a gift from a friend in 1898, was one of a succession of dogs that were an important part of the Gays' life in the country. "Thinking that he was getting rid of an inefficient sporting-dog, he little dreamed that he was giving us an angel dog, who has filled our lives with happiness." Matilda thought of Jet as Walter's dog. "Motored to Le Bréau, where Jet flung herself sobbing into her master's arms." On one occasion she got so excited at their return that she leapt from a window, landing, fortunately, on the laurel hedge below without injury. A later dog named Peggy was regarded by Walter as Matilda's, as he wrote in 1914, "Peggy also begins to think it about time she saw you, and is reserving a choice stick to retrieve for you when you appear. She brought one to me when I got here, and appeared disgusted when she found I was the only occupant of the motor." When the Gays went traveling and had to leave a dog with the keeper, they could hardly bear the look of reproach. "How dogs make us blush for ourselves. . . . Canine sincerity is a consolation for human hypocrisy."

Bastille Day was celebrated at Le Bréau with less than full enthusiasm. "We have hung out flags for the 14th, but the national holiday is so unlike our glorious Fourth that one is only half-hearted about it," Matilda wrote. "Ours commemorates the birth of a nation, while the 14th awakens souvenirs of civil war, massacre, and bloodshed. No wonder a large part of the French people are either indifferent or hostile to the anniversary."

In August they picked baskets full of heather in the forest, and on the last day of the month the gardeners feted their patron saint, Saint Fiacre, by making an airplane of flowers to hang from the ceiling of the salon.

When the Gays acquired Bréau, it had the reputation of being well stocked for shooting, but Walter soon discovered that the shoot was overrated and set about to develop it. "I therefore got rid of the old keeper, who never could have been any good, and built up the shoot, owing to a very skillful man who replaced him. In the twenty-two years that he was with me he made the shoot what it is today." Walter was regarded by many as the best shot in France.

To his French friends he embodied a rare combination: a sportsman "doublé d'un homme de goût" [who doubled as a man of taste].

The season began with partridge shooting in early September, shifted to pheasant in mid-October, and finished with the stag hunt in the Fontainebleau Forest from November to the end of the year. During this period Walter was out shooting with friends nearly every day, either at Le Bréau or at such nearby houses as Vaux-le-Vicomte, Courances, La Rochette, and Assise. Matilda scrupulously recorded the results, however unexpected. "September 24th, 1917. Second partridge shoot. Bag 181 partridges, 7 hares, one pheasant, a bustard, and a cat." For many years Walter got an early start by going off to Scotland in August to shoot grouse with Matilda's cousins, the Cochranes at Cromlix or with her nephew Clarence Mackay at Fetteresso Castle. In the autumn Matilda filled the main rooms of Le Bréau with bouquets of leaves and berries. When Indian summer extended into mid-November, they would continue to eat on the terrace as long as possible until finally moving back into the dining room. The appearance of holly fresh from the forest in November in the entrance hall marked the passage from autumn to winter.

Preparations for Christmas began well in advance with bunches of mistletoe hung throughout the house. There was often a house party of several friends for Christmas when everyone, even Walter, attended midnight mass in the chapel, which naturally drew the largest audience of the year. This was followed with a quiet, cosy supper in the dining room where a small Christmas tree stood on the table. The following morning Matilda, on her own, would often attend no fewer than three Christmas masses, two in the chapel and a third in the nearby village of Villiers ("It is not too much on this most blessed and hopeful of feasts"), before hosting the traditional luncheon of turkey and plum pudding. The large Christmas tree was then lighted in the library and presents were exchanged. Long walks in the forest, naps, a light supper, and a reading aloud of Dickens's *Christmas Carol* ended the day.

New Year's Day meant little to the Gays but much to their household. "I have no sentiment whatever about New Year's," Matilda wrote. "The associations are only with the presents of the domestics, who fly around with expectant alacrity."

As soon as the shooting season was over, generally at the end of the first week of January, the Gays packed up, closed the house, and returned to Paris, reversing the process of the spring by giving the servants several days to heat and prepare the Paris apartment while they waited at the Hôtel Crillon on the place de la Concorde.

7. Travel

France

STARTING IN THE EARLY YEARS OF THEIR MARRIAGE, THE GAYS traveled for two months each summer. "Before 1895, we had visited Normandy, Brittany, the great Gothic cathedrals within eighty kilometers of Paris, and Touraine. Henry James' *Little Tour in France* had inspired our travels," Walter wrote in his *Memoirs*. "The trains were inconvenient, the inns detestable, but the monuments and the landscape made up for any material drawbacks, and our great luxury was that we met no tourists, for the only travelers in France, at that period, were the *commis-voyageurs* [commercial travelers]."

Shortly after the turn of the century the Gays began traveling by automobile, and from that point until the early 1930s, each year they made two, sometimes three, short trips lasting a week or ten days around France. Their capacity for sightseeing seemed inexhaustible. "If I did not love monuments so much, if they did not strike a deep chord in my soul, I could not possibly endure the fatigue and discomfort of travel," Matilda wrote. "But we love these little trips—when shall we take another?"

They wanted to see everything and in fact only rarely complained about the fatigue and discomfort, putting up with the inconvenience of old-fashioned musty hotels with their familiar odors ("suggestive of rats who may have

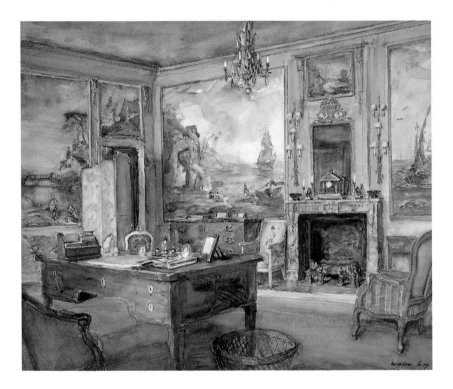

49. Walter Gay. *The Blanchetti House, Avignon*, 1907. Watercolor. Private collection

OPPOSITE:
50. Walter Gay. *The Green Lacquer Room, Museo Correr, Venice*. Oil on canvas, 21½ x 18¼". The Metropolitan Museum of Art, New York. Bequest of Anne D. Thomson, 1923. 23.280.8

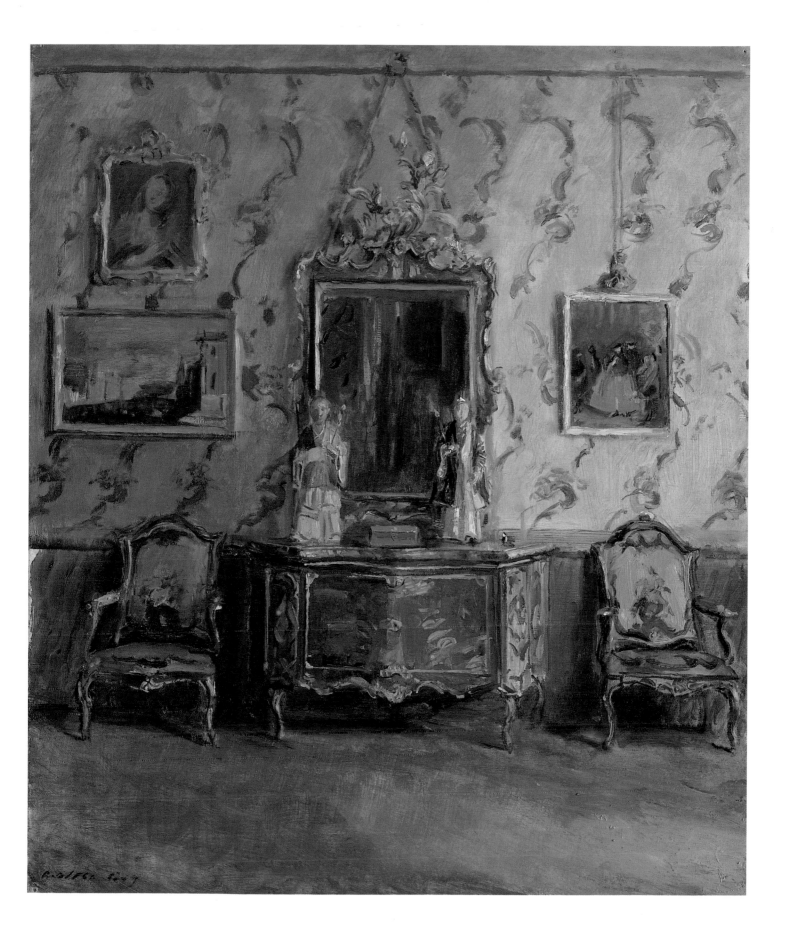

expired within the walls") and restaurants smelling of fried onions and defective drainage. No church was too small: "One must not be deterred from entering a church by the facade; this mistake occurs with people, as well as monuments." No château was too plain: "I love nothing better than visiting châteaux, and prying into the secrets of the occupants, for the air of each house is always full of hidden things, unconcealed, however, from the Sentimental Traveler," the term that Matilda borrowed from Henry James and applied to herself. No museum was too obscure: "One should never skip the museums in the provinces—often badly arranged, and worse presented, there are always pearls of price buried in these neglected places."

Walter always took his paint box and did some of his best work on these trips. He was always particularly interested in the rooms of collectors, such as the Blanchetti house in Avignon, which he painted in 1907, recording its large paintings by Joseph Vernet (fig. 49). Armed with introductions from friends, the Gays were able to see many châteaux that were not open to the public. They were particularly attracted to houses that had been lived in by generations of the same family with layered accumulations of art. "When a château is occupied by the descendants of the builder, it gives it a *cachet* that no purchaser, however intelligent, can continue. Then it ceases to be a *château familial*." These houses were often an appalling mess inside, but the Gays were completely unfazed by disarray. "How I love these old houses with their souvenirs, their dreaminess, and their untidiness. If they were clean, they could not be picturesque," Matilda wrote. "The housemaid's broom chases poetry away."

The Gays traveled in search of the past, their taste for which they described not as hunger, but as sheer gluttony.

Italy

Their favorite destination outside of France was, of course, Venice. Getting there was never easy, given Matilda's dislike of trains, but the journey was always worth it. "Arrived in Venice this afternoon after a horrid 21 hours in the train. . . . But when the terminus is this great opal, called Venice, one's sufferings are forgotten. We shrieked for joy coming up from the station through the side canals. The color, the stones, the sculpture, the grace and charm—all this is a beauty ever ancient and ever new."

Walter painted several views in Venice of the small chinoiserie room in the Museo Civico (now Museo Correr), which was then housed in the rebuilt

Fondaco dei Turchi. This colorful room had a wall covering of silk painted on a yellow ground and pictures by Longhi, Rosalba, and the Canaletto school above green-and-gold-lacquered Venetian furniture, whose exuberant vitality was well captured in the shimmering light (fig. 50).

Another of Walter's Venetian interiors was done in that least-visited of Venetian museums, then and now, in the elegant Palazzo Querini-Stampalia. He set up his easel and painted one end of the library hung frame to frame with Gabriele Bella's views of Venetian life, those unstarred pictures described kindly in guidebooks as "vivaci" and "interesanti soprattutto per i costumi [interesting above all for their costumes]" (fig. 51). "To the Library of the Querini-Stampalia, to see the very interesting views of Venice by an 18th-century painter, representing the fêtes, the amusements and the life of the citizens—most interesting documents of a state of things that has passed away. . . . One notable incident—the intelligent little *custode* who showed us the library refused a tip! This in Italy! or indeed in any European country!" Matilda exclaimed.

Florence was another of their favorite cities, where they did the rounds of the museums and dealers. On one visit, they rented the Villa Torre in Bel-

51. Walter Gay. *Palazzo Querini-Stampalia, Venice.* Oil on canvas, 21½ x 26". Private collection

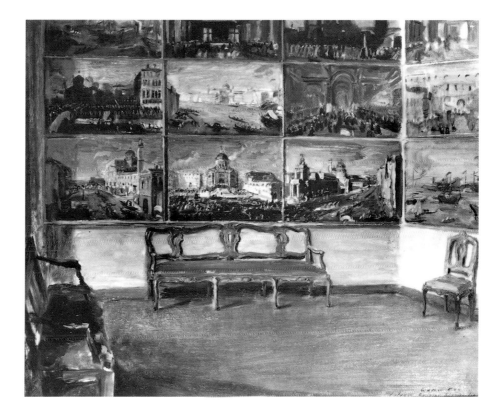

losguardo belonging to Lady Paget, widow of the diplomat Sir Augustus Paget, who had been the English ambassador in Italy in the 1870s. "This fortress-villa has been comfortably modernised by Lady Paget—electric bells, bathroom, English plumbing—everything in the way of furniture tasteless and hideous, but how beautiful it could be made!" This comment would have infuriated Lady Paget, who was an enthusiastic, if amateur, decorator.

The one aspect of Italy that caused ongoing complaints from Matilda was the food. "Is there such a thing as good food to be had in an Italian restaurant?"

England

If trains were a problem for Matilda, ships were far worse, as she invariably got seasick, regardless of how rough or calm the sea. She once spent an entire day desperately seasick on the day after a perfectly smooth crossing of the English Channel. "How hopeless to be seasick *après coup* [afterward]," she moaned. Despite this problem, they braced themselves for the trip and traveled nearly every year to England, where they first stopped at Folkestone to recover from the voyage.

On one of these stopovers, they encountered the sort of incident that Matilda relished. "A lady occupying the room next to Walter Gay asked, through the manager, if I would change rooms with her, as W. G.'s room gave out on a balcony which ran along her room as well; that her husband would not permit her to sleep in a room where a man might possibly get in; and that if the change were not made, she would return to London by motor car. This request was met, of course, by a prompt refusal on my part; it was then 9:30 p.m. and I was unpacked. We asked the manager, who had some difficulty in keeping his gravity, to point out this highly virtuous lady. He did so: she was 45, with dyed red hair, enormously stout and extremely plain. But W. G. assumed a certain jaunty air, flattered by the lady's suspicion. It ended in her moving out her ponderous person at 10 p.m." When things went wrong, as they inevitably did while traveling, Matilda saw that they were promptly set right.

In London the Gays usually stayed at the comfortable Ritz, which did not have the same disagreeable atmosphere as its Parisian counterpart, but which did nonetheless offer Matilda the opportunity to complain about the expense. "To London, putting up at the luxurious Ritz, where one spends a pound a minute. I get a surfeit of all this material softness and miss it very much when it is absent."

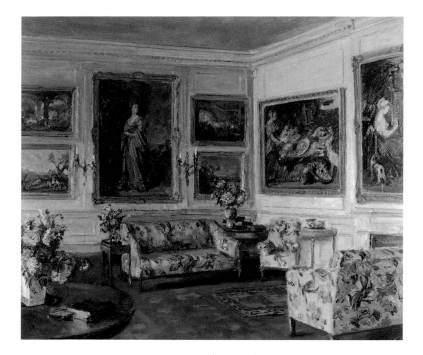

52. Walter Gay. *Ranston House, Dorset*, 1925. Oil on board, 18⅛ x 21⅝".
Spencer Museum of Art, The University of Kansas. 52.6

One of the Gays' closest friends in England was Elizabeth Cameron, the estranged wife of the American Senator James Donald Cameron. She lived at Stepleton House at Blandford in Dorset, where the Gays frequently went to visit. "To Stepleton House, where we were clasped in Lizzie Cameron's hospitable arms. She has modernised Stepleton with every conceivable comfort, and yet preserved the old-time character of the pretty Georgian house."

In the summer of 1925, Cameron's neighbors Sir Randolph and Lady Baker asked Walter if he would come over and paint at their place, Ranston House. Here was another of those awkward situations where Walter had to do the best he could with unsympathetic material. As usual, Matilda called spades by their rightful name: "W. G. is painting at the house of a neighbour, Ranston . . . so he took me over there in the afternoon to see Lady Baker. She is a charming and intelligent young woman of 30, very kind and hospitable. Sir Randolph is away in South Africa, where they have large estates. Lady·Baker showed us over the house, which is quaint, but W. G. has selected the only paintable corner in it: a staircase. Lady Baker pointed out a good deal of uninteresting and ugly furniture, which we admired, with hypocritical courtesy. . . . Besides the staircase, Lady Baker is the most attractive object in the house." In the end, Walter found another paintable corner, the drawing room (fig. 52), but even filling it with vases of flowers could not conceal its unlived in, museumlike air. He completed the two pictures in "an incredibly short time" and Matilda summed it up concisely: "He has made charming interiors of an ugly place."

Matilda saw the essential difference between England and France in terms of hospitality: "There is no art of conversation in England, but there is an easy hospitality which is never found in France. One feels at home at once, and the host does not take his guests too seriously."

53. Walter Gay. *Interior of Eben Howard Gay's House, Boston*, c. 1902. Oil on canvas, 20 x 24⁷⁄₈". Santa Barbara Museum of Art. Anonymous Donor to the Preston Morton Collection. 1961.12

If seasickness made England a difficult trip, it made the crossing to New York an absolute nightmare. Nonetheless, the Gays made the journey every two or three years to visit relatives in New York, Boston, and Washington.

Walter's mother and two of his brothers lived in Boston. Eben Howard Gay did well in banking and built a lavish Adam-style townhouse, designed by Ogden Codman, at 170 Beacon Street. Paneling and marble chimneypieces from England were incorporated into rooms with a rich variety of ornament.

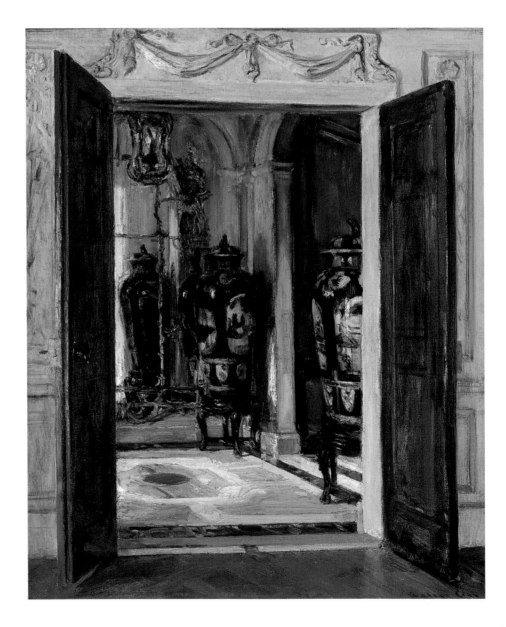

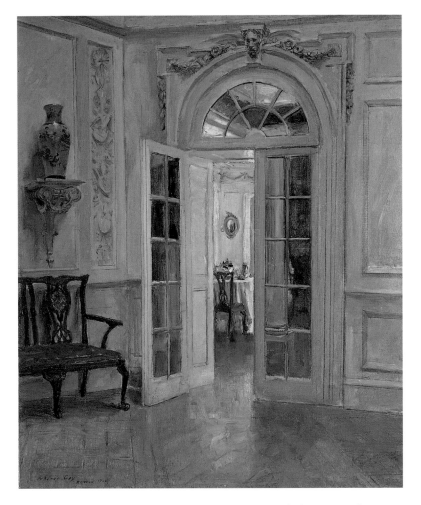

54. Walter Gay. *The Music Room and Dining Room of Eben Howard Gay's House, Boston*. Oil on canvas, 22 x 18". Private collection

Client and architect, both perfectionists, had made several trips to Europe to gather ideas and materials, including the English limestone for the facade.

"Howard's intelligence seems to get the best, in anything he undertakes—but none of his tastes seem spontaneous—they are all acquired. His house is beautifully correct—but cold in consequence," wrote Matilda, whose opinions of Walter's relatives were no more restrained than of anyone else. On the whole, she found them a tiresome lot.

Walter painted a view of his brother's library looking into the front hall with two large blue-and-white Chinese vases on low stands near a large Chippendale-style mirror (fig. 53). The monumental vases were of a type that King Friedrich Wilhelm I of Prussia had traded in 1717 to Augustus the Strong of Saxony for a regiment of six hundred strapping soldiers who became Friedrich's much-loved giant dragoons, a provenance that would not have amused Eben Howard Gay.

When this picture was exhibited in Paris in 1908, it was admired by the actor Lucien Guitry, father of Sacha Guitry, who returned a few days later to see it again. "But as he had a little lady with him (young enough to be his daughter) he feigned not to recognize Walter Gay, owing to my respectable presence," recounted Matilda. "I left tactfully, so as to allow the great actor to talk to the painter. Guitry purchased the best picture (to my mind) in the exhibition—the interior of Howard Gay's house in Boston, with the Blue & White potiches."

Another view of his brother's house shows a corner of the music room looking through the half open door into the sunlit dining room beyond (fig. 54). To the left of the door is a Chippendale-style settee below a gilded bracket that supports a Chinese porcelain vase.

Matilda was right in regard to the house being correct and cold, but

wrong about Howard's ability to get the best of everything. He did not, for example, get the best of Thomas Chippendale, whose furniture gave him a good deal of trouble, both during his life and after his death. The settee in the music room was only one piece in Howard Gay's large collection of furniture that he believed "could only have sprung from Chippendale's genius" but which financial reverses forced him to sell in 1907 as well as the house (which is today the Goethe Institute Boston). Eight years later Howard Gay published many of these pieces in a thinly veiled story about his passion for collecting furniture entitled *A Chippendale Romance*, in which the illustrations leave no doubt that his furniture was very far removed indeed from Chippendale's genius.

Time passed, Howard's financial position improved, and he assembled a second collection of "Chippendale" furniture, some of which he gave to the Museum of Fine Arts in Boston, where it was determined that the pieces could not be more than about forty-five years old. "My own confidence in the authenticity of the pieces is undisturbed," answered an aggrieved Howard Gay, "but I feel toward them like I do toward the fair name of a woman. Like Caesar's wife, they should be above suspicion." But since they weren't, he withdrew them and spent the next several years shopping for more Chippendale furniture, this time of absolutely unquestionable authenticity. After his death, this new set went to the museum in Boston only to meet the same verdict: all of it was nineteenth-century Chippendale reproduction furniture. Howard had indeed had a Chippendale romance, captured in the first and more attractive sense of the word in his brother's pictures at a time early in the century when the furniture was thought to be old and fine and looked so good in the beautiful new house at 170 Beacon Street.

Nearby in Beacon Street was another of Walter's brothers, William, who after first visiting Le Bréau thought that it might seem too large at first for two people, but that Walter and Matilda would no doubt get used to it. He compared the château to his own one-hundred-foot yacht, which at first seemed so large that he could hardly turn it around in Newport harbor; but with time, however, it felt just right.

Another house in Beacon Street visited periodically by the Gays was that of their friends the Joseph Bradlees, a view of whose dining room Walter had painted in 1904. Matilda preferred Mrs. Bradlee to her children. "Lunched with the Bradlees in Beacon Street. A modest little house, full of nice pictures. Mrs. Bradlee very unchanged. [Her daughter] Sarah, however, has been severely buffeted by Time. A very ordinary son was there, who had manners like a car conductor. . . . Why are children so different from their parents?"

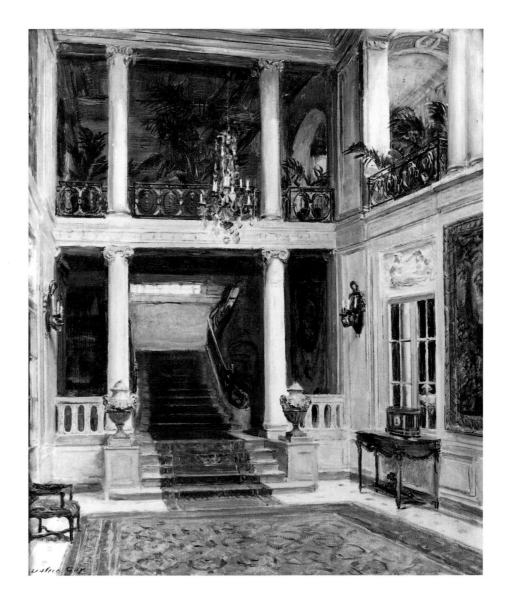

55. Walter Gay. *The Entrance Hall, James Speyer's house, 1058 Fifth Avenue*. Oil on canvas, 35½ x 31" (framed). Museum of the City of New York, Gift of Herbert Beit von Speyer, 51.210

Walter generally stayed on in Boston to spend more time with his mother while Matilda went to Washington to see her sister Louisa Wadsworth and friends such as Henry Adams. The Gays then rejoined for more visits with friends and relatives in New York, where they sometimes stayed with Matilda's cousin Nellie Speyer and her husband James in their new house by the architect Horace Trumbauer on Fifth Avenue and Eighty-seventh Street (fig. 55). "The house is very large, beautifully built, planned with great care and intelligence and special attention paid to harmony of colour. The pictures, tapestries, and bibelots are not of the very first quality, but their setting is so perfect that they have a reflected value." But the house seemed to overwhelm its mistress. In giving Matilda a tour of the kitchen in 1914, Nellie, "over-strained, nervous,

fatigued, looked like a wreck as she showed me the wonderful appliances which have taxed her beyond her strength. At sixty-four, with no children, was this gigantic effort worth while?" asked the fifty-nine-year-old childless châtelaine of the far larger Château du Bréau.

New York was a whirlwind of lunches, teas, and dinners in the grandest houses in the city, most of which failed to impress Matilda. "Tea with Anne Vanderbilt in her gorgeous white marble palace on Fifth Avenue. Why do such houses always seem like splendid prisons?" The Vanderbilt house that *did* impress the Gays was Biltmore in North Carolina, where they stayed for a week with Anne's brother-in-law, George Vanderbilt, and his wife in 1905. "He is a Vanderbilt who is determined to be simple, and in order to prove to the world this laudable intention, he has sunk many millions in the erection of a palace in North Carolina. . . . There has perhaps never existed before the combination of so much wealth, taste, and pleasing personality as in the case of this attractive young couple who have so much, and are so much in themselves." Other members of this family Matilda found far less attractive. "Mrs. Cornelius Vanderbilt, Jr., talked to me after dinner on painful family topics. I tried to silence her, and finally did so, but stupidity and bad taste are hard to quench."

Considering how much the Gays disliked New York, it is surprising that they spent as much time there as they did. On their 1908 trip, Matilda returned early to France and received the following from her unhappy husband: "How I long to get back anywhere over there! and away from this fearsome New York. It is always a perpetual tearing up of the city, and the noise and the smoke, now that the omnibuses have been replaced by autobuses, is enough to drive one mad. They allow the motors to smoke as much as they like in New York, although that would not be permitted elsewhere, and there is no escaping it, even when you are lunching at Delmonico's, as we were yesterday, when clouds of smoke were wafted in through the open windows. Cabs are quite as expensive as they used to be—$1.00 to go from the Manhattan to the Speyers house, a couple of blocks away only. They were surprised when I refused to take one. There are taxicabs, but not enough of them." (Why, ninety years later, has New York changed so little?) After their American visit in 1920, they gave such a horrifying account of New York to Edith Wharton that it "fairly kept me awake with terror," she reported to Bernard Berenson. The Gays invariably returned from their trips to America exhausted but delighted to be back in France. "I love and admire my country for all that is best in her, and there is a great deal which is lovable and admirable," Matilda wrote. "But we are native-born foreigners."

8. The Gays as Collectors

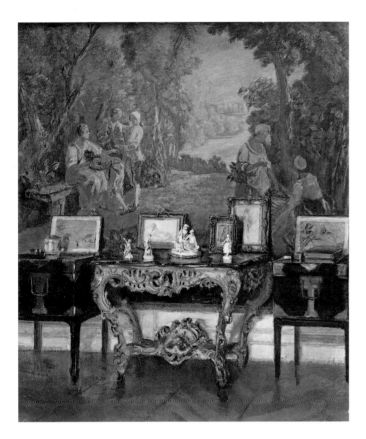

56. Walter Gay. *La Console* (73, rue Ampère), c. 1902. Oil on cardboard, 21⅝ x 18". The Pennsylvania Academy of the Fine Arts, Philadelphia. Joseph E. Temple Fund. 1903.3.2

As an impoverished student in Paris, Walter Gay was already actively buying works of art. He knew firsthand several of the most famous collections put together by artists such as Whistler, Degas, and particularly that of his teacher Bonnat, whose old-master drawings subsequently formed the basis of the Musée Bonnat in Bayonne. In looking about in the shops in Paris, Walter had found that in certain areas, works of great quality, especially Oriental scrolls and old-master drawings, could be had for relatively small sums. Matilda was not at all sure about the Chinese chests and paintings that the movers brought into the house in the rue Ampère. "Oriental art does not touch me, save when it comes through Occidental sources, as in the stained glass at Chartres. It must be baptised to talk to me." But she grew accustomed to these pieces, which remained part of their furnishings.

Together they went shopping for eighteenth-century French furniture and tapestries. On several trips to England they also bought some simple Georgian pieces of furniture. While they were both interested in furniture and decorative objects and over the years enjoyed shopping for these things, they reserved their real passion for paintings and drawings, which soon covered the walls, with the overflow spilling over onto chests and tables (fig. 56). In the study drawings were even hung on doors (fig. 57). Matilda described the place as cozy, comfortable, and crammed.

Someone who watched the formation of the collection from the start was Daisy Chanler, who was frequently in Paris and who wrote in her autobiography, *Autumn in the Valley*: "Very early in Walter Gay's career he began to collect the drawings and paintings which now hang on his walls, the envy of

89

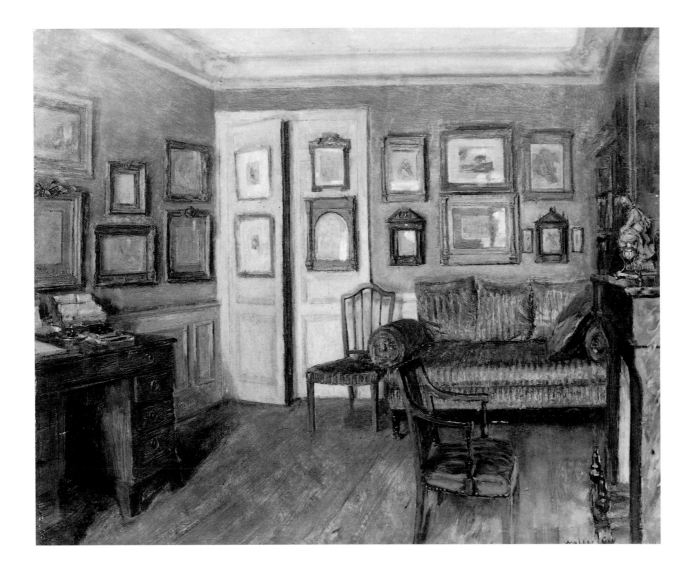

57. Walter Gay. *The Study, 73, rue Ampère*. Oil on canvas, 20¼ x 24⅜". Yale University Art Gallery, New Haven. Given by Geoffrey Dodge, B.A. 1909, in memory of Charles Noyes Forest, B.A. 1929. 1930.1

museums. They were gathered slowly, one by one, with great love. Some of the masterpieces were bought in the old days when money was scarce, before fame was attained. Matilda agreed to go without a carriage one winter that he might acquire Durer's wonderful watercolor of a hare. The collection has a quality all its own. . . . His sensitive understanding seems to reconcile the differing schools and widely different periods, for they do not clash or detract from one another."

The Gays went shopping for art in Paris, London, and Florence. Sometimes they looked at works they could not afford. In London, a Titian portrait of Aretino at Colnaghi's gallery. "That scandalous personage was dressed in a splendid silk and velvet Venetian costume of golden brown. His face looked like a vicious old eagle. The price, of course, is far beyond us," Matilda wrote. In

Florence, at Volpi's, a famous shop of pictures and furniture, she "saw a great many things I didn't want, and one or two I couldn't afford, among the latter a portrait by Giorgione, at a Pierpont Morgan price." It was one thing to be tempted by art that was too expensive, quite another by art that was too cheap. "Went to a bric-à-brac shop in the rue de Penthièvre, to look at a Porbus and an 18th-century picture by Desportes. These pictures are both so cheap that it would be foolish not to buy them." That was an exceedingly infrequent complaint.

Far more common was the cry of poverty following a major purchase, as happened in 1909 after Walter bought two paintings by Francesco Guardi. "[He] is in a state of happy excitement—he has bought *both* Guardis!! and we are so strapped just now. It is extraordinary, how extravagant one can be, when there is so little in the bank. But the arch enemy of mankind, who never sleeps, arranges so that the temptation of spending always presents itself when the pecuniary resources are low." In fact, it was Matilda who bought them, as she explained to her friend Comtesse Murat, adding an art historical comparison of dubious merit: "I told her the sentimental reason that prompted me to commit the extravagance of buying them: that I saw a likeness of *facture* [treatment] between Guardi and Walter Gay. In fact, Guardi was the Walter Gay of *extérieurs*. The quick-witted young lady answered: 'Et Walter Gay, c'est le Guardi des intérieurs!'"

Walter and Matilda viewed most of the major Parisian auctions of the period and bought at several of them. At the sale of the collector Paul Chéramy in 1908, Walter secured what Matilda described as a "delicious little landscape by Gainsborough" and an "amusing little drawing by Delacroix."

Matilda's first experience in bidding was a not uncommon one. At the Alfred Beurdeley sale in 1905, "we sat in the front row, in reserved seats, and I became very much excited, having never before bid at an auction sale. Trembling in every limb, hot and cold by turns, we bid for and carried off the aquarelle *La Fête de*

58. Jean-Honoré Fragonard. *La Fête de Saint-Cloud* (now usually titled *View of a Park*). Black chalk with gray wash and touches of green and pink watercolor over pencil underdrawing, 13¾ x 16¾". The Metropolitan Museum of Art, New York. The Robert Lehman Collection. 1975.1.628

Saint-Cloud by Fragonard [fig. 58], for 9,000 francs." Their competition had been the famous collectors Camille Groult and the couturier Jacques Doucet, who "both said afterwards that if they had known that Walter Gay was bidding for the *Fête*, they would not have pushed up the price, as such a *délicieuse chose* ought to belong to an artist."

The following evening the Gays dined alone with Groult and his wife. "This grotesque, witty old man lives in his beloved 18th century. On one side he is a hard practical business man, who has made an immense fortune . . . on the other a dreamer and a passionate lover of beauty. He has bad table manners and he is far from neat, but he has a subtlety and a taste too often lacking in the well-bred. His old wife is a kindly soul, not much more than a peasant, but a saintly woman who has endured many things from her affectionate tyrant." Groult asked Walter to choose and buy for him any drawing in the next session of the Beurdeley sale. "That he would be satisfied to add to his collection whatever drawing Walter Gay thought worthy of it. This, from such a fastidious *collectionneur,* was the greatest tribute to my husband's taste." To compensate Groult for his loss of the Fragonard, Walter made him a copy. Shortly thereafter, Matilda found on her return home a package, with Monsieur Groult's compliments, "ornamented with a fresh azalea blossom, stuck into the pink ribbon. With astonished fingers, I found a lovely little tortoise-shell and gold étui, which contained a beautiful miniature, set in diamonds, of a lady of Louis XVI's time. It is an exquisite bibelot, most delicately offered." Later that year Groult commissioned Walter to paint an interior of his house in the avenue de Malakoff.

In 1912 Jacques Doucet decided to sell his own collection, a sale that caused a huge commotion among the Gays and their friends. "W. G. is madly excited over the Doucet sale, which begins on Wednesday—the most famous sale of 18th-century things that has ever taken place. Everything will therefore go for quadruple its value. I earnestly hope that W. G. won't make a *folie* there." They had been to see it a month before when it was still in Doucet's house. "M. Doucet was not there, but one felt all the sadness of his farewell to the beautiful things he has gathered together. It is impossible for such a collection to be made again, for the opportunities will not present themselves. And the Doucet sale is provoked by a *chagrin d'amour*—the woman died suddenly whom he wished to marry. It is all the sadder, in that one is convinced he will be so sorry for it in five years, or perhaps even one. It is the act of a spoilt child who, having been deprived of his favorite toy, breaks all the others." After the first day of the sale, Matilda reported, "It will be famous in the annals of posterity as the

92

culminating point of madness. The prices were frenzied—the dealers and amateurs went there to do battle, and they seemed oblivious of everything save the sport." The Gays tried and failed to buy two drawings by Watteau. "The absurd prices given by others calmed W. G.'s ardor, and for me I looked upon it as an exhibition of snobbishness, sport and grasp."

Like most collectors, the Gays on their travels could not resist comparing their pieces with closely related works. At Longford Castle in Wiltshire, they saw the portrait of Erasmus by Holbein: "Almost the duplicate of our own. But the Longford Castle Erasmus has been almost entirely repainted," Matilda wrote. At Knole in Kent: "Noticed in Lady Betty Germaine's drawing room a painted figure near the fire-place, peeling an apple, just like ours at Le Bréau. They were the jokes of that period." At the Hôtel-Dieu in Beaune, the famous retable of Rogier van der Weyden: "W. G. has the drawing for the figure of Our Lady in blue, to the left of the Saviour as Judge, and this rejoiced his heart."

Walter and Matilda rarely refused a request for loans from their collection. In 1904 they lent two Clouets to the "Exposition des primitifs français" ("Our little Clouets look well, though hung a little high"). In 1905 a marine subject went to the Whistler exhibition at the New Gallery in London ("Our own little marine looks better surrounded by similar works than it does in our house in Paris"). In 1907 seven portraits were exhibited at the Bibliothèque Nationale, and in 1908 their twenty-three Rembrandt drawings went to a Rembrandt exhibition at the same institution ("They look very well and are admirably hung"). These Rembrandt drawings were sent in 1911 to the "Exposition des maîtres hollandais" ("The exhibition is mediocre, there are not enough fine things to carry it off; the trouble is, that the Rothschilds and other collectors would not lend. W. G. lent his Rembrandt drawings, which look better than many of the pictures there.") And in 1913 the Fragonard *Fête* was part of an exhibition on the art of the garden at the Musée des Arts Décoratifs, where the Gays attended the private view for the Société des Amis du Louvre. "Went early, so as to avoid our fellow friends of the Louvre," Matilda wrote.

The Gays had belonged to the Société des Amis du Louvre since 1904, when Walter had made his first gift to the museum, a French primitive portrait of the fifteenth century, the so-called *Yolande de Savoie*. The following year he donated another early portrait, this one of Mary Tudor by Jean Perréal. "This gift is a testimonial of [W. G.'s] gratitude to France for all the advantages he has enjoyed, artistic, aesthetic and intellectual," Matilda wrote. Later he was elected to the Louvre's Committee on the Purchase of Paintings, despite his nationality, which would normally have excluded him. When Matilda asked how this

obstacle had been circumvented, the curator, Monsieur Metman, replied simply, "Pour nous, Walter Gay ne compte pas comme étranger" [For us, Walter Gay does not count as a foreigner].

In 1913 Walter presented five drawings of the Barbizon School. "W. G. feels deeply his debt to France, and the poverty of the Louvre in works of the Barbizon School made the gift a felicitous one." At the same time he also gave an oil sketch titled *Les Repas des moissonneurs* [*The Reapers*, fig. 59] by Millet, one of his favorite artists. "The oil-sketch by Millet belonged to the eccentric old artist, William Babcock, to whom Millet gave the sketch," Matilda explained. "W. G. saw it at Babcock's in Barbizon, the first year he came over, in 1876. In 1894 Babcock gave it to the Millet family, to be sold for their benefit at the Drouot. As the sale was not advertised, W. G. bought it for the very low price of 7,500 francs, a fearful disappointment to the Millets, who had expected at least 20,000. The picture had hung in W. G.'s bedroom all these 19 years, so that many souvenirs were attached to it, and it was therefore a real emotion to part with it. It is a little like attending one's own funeral to give up one's treasures before one must. But no one has more than a life interest in anything, and unless it hurts a little, there is neither merit nor generosity," she moralized. The following month they went to see the pictures on exhibition. "They all looked very well and carefully chosen. It is pleasant to see them where they are, giving pleasure and instruction to others, after having taught and pleased us for so long."

The Louvre had been their lodestar ever since their marriage. "What a bath for the soul it is, to wander through those treasures." At one point, Matilda playfully wrote, "I should like to live in the Louvre and frequent the pictures, cutting myself off from all other society." During the war, they decided to leave the major part of their collection to the museum. "W. G. intends leaving a certain number of his pictures to the Boston Museum of Fine Arts. But the French things are to remain in France. It is as well to make all arrangements of this kind now, for who knows how soon we shall disappear? After sixty, every year is a year of grace." Walter began to catalogue the drawings. "I went over the catalogue with him, and learnt many things about these familiar companions of our life."

In the end, far more than just the French drawings were given to the Louvre. After Walter's death in 1937, Matilda formally presented the collection of more than two hundred works. In addition to the large group of drawings by Rembrandt, there were important drawings by Rubens, Jan van Goyen, and Jacob van Ruisdael. The Italian Renaissance was well represented by Michelan-

94

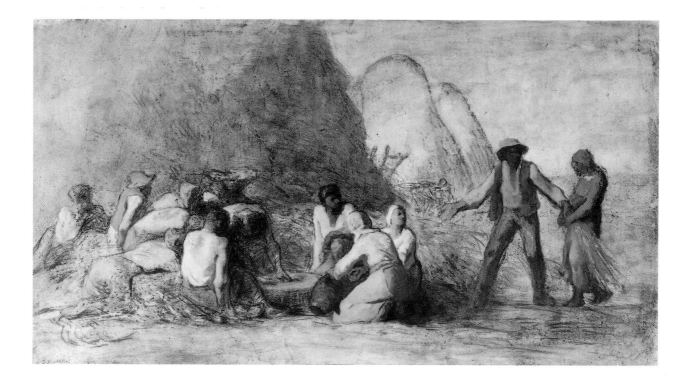

59. Jean-François Millet.
Le Repas des moissoneurs.
Pastel, oil, watercolor,
and black chalk on paper,
18³/₄ x 33⁵/₈". Département
des Arts Graphiques,
Musée du Louvre, Paris.
RF4182

gelo, Perugino, Filippo Lippi, and Ghirlandaio. But the strongest part was the group of French and English drawings of the eighteenth century, a catalogue of which was finally published in 1984.

The collection was exhibited first at the Orangerie in the Tuileries Gardens and then in a single room on the second floor of the museum. "It certainly is a great gesture on [Matilda's] part and, as she says, she will have the pleasure of knowing how they are arranged during her lifetime," wrote her friend Geoffrey Dodge. "It is a magnificent gift." The *New York Herald Tribune* reported that the gift had aroused much comment in Paris.

Matilda attended the opening of "La Donation Walter Gay" in February 1938, when the president of the Sauvegarde de l'Art Français recounted the Gays' passion for collecting art and their long friendship with the museum. The collection was published in two articles that year, one by René Huyghe, the curator of paintings, in the *Bulletin des Musées de France*, and the other by the art historian Germain Bazin in *L'Amour de l'art*, where he commemorated Walter Gay as "cet homme de goût."

Matilda once wrote, "I am convinced that collecting dries up the milk of human kindness, if you do nothing else to counteract it. Collectors are really birds of prey." The Gays had done much to counteract it, as collecting had been only one small part of their very busy lives.

95

60. John Singer Sargent. *An Interior in Venice*, 1898. Oil on canvas, 25 ½ x 31 ¾". Royal Academy of Arts, London

Part Two.

FRIENDS AND ACQUAINTANCES

9. Edward Robinson

WALTER GAY'S GROWING REPUTATION AS A DISCRIMINATING ART collector came to the attention of the new director of the Museum of Fine Arts in Boston, Edward Robinson, who asked in 1903 if Walter would help the museum find important paintings and drawings. Walter consulted with his old teacher Bonnat and wrote to Matilda, "I told [Bonnat] that I had been entrusted to buy pictures for the Museum in Boston. He said that I was the only one, 'Le Seul,' that they could apply to for such a mission." Robinson probably got the idea of using Walter Gay for this purpose from their mutual friend, the artist Ralph Curtis, who was also advising the museum on acquisitions.

When Robinson visited the Gays the following year, with the president of the museum and a friend, to view their collection, Matilda was not impressed. "They are sceptical of authentic pictures, and credulous of doubtful ones. While they were here, the young Marquis de Trévise came in, and they all went upstairs to see the Rembrandt drawings. The young Frenchman showed the artistic finesse of his nation and thoroughly appreciated all he saw. The Americans saw nothing."

Robinson and Gay began looking at art together in London. "Robinson is a first rate man to go about with," Walter wrote to Matilda. "He knows everybody—offered to put me up at the Burlington Club whenever I came here, and would take me anywhere." In addition to social entrée, Robinson offered new opportunities for Gay to add to his own collection. "I lunched with Robinson, spent an hour or two looking over old drawings, one or two of which I was able to get from him for nothing; wait until you see them. Then we went to Christie's, . . . then to another auction place, where they sell old masters, and lastly to the Burlington Club, where they are having one of their exhibitions of old paintings, furniture and drawings. . . . I have seen more old masters today than I would see in six months in Paris, unless I went to the Louvre. Everything that I have seen so far can be had for a third what things cost in Paris, and everyone wants to sell."

Walter Gay's first recommendation to the museum was a portrait of a young man by Goya. "Wasn't it nice of Robinson to write me (with all his work at the Museum) at once, on receiving the Goya, and how nice it is, that he, at

61. John Singer Sargent. *Edward Robinson*, 1903. Oil on canvas, 56½ x 36¼". The Metropolitan Museum of Art, New York. Gift of Mrs. Edward Robinson, 1931. 31.60

all events, liked it. It really ought to be a popular purchase, as it is quite understandable, besides being a charming picture, as Robinson says." Charming it still is, although later scholars have liked it somewhat less and it now hangs in storage catalogued as "Spanish, late eighteenth century."

In 1905 Walter was in Boston helping the museum choose drawings for an exhibition and giving his opinion on a questionable Velázquez portrait. "There is plenty for me to do here in connection with the Museum," he wrote to Matilda. "They asked me to sort out old drawings this morning, and I looked over some hundred of the latter, choosing the best for an exhibition which is to take place in the Museum. I spent the entire morning and finally settled what I am going to say in regard to the much-disputed Velasquez 'Mr. Walter Gay is of opinion that the portrait is not by Velasquez, but a very interesting work of his time by an unknown hand.'"

By this time Matilda had come around to liking Robinson. "I know of no more delightful personality than this scholarly man, whose modesty is as great as his learning. He has a beautiful head, like one of his own beloved Greek marbles, and is the only good-looking *savant* I ever saw" (fig. 61).

Over the years Walter became a generous donor to the Museum of Fine Arts, giving two of his own pictures and twenty-seven drawings, including works by Whistler, Delacroix, Millet, Paul Helleu, and Jean-Louis Meissonier. His role as adviser and donor no doubt helped pave the way for the acquisition by the museum of two of his pictures: *Interior of Palazzo Barbaro, Venice* (see fig. 66) and a watercolor of Bréau entitled *La Chaise-longue, Bréau* (fig. 42).

The art school affiliated with the museum engaged him to serve as one of two representatives in Europe "responsible for keeping at a high level the work of the holders of the Paige Traveling Fellowship, one of the most desired prizes offered to students of marked talent." After Robinson resigned in 1905, Ralph Curtis suggested to Walter that he should be the next director in Boston,

99

a job that did not remotely interest him. When Robinson then accepted the position as assistant director of the Metropolitan Museum of Art, however, he came to Walter Gay with a proposal that did interest him: work in Europe as an agent for the Metropolitan. Within a year Walter was helping the museum buy a picture by Whistler.

He had known Whistler well and later contributed a perceptive account of him to the Pennell *Life of James McNeill Whistler*, in which he described the artist's wit, eloquence, subtlety, and sensitivity, as well as his famous combativeness. The two artists had met in 1894, when Whistler was living in the rue du Bac, and they continued to see each other regularly. "My last interview with Whistler took place in the spring of 1903, in London, about two months before his death. Hearing that he was far from well, I went to see him, and found that the rumour was only too well grounded. I spent the afternoon with him—he was singularly gentle and affectionate, and clung to me pathetically, as though he too realised that it was to be our last meeting in this world." Walter had acquired two of Whistler's small watercolors. And yet, for all his friendship with the artist and familiarity with his work, he could not have chosen a painting that would cause more trouble.

Gay wrote to Robinson in February of 1906: "One of the well known series of Nocturnes by Whistler has just been offered me to purchase. It is Cremorne Gardens at night, with figures dancing in the distance. . . . Personally, I find the picture a little black, but that is the fault of a good many Whistlers, but they are so hard to find, and so few of them of any importance, that I thought you might like to hear of it." Robinson wanted more information on its provenance, which was provided.

The dealer who owned it was not willing to engage in a lengthy museum negotiation, so Gay went ahead and bought it himself. Without telling Robinson, Walter then set off with Matilda on a trip to Italy, while a series of increasingly frantic cables from the Metropolitan to GAYBOY, PARIS, Walter's cable address, asked about the Whistler.

Back in Paris, he had second thoughts about parting with it, a little black though it might be, and wrote to Robinson: "On arriving from Italy last night I found the Whistler awaiting us and this morning cabled you that it was yours. It is needless to say how I want it myself; still having promised it to you, I can't change my mind, but you don't know how it hurts to let it go, but next to having it myself, I would prefer its going to the Metropolitan. The picture awaits your orders. The cheque has not as yet turned up, but as I have bought it, there is no hurry."

In due course the check turned up and the picture was sent to New York, where it was described in the museum's *Bulletin* as "perhaps the most beautiful of the series which were inspired by Cremorne Gardens at night, with their illuminations and fireworks, their dancers and spectators, appearing as so many bits of bright color against the soft darkness of the London night sky in summer." Full acknowledgment was given to Walter Gay's role: "For the opportunity to secure it the Museum is also indebted to Mr. Walter Gay, of Paris, a Fellow for Life, by whom attention was called to the fact that it could be had, and through whom negotiations for its purchase were conducted."

Robinson, however, began to notice the bits of bright color less, observing that the dark areas were much darker and more severely cracked than had been noted. Walter naturally replied that this must have happened after it left Paris. "[The cracks] must have become accentuated on the voyage. At all events, the picture when it left my hands was in the same condition that it was in the Whistler exhibition two years ago, when the cracks existed, but very fine, and *no white* showing underneath. The latter development has taken place since I saw it, I feel sure. I showed the picture to a number of people while it was at my place, and no one spoke about the cracks." It has subsequently further darkened and cracked and is now unexhibitable.

Walter also reported to Robinson about works he had seen on his Italian trip: a Botticelli, a Giorgione, and a collection of Greco-Roman bronzes from the Barberini family, the latter outside of Gay's expertise but very much within Robinson's. While the Whistler acquisition was proceeding, Robinson thought that Gay should meet the museum's prickly new curator of paintings, Roger Fry, who had just turned down the offer of directorship at the National Gallery in London. At least on this front, all seemed to go well. "In the short visit [Fry] made, I was most impressed with him, and found him very appreciative and sound in his judgment of the few things he had time to see in our house," Walter wrote to Robinson. Matilda, of course, was interested in Mrs. as well as Mr. Fry, writing in her diary, "Mr. and Mrs. Roger Fry lunched here. He is the well-known art critic and *littérateur*—very agreeable, enthusiastic, and clever. Mr. Fry is that rarity—a *natural* Englishman. Mrs. Fry very sweet, womanly, and intelligent. She looked like a rag-bag but her simplicity and charm effaced the impression of her appalling dowdiness." His genial reception by the Gays notwithstanding, Fry was already finding too many chefs in the kitchen at the Metropolitan and felt strongly that the curator of paintings did not need the help of European agents. By 1909 he had quarreled with the chief chef, Pierpont Morgan, the president of the museum, and departed shortly thereafter.

62. Walter Gay. *The Hoentschel Room, Metropolitan Museum of Art*. Oil on canvas, 25 ¹/₂ x 21". The Saint Louis Art Museum. 27:1926

Robinson must have realized by the end of the Whistler episode that an agent who could not quite decide whether he was buying on behalf of the museum or for himself, quite aside from questions of reliability on condition reports, would almost certainly create more problems. Gay's period of advising Robinson on paintings began and ended with the Whistler. But not their friendship.

It would in any event only have been a matter of time before other conflicts developed between the Gays and the Metropolitan, given Matilda's mixed feelings for Pierpont Morgan, whom she encountered several times on the social circuit. After sitting next to him at a dinner in 1908, she wrote, "Mr. Morgan, whom I had not seen for 20 years, is a hale old gentleman of 74. His nose

has become a polypus now, and is unpleasant to look at. No doubt he would give half of his colossal fortune to change it. How useless millions are. But the man is a great force, and his expressive and fiery dark eyes indicate his intelligence. It seemed to me, as I looked around the table, that we were all acolytes swinging our censors before the representative of Mammon. There was a deferential air in the atmosphere, although the object of this reverence was simple enough and rough in manners and accent. He was suave with me, and made me sip some rare old sherry out of his glass."

Walter continued to visit the Metropolitan Museum and see Robinson whenever he was in New York. In 1911 he painted a view of one of the galleries, an alcove of Louis XV *boiserie* with a few carefully placed pieces of French furniture that were part of a large collection of furniture and woodwork assembled in Paris by the architect and decorator Georges Hoentschel, and given to the museum by Morgan (fig. 60). "The 18th-century French things were just what we would have collected ourselves, had we been able to do so," Matilda wrote. "Admirable specimens of carved panels, chairs, brass ornaments, etc. I wonder how many people in this teeming city appreciate all these delicate lovely things?"

Robinson, who became director of the Metropolitan in 1910, seemed to intimidate much of the staff, but with the Gays and their circle of friends he was relaxed and amusing. On their summer trips in Europe he and his wife often visited the Gays at Le Bréau and once vacationed with them in Venice and Munich. "Delightful talk with this delightful man, who has a tranquil charm rare in our agitated compatriots. He told us of the ever-increasing treasures he is acquiring for his beloved Metropolitan Museum, which he directs with so much tact and intelligence. . . . [He] is made of *pâte tendre* [soft-paste porcelain], physically and mentally—the essence of daintiness and subtlety." Matilda liked his delicate sense of humor, his irony, and "gentle malice." Robinson bought a view of Le Bréau, *The Green Salon,* for the museum in 1912 (fig. 43); the four other pictures by Gay at the Metropolitan came later as gifts or bequests.

When the Gays were in New York, they enjoyed having dinner with the Robinsons at their house in Irving Place. "Mrs. Robinson has given a strongly personal note to her house. The open fire, the birds singing in their cages, the simple arrangement of the flowers, her embroidery work, all these details give a home atmosphere lacking in the gorgeous places of the multi-millionaires."

Although the professional involvement between the two men had been short, it led to a long friendship that both couples treasured.

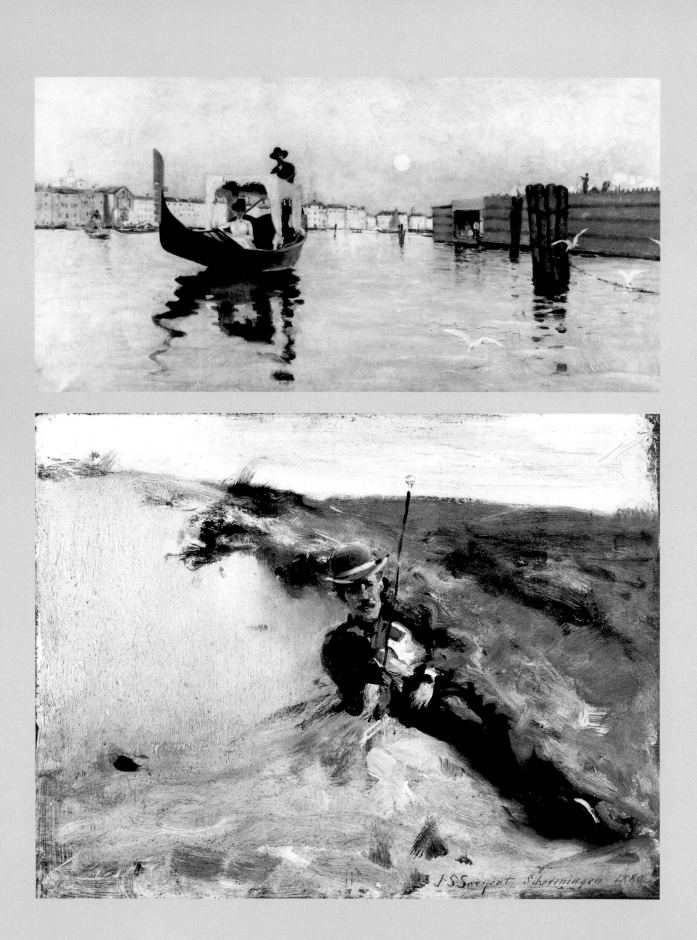

10. Ralph Curtis

RALPH WORMELEY CURTIS WAS ONE OF WALTER GAY'S CLOSEST FRIENDS from their early days in Paris. After graduating from Harvard, Ralph had come to study in the atelier of Carolus-Duran. His Venetian views were, at a distance, sometimes mistaken for those of John Singer Sargent, his second cousin, fellow student, and lifelong friend (fig. 63). But Ralph was a little too rich and too indolent to make a career as an artist, choosing instead what Henry James described, perhaps harshly, as "a profession of merely knowing every-body and doing nothing." Bernard Berenson was probably closer to the mark in regarding Ralph Curtis as "the last of the boulevardiers." His charming easy manners and infectious wit endeared him to the Gays. When this raconteur was "en veine" (in good form), as he often was, he could tell amusing stories all evening. Sargent's portrait of him in 1880 reclining on a sand dune with cane and bowler hat deftly captures his stylish insouciance (fig. 64).

Walter and Ralph traveled to Berlin together in 1906 to see the recently opened Emperor Frederick Museum. "I find Ralph an excellent traveling companion, but inclined to take things far too leisurely for me," he wrote to Matilda. "He would like to spend a month here and go day after day to the Museum, and look at everything, whereas I probably would have finished by this time, if I had been alone. . . . We go everyday to the Museum, and come back in an exhausted condition to rest in the Zoological Gardens, where there is music and beer. Ralph has no idea of time, as you know. . . . We are in an excellent hotel, which is perhaps one of reasons why he is so happy here."

Ralph married a young, pretty, sweet, affectionate, and very rich widow, the former Lisa Colt of Providence, Rhode Island. Although she was widely thought to be none too bright, Henry Adams knew better: "Mrs Ralph is charming when she says she knows she's a fool. I've learned to mistrust women who know they're fools. It has taken me sixty years to learn what a fool is, and a woman who knows it before thirty is dangerous."

The Curtises frequently dined with the Gays in Paris and were often at Le Bréau for weekends, on one of which disaster was narrowly averted. Edith Wharton had published in *Scribner's Magazine* a story entitled "The Verdict" about a failed artist and his dim, rich wife, which could only be read as a

thinly veiled—very thinly veiled—account of Ralph and Lisa Curtis. A furious Lisa Curtis complained to Henry Adams: "It's all about me, and Ralph, and our house, where Teddy [Wharton] made us a visit, and his wife has put down his whole account of it even to the furniture of the bedrooms, and described me as a rich widow without any mind, who has let my artist husband give up his career which he found himself to have failed in." Their friends were all asked to take sides, which the Gays did not wish to do. Nor did Henry Adams, who wrote, "I am too old to be drawn into a battle of ladies, and am an intimate friend of all parties." The warring sides felt that it would be wise to keep a greater distance than happened in September 1909, when the Curtises arrived at Le Bréau only hours after Edith Wharton had departed.

The house Lisa referred to was the Villa Sylvia, named after one of their daughters, in Saint-Jean-sur-Mer near Beaulieu, where the Curtises spent the winters. Although Matilda did not care for the Riviera ("that brainless place"), the Gays stayed twice at the Villa Sylvia. "Everything unites to charm the eye and the mind in that attractive house," she wrote. It had "the perfume of good taste, instead of the stink of money, often so offensive in grander houses." Mutual friends agreed, including Berenson, who often stayed there and enjoyed "all the luxury, all the pretty clothes and playful ways of their crowd."

The Curtises often went from the Villa Sylvia to Venice to visit Ralph's parents at the Palazzo Barbaro. His father, Daniel Sargent Curtis, had acquired the house after an unfortunate incident in Boston involving a dispute with a gentleman over a seat on a tram car, which resulted in a twisted nose and broken spectacles; unluckily for Daniel Curtis, the gentleman happened to be a judge, who sent him to prison for two months. Complaining bitterly about the uncouthness of America, Daniel and Ariana Curtis moved to Venice, where they entertained grandly. Ariana, whom her son called La Dogaressa, was formidable. "Mrs. Curtis is intelligent and has many friends, but she suffocates me," Matilda wrote. "Her finely cut stony face looks as though she were forever dealing out death sentences—she would have made an admirable judge of the criminal court."

Henry James, a frequent guest, loved the Palazzo Barbaro with its "space and drafts and gondoliers and gardeners and cooks" and completed *The Aspern Papers* there. In *The Wings of the Dove* it appears as the Palazzo Leporelli, where James's sad heroine Milly Theale spent her last months "in the high florid rooms, palatial chambers where hard cool pavements took reflections in their lifelong polish, and where the sun on the stirred sea-water flickered up through open windows, played over the painted 'subjects' in the splendid

ceilings—medallions of purple and brown, of brave old melancholy colour, medals as of old reddened gold, embossed and beribboned, all toned with time and all flourished and scalloped and gilded about, set in their great mounded and figured concavity."

Walter's view of the principal room, the *salone*, painted in 1902 (fig. 66), shows the elaborate Baroque stucco decoration by Antonio Gaspari that frames the vast eighteenth-century canvases by Sebastiano Ricci (left) and Giovanni Battista Piazzetta (right), as well as the oval overdoors, which originally contained works by Tiepolo that had been sold by the Curtises' predecessors.

Sargent's portrait of the family set in the same room did not meet the approval of La Dogaressa, who was annoyed at her son's pose sitting on a table, and she rejected the picture, against the advice of her friends, including Henry James, who liked it enormously (fig. 60). Sargent took the portrait back and submitted it as his diploma painting at the Royal Academy in London, where the Gays saw it in 1910. "The interior of Palazzo Barbaro interested us very much, as W. G. has done such a brilliant one of that beautiful salon. Sargent has given the impression of a dark background, in fact, has hardly done the room at all, in order to throw out the figures of the Curtis family. The latter, with the exception of Lisa, are admirable. The old gentleman, so naturally turning over the leaves of a portfolio, the old lady, with her stone face . . . Ralph, a graceful *flâneur* attitude, so typical of him." A comparison of the two pictures inevitably favors Sargent, who was after all a much better artist. Walter sold his view to the Museum of Fine Arts in Boston in 1911.

He painted another interior of the Palazzo Barbaro in 1910 while the Curtises were away. "One feels like a burglar in a house where the owners are absent, although their psychic presence makes itself felt, particularly in this case, where the mistress has such a dominant personality," Matilda wrote. Two years later they watched a regatta from Ariana's gondola and prowled about the Giudecca with her, as she told them about her early years in Venice. "She is a wonder, this clear-minded and cold-blooded old lady of 80."

As Ralph Curtis grew older, he became less amusing and more tiresome, his stories more highly seasoned than was to the Gays' taste. Now rubicund from drink ("purple with high living and low thinking"), he acquired some unattractive friends. "Curtis criticised merrily some of my friends whom he doesn't like," Matilda complained. "Had I chosen I might have paid him back in his own coin with double compound interest, but I contented myself with silently thinking of the awful bounders whose society he used to seek—one of them, indeed, ended his career as a murderer." But Ralph was still able to

behave just well enough to sustain the strained relationship. "He is kept within bounds by my presence, but always ready to step over them. We disagree politically, morally, and socially—but by careful avoidance of thin ice, we manage to keep out of the pond of conflict."

Walter was deeply saddened when this friend, with whom he had enjoyed such a close camaraderie for so many years, died in 1922. Matilda was rather relieved.

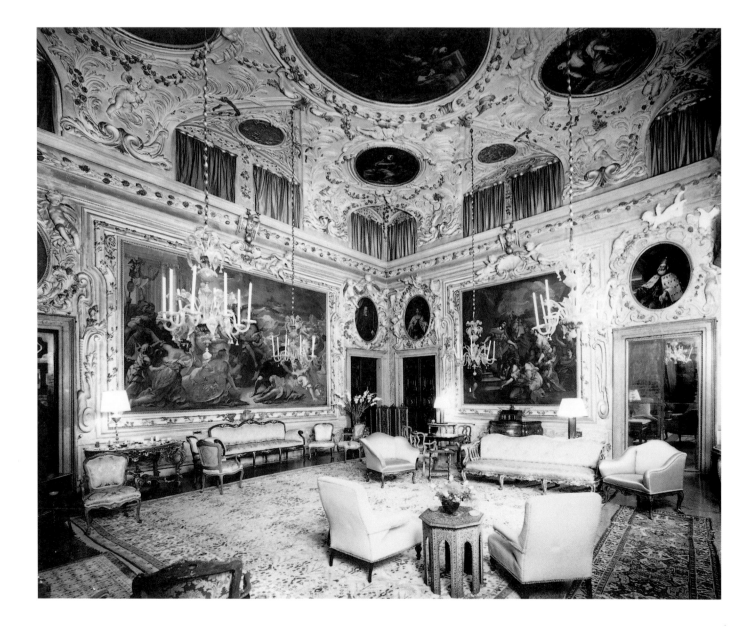

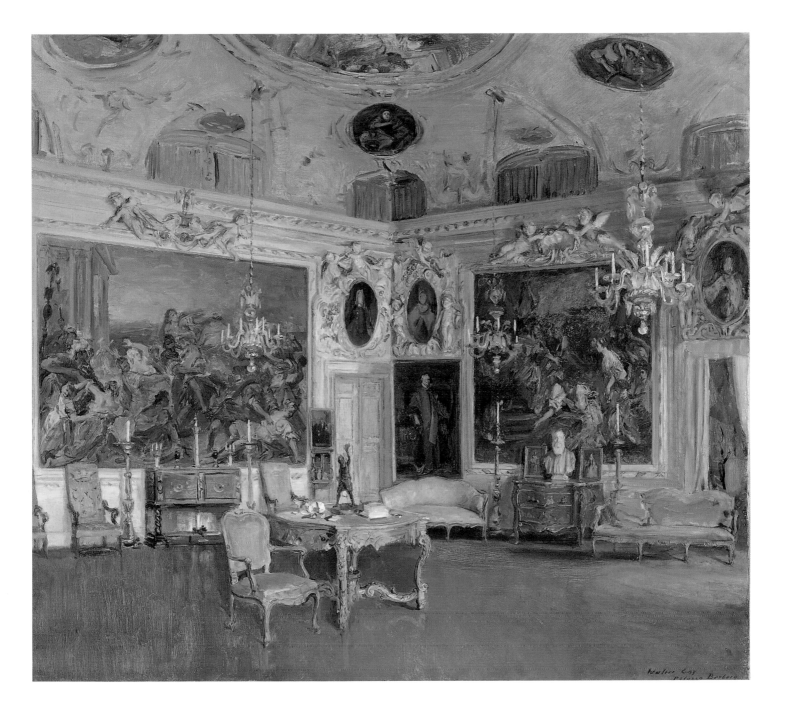

11. John Singer Sargent

WALTER GAY AND JOHN SINGER SARGENT FIRST MET AT THE STUDIO of Léon Bonnat, where Sargent occasionally painted in the evening after studying during the day in the atelier of Carolus-Duran. The same age as Walter, Sargent had come to Paris two years before him in 1874, after an expatriate childhood spent with his parents moving frequently from place to place on the Continent. "[Sargent] was then a slender young man, very shy. We saw at once that he was going to excel in his art," Walter wrote with some understatement in his *Memoirs*. Sargent was far more cosmopolitan than Walter. He spoke four languages, was widely read, and played the piano well. His childhood friend Vernon Lee described him in 1881: "John is very stiff, a sort of completely accentless mongrel . . . [with] rather French, faubourg sort of manners." After Sargent moved to London in 1886, Walter and Ralph Curtis would drop to his studio in Tite Street when they were in London together. After a visit in 1907, Walter wrote to Matilda, "At Sargent's I met a number of Frenchmen, all of whom were admirers of my works, as well as his, of course."

The Gays and the Curtises went together to have dinner with Sargent in July 1904: "Talked of Italian painting of the 18th century, Canaletto and Guardi," Matilda wrote. The Curtises stayed on after the Gays had left and later reported that Sargent compared Walter's work with that of a little-known contemporary painter named Maurice Lobre. "[Sargent] said that Lobre's pictures gave him the impression of a dull day, with the rain pouring down outside, and all the rooms dim with melancholy; whereas Walter Gay's interiors seemed so bright and gay, with the windows open, the birds singing, and sunshine pouring in," Matilda recorded. "Curtis answered aptly, 'Yes, Lobre is the Canaletto, Gay the Guardi of interiors.'" Had Curtis been speaking with Comtesse Murat?

On a visit to Sargent's London studio in July 1904, Matilda noticed the interesting differences between the artist and his art: "In the afternoon went to John Sargent's studio. Delighted with the works of that great painter. He showed us brilliant watercolors, also several unfinished works—a head of Lady de Grey (see fig. 69), a family group of the Duke and Duchess of Marlborough, Miss Wertheimer in a long cloak, a full length of Lady Warwick and her little son, Mary Garrett, etc. His personality gives one no idea of his great talent. No

glimmer of genius in the impression he makes in ordinary life. It is all absorbed by his pictures. What remains is a pleasant, embarrassed, affected society man, with an artificial accent, and the *fond* is distinctly ordinary. He has grown very stout of late years, as unbecoming to him as it is to everyone else."

On a visit to the Endicott family in Boston in 1911, Matilda saw another aspect of Sargent's work. "Mrs. Endicott, the mother, is a *grande dame*. Her portrait by Sargent is the portrait of a lady, showing the power of her distinction in curbing the natural coarseness of the great painter." Nonetheless, the Gays admired the way in which Sargent's portraits commanded attention even when exhibited side by side with old masters. They thought that his portrait of the philanthropist and art patron Henry Marquand in the Metropolitan Museum was as strong as the pictures by Van Dyck, Frans Hals, Turner, and Rembrandt from the Marquand collection hung in the same gallery. At the National Gallery in London, Sargent's portraits of the Wertheimer family "hold their own beside Sir Joshua [Reynolds] and Gainsborough, those 18th-century giants." Sargent's portraits had an even stronger impact when compared with nineteenth-century work. "The three Sargent portraits of Octavia Hill, of Henry James and Coventry Patmore, stand out triumphantly in the 19th century room. They make the Millais and Watts portraits look a little sick," Matilda wrote. Sargent, she concluded, was an old master in his lifetime.

On several occasions Gay and Sargent displayed their pictures at the same exhibitions. At the Société des Beaux-Arts exhibition in April 1904, several of Gay's interiors were exhibited with Sargent's portrait of Lord Ribblesdale (fig 68), where both the hanging and the portrait pleased Matilda: "Went to the Salon to see my husband's pictures. Well hung, as usual, and a satisfactory exhibit. Sargent's portrait of Lord Ribblesdale very fine, a masterly portrait of a distingué man." The same year at the annual exhibition at the Pennsylvania Academy of the Fine Arts in Philadelphia, Walter exhibited four pictures (views of the Château de la Rochette and the Château de Courances, a picture described only as a Boston interior, and one of his rare outdoor views—the roofs of the palace at Fontainebleau) in a show that included nine portraits by Sargent. In 1907 at the exhibition of a group called the Société Nouvelle at the Galerie Georges Petit, Gay's and Sargent's pictures were again shown together.

What impressed the Gays most about Sargent, aside from his talent, was his absolute disinterestedness: neither fame nor money would tempt him to paint anything against his inclination. "This," said Matilda, "is real luxury."

67. John Singer Sargent. *Self-Portrait*, 1892. Oil on canvas, 21 x 17". National Academy of Design, New York

12. Lord Ribblesdale and Lady de Grey

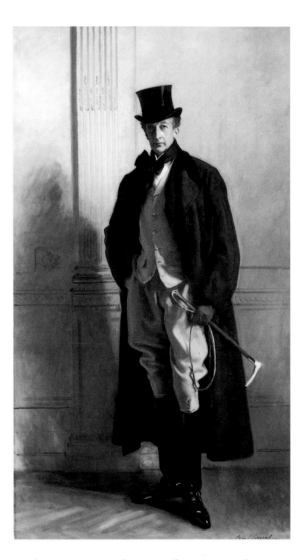

I
N MAY 1904 TWO OF Sargent's many socially prominent sitters came to see Walter Gay in Paris. "Lady de Grey and Lord Ribblesdale came to ask W. G. to paint the interiors of their houses in London. Great compliment. Hope it can be arranged," Matilda reported. "Lord R. most charming, mellow Englishman. When they *are* nice they are so much nicer than we." Charming and nice he may well have been on occasion, but that is not how Lord Ribblesdale appeared in Sargent's portrait, which had received such lavish praise when it was first exhibited at the Royal Academy in 1902 (fig. 68). Dressed in hunting clothes, Thomas Lister, 4th Baron Ribblesdale, was the very personification of aristocratic hauteur and Edwardian elegance. In the 1890s he had been Master of the Buckhounds and wrote a book on fox hunting. A Liberal peer (whip of the House of Lords), a lord-in-waiting at court, and a trustee of the National Gallery, he was part of that brilliant and witty circle of friends known as "the Souls." He married Charlotte Tennant, the very rich daughter of Sir Charles Tennant, and after her death wed the even richer widow of John Jacob Astor, Ava Willings. Walter

68. John Singer Sargent. *Lord Ribblesdale*, 1902. Oil on canvas, 101¾ x 56½". The National Gallery, London

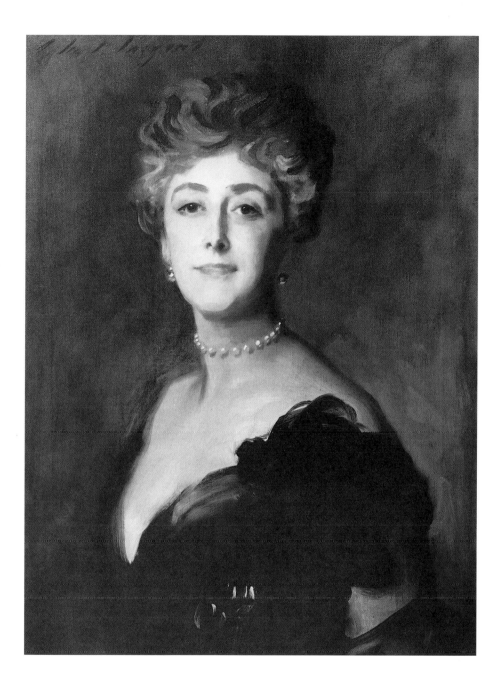

69. John Singer Sargent. *Gladys, Marchioness of Ripon*. Oil on canvas. Private collection

accepted Lord Ribblesdale's offer and in July of 1904 went to work in London painting at his house. The resulting interior was lent back to Walter for his exhibition the following year at the Galerie Georges Petit.

During the same week he was painting at Lord Ribblesdale's, Lady de Grey, later known as Gladys, Marchioness of Ripon (fig. 69), drove the Gays out to Surrey to see her house, Coombe Court. Matilda reported: "The house itself an ordinary, largish suburban villa, filled with French things and *porcelaine de*

113

Saxe. The *Ier Empire* room is very good—a very fine Romney on the wall, a woman in pink, the *right* pink, a good Boilly, etc., and some of the clocks. The things are, with these exceptions, not of the first order, but she loves them so it imparts a sentimental value to them which really adds to their merit. Like ourselves she has economized on champagne and clothes to get them." In his den Lord de Grey had some good porcelain and jade, but the Gays felt that by far the most interesting of all the bibelots was Lady de Grey herself. "With the quick wit of an American, the mellowness of the English, and her aristocratic beauty, she is indeed one of the pleasant experiences of our lives." Lady de Grey kept a large menagerie of exotic pets, some of which reminded Matilda of Walter's old teacher Bonnat.

Lady de Grey purchased two of Walter's interiors, which she showed to the king and queen, to whom she sounded the artist's praises. When the Gays next saw her at the Ritz in Paris the following October, they were understandably excited by her news. "She said that [the king and queen] were both delighted with W. G.'s pictures, which they saw at her house, and their Majesties wished to send for him at once to paint the interiors of their favorite rooms. She told them that he was not to be sent for like a photographer—but that she would undertake to find out when it would be convenient for him to go over to England. She also said that it was far preferable for him to paint at Windsor, and not at Buckingham Palace, which is far less paintable; and described a beautiful room at Windsor, just his *genre*. It was arranged that all is to be left in her hands."

Walter painted a room at Coombe the following June and reported to Matilda: "I haven't got the King yet, but am having the time of my life painting at Lady de Grey's. She sits and watches me paint, we lunch under the trees, all alone, and she sends me back in her motor afterwards. I can't ask any more than that. I stayed to a grand dinner there the other night. . . . Prince Alexander of Teck was there, but was such a nice fellow, that I had no idea who he was, until afterwards they told me he was brother to the Princess of Wales. Lord de Grey is as simple as possible. He helped arrange the room for me to paint, and showed the greatest interest. . . . So you must be prepared to find me quite spoiled and uppish after all this attention." He finished the picture on July 4, and that night the Gays joined Lady de Grey in her box at Covent Garden to hear *Un Ballo in Maschera* sung by Enrico Caruso. In the box opposite sat the queen, so near and yet so far. Alas, the commission to paint at Windsor never materialized.

13. Elsie de Wolfe, Bessie Marbury, and Anne Morgan

O N A SUMMER AFTERNOON IN 1906 MATILDA WAS RETURNING TO LE Bréau from Paris when she passed on the road the three friends she expected for dinner. Seated in their car while the chauffeur struggled with a flat tire were Bessie Marbury, Elsie de Wolfe, and Anne Morgan. "We took them in and proceeded merrily on our way. These ladies enjoyed immensely dining on the terrace, and feeding the carp. . . . Pleasant evening with these most agreeable women."

Bessie Marbury was a prominent theatrical agent and childhood friend of Matilda's; Elsie de Wolfe, as she never hesitated to explain, regarded herself as the first American interior decorator; and Anne Morgan was the daughter of J. Pierpont Morgan (figs. 70, 71). The large and mannish Bessie (once described by P. G. Wodehouse as "dear, kindly, voluminous Bessie Marbury") and petite and feminine Elsie were perhaps the most fashionable lesbian couple of the period (fig. 70). They shared two houses, one of them on Irving Place near Gramercy Park in New York, which Matilda described as "their dear little house in 17th Street, formerly occupied by Washington Irving—a quaint little narrow place, charmingly arranged with French furniture and pictures of no great value, but of which an ensemble is made by Elsie's instinctive taste." The other residence was the Villa Trianon at Versailles, which they bought in 1906 and which Matilda had been to see in May of that year: "In the afternoon drove out to Versailles to a garden party at Bessie Marbury's in her delightful Villa Trianon, most tastefully arranged by Elsie de Wolfe." After a second visit in August, she described it in greater detail: "This charming little house was formerly a *garçonnière* of the Duc de Nemours in the 18th-century (Great Heavens, what it must have seen!). Our friends have arranged it with exquisite taste and judgment. The garden is also carefully laid out in

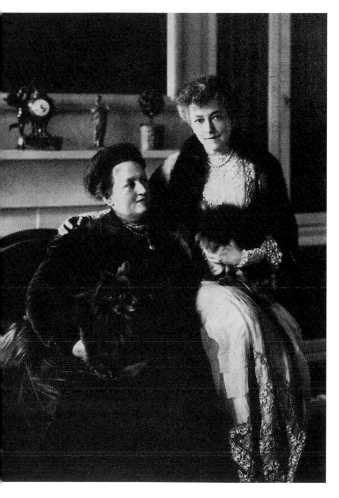

70. Bessie Marbury and Elsie de Wolfe. Photo reproduced from Elisabeth Marbury, *My Crystal Ball*, New York, 1923

the epoch, and everything is in the same note of harmony: no discords any-where."

Known as "the Bachelors," Bessie and Elsie loved to entertain, and their Sunday afternoon teas in New York were legendary. Henry Adams reported on one to Elizabeth Cameron in 1901: "I went to the Marbury salon and found myself in a mad cyclone of people. Miss Marbury and Miss de Wolfe received me with tender embraces, but I was struck blind by the brilliancy of their world." After buying the Villa Trianon, the Bachelors simply moved the parties to France.

In her autobiography, *After All*, published in 1935, Elsie de Wolfe included Walter Gay with Ogden Codman, Henry Adams, and Elizabeth Cameron as part of "a brilliant coterie who gathered at our hearth now and then. When they were together there was always sure to be good talk." Another frequent guest and mutual friend of the Bachelors and the Gays was Bernard Berenson, who rather surprisingly enjoyed "the flutter of Sapphic society" at the Villa Trianon and described a 1908 visit as tumbling "into the very lap of the most refined, back-comforting, eye-caressing, tummy-comforting, soul-soothing luxury."

But not all of the guests were of the caliber of Henry Adams and Bernard Berenson. In fact, the Gays found that on the whole they rather pre-ferred the Villa Trianon's owners to its visitors. "Some of the . . . guests have unpleasant little stories of various kinds hanging on to them, which may be more or less true," Matilda wrote. "But the Marbury and de Wolfe house is a most amusing one, in spite of the element of knavishness and slipperiness among the habitués—one meets respectable people as well—all kinds, in fact. It is the only really Bohemian house I know where the hostesses have them-selves kept within the limit that their guests have frequently overstepped."

Their Sunday parties at the Villa Trianon acquired a certain fame. "[They] were international in aspect, as our guests came to us from every coun-try in the world," Elsie wrote. "Diplomats, now and then a king or queen, princesses of royal blood, poets, painters, musicians, the people of the theater, motion-picture stars, admirals, generals, gay groups of young people, all fore-gathered in the common pursuit of a good time." A good time was not, howev-er, always had by the Gays. After one of these affairs that Walter had attended without Matilda, he wrote to her at Le Bréau: "Miss de Wolfe kindly asked me out to lunch today. . . . The lunch was the usual large one of discontented Americans and rather off-colored French people—you know the kind—but was tastefully served out doors under an awning, though the day was far from

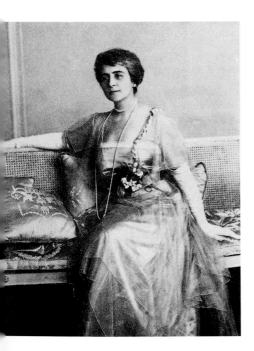

71. Anne Morgan. Photo reproduced from *My Crystal Ball*

warm. . . . More [people] came after lunch, but I left before the luncheon had become a reception, as it always does on Sunday." Sunday luncheons averaged twenty to thirty guests, for whom there was usually not enough food. Elsie was not much interested in food.

Amid the mellifluous and cultivated voices of princesses, poets, the occasional king or queen, the Gays and other guests, the one voice that must have stood out was that of Elsie de Wolfe, whose pronunciation of furniture as "foiniture," servants as "soivants," and pearls as "poils" must have been disconcerting in the sophisticated ambience of the Villa Trianon. Only one of her friends, Ludwig Bemelmans, ever described the accent, and then only after her death, in his amusing and naughty biography of her, *To the One I Love the Best*.

Not all of the Gays' friends shared their affection for Bessie Marbury and Elsie de Wolfe. Edith Wharton, for one, couldn't stand them and wrote to a friend: "Those two women are really not fit to traffic with, and I always feel degraded when I go against my prejudices and treat them as if they were." At least in this case it was mutual, Elsie writing in her autobiography, "Edith Wharton, as I remember her—I have not seen her for many years—was handsome, small and slight and with a wealth of blond hair. There was something sharp about her and she had a forbidding coldness of manner." Edith Wharton dropped in to see Matilda at Le Bréau one day in 1914, without having been warned that Bessie and Elsie were weekend guests, and she left very shortly thereafter.

Elsie de Wolfe's career was launched with the decoration of the Colony Club in New York, the commission that its architect, Stanford White, secured for her in 1902. By dint of talent, hard work, self-promotion, and relentless entertaining, she managed to stay on top of the increasingly competitive vocation that she claimed to have invented.

However inflated her view of the matter, there is no question that she effected a revolution in taste. Diana Vreeland once summed it up well: "She simply cleared out the Victoriana and let in the twentieth century." Banishing the lace curtains, tasseled tiebacks, and fringed lamp shades of the nineteenth century, Elsie de Wolfe introduced English chintz and French furniture to the United States. In 1913 she wrote a popular, how-to-decorate manual, *The House in Good Taste,* in which she advocated the tripartite rules of suitability, simplicity, and proportion in sensible, homey language aimed at the upper middle class. "I believe in plenty of optimism and white paint, comfortable chairs with lights beside them, open fires on the hearth and flowers wherever they 'belong,' mirrors and sunshine in all rooms." It was a book far removed from

the grand, palace-decorating orientation of Edith Wharton and Ogden Codman's *Decoration of Houses*.

The Villa Trianon, on the edge of the park of Versailles (but unrelated to the royal Grand and Petit Trianons nearby), was not just a party house; it was Elsie de Wolfe's showroom. She saw to it that articles about the Villa Trianon, and herself, were featured frequently in the fashion and decorating magazines. In order to achieve what Elsie regarded as a minimum level of comfort, they added five bathrooms, one for each of the four bedrooms on the second floor and one for the servants, causing much consternation among the workmen and neighbors about American extravagance and obsession with sanitation.

A few years later their friend Anne Morgan began to spend more time there, and soon this *ménage à trois* became known as the Versailles Triumvirate. The Gays came to visit in June of 1913 and admired the new changes in the garden: "Motored to Versailles for tea, dinner, and a night's lodging at the delightful Villa Trianon. A warm reception awaited us from the hospitable trio. They have built a delicious pavilion at the end of their garden, with a *pièce d'eau* in front of it. The interior is adorned with decorative panels of garden scenes which look as though they had waited one hundred and fifty years to be placed in that spot. . . . Pleasant dinner with these three jolly women."

The following year Anne paid for a new wing, aptly called the Morgan Wing, which Walter described in a letter to Matilda: "The Morgan wing in the de Wolfe-Marbury house is going to be good. Elsie was in her element showing it to us today. On the outside are marble columns supporting a veranda— perhaps just a little grand for such a small house, but as they give out on the garden, where there are many dressed-up things, I think it will do."

Although much of the house dated from the early nineteenth century, Elsie restored it with a Louis XV scheme of decoration, paneling the main rooms with *boiserie* from the nearby pavilion of her friend Mina Anglesey. It was furnished with a combination of eighteenth-century and reproduction furniture. "I am not one of those decorators who insist on originals. I believe good reproductions are more valuable than feeble originals, unless you are buying your furniture as a speculation. . . . A chair honestly copied from a worm-eaten original is better for domestic purpose than the original," she wrote in *The House in Good Taste*.

The color scheme at the Villa Trianon was blue and cream. "The note of the interior of the house is blue, and there are masses of blue flowers in the garden," she wrote. "The interior woodwork is cream, painted with blue, and there are blues innumerable in the rugs and curtains and *objets d'art*." Blue was

one of Elsie's favorite colors. She was credited with starting that unfortunate fashion for hair tinted blue, and one of her many dogs was named Blue Blue. Her other favorite color was beige. On first seeing the Parthenon, she shrieked, "It's beige—my color!"

Walter painted several interiors of the Villa Trianon between 1906 and 1922. His view of the Blue Drawing Room looks through the arched opening to the hall with a French window facing the garden (fig. 72). Despite the vitrine full of porcelains on the commode in the left corner and the table with vase and bowl on the right, obviously placed there as a device to help balance the composition, the room looks oddly underfurnished, and the picture fails to convey the "tasteful, coquettish, and charmingly arranged" house described by Matilda.

Diana Vreeland, a frequent guest at the Villa Trianon, wrote the best account of it: "The house itself was enchanting. It was . . . filled with wonderful eighteenth-century furniture and boiseries and modern murals and amusing touches like the box trees in the garden trimmed to look like huge elephants. . . . There was a smell of freshness in the house that I shall never forget; the house always smelled like the outdoors and lavender and violets. . . . [Elsie] adored miniature furniture, and she had a sense of proportion that was unique, a sense of scale that I don't think anyone else ever caught. She knew how to arrange things for conversation, to create an effect and yet take up so little room. It was all charming and quiet, secret and small."

Much as she liked Elsie de Wolfe, Matilda would never have dreamed of using her or anyone else as a decorator. When Elsie, together with the architect Ogden Codman, furnished and decorated a house in New York in 1910, Matilda came to have a look. "It is admirably arranged, daintily furnished, with every possible domestic convenience, and ought to find a purchaser among numbers of New Yorkers who want their work and thought done for them. But I would rather furnish my own place, and express my own personality. This house, exquisite as it is, expresses Elsie de Wolfe."

Bessie and Elsie soon found that the house on Seventeenth Street was too small and bought a larger one on East Fifty-fifth Street, where Elsie once again enlisted the help of Ogden Codman. Matilda called it their "little bijou house in 55th Street—a bit of Versailles in New York." During the Gays' trip to New York in the winter of 1914, they dined at the house several times and Walter painted a view of the drawing room (fig. 73).

Elsie described the room in her autobiography: "There was a marble mantel, above which was an antique mirror set in a columned frame along the

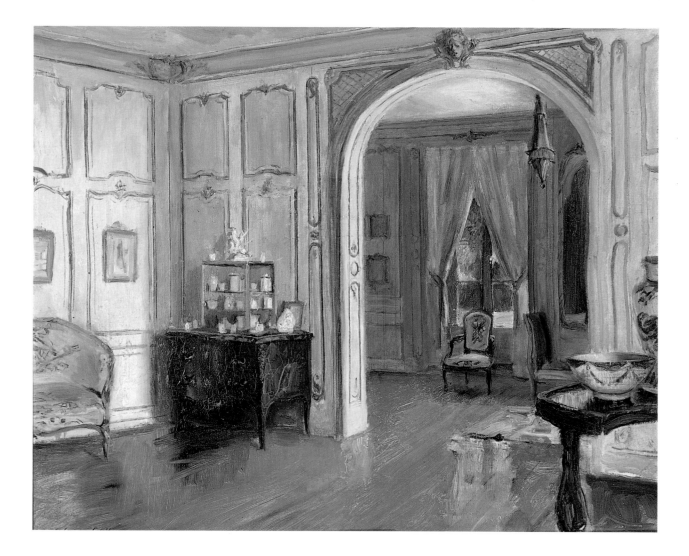

72. Walter Gay. *Villa Trianon, Versailles*. Oil on canvas. Elsie de Wolfe Foundation, Los Angeles

OPPOSITE:
73. Walter Gay. *Elsie de Wolfe's Drawing Room, 123 East Fifty-fifth Street, New York*. Oil on canvas. Elsie de Wolfe Foundation, Los Angeles

top of which, arranged in a row, were five carefully chosen pieces of porcelain. In the narrow panels on each side of the mantel was a sixteenth-century flower appliqué with two candles. In the center of the mantel was a terra-cotta group by Pajou. On the ends there were always little white flowers, preferably roses and lilies, arranged in crystal bowls. Two Louis XV armchairs covered in Beauvais tapestry stood on either side of the fireplace." Unfortunately, Elsie did not always get room descriptions quite right. The wall lights flanking the mirror were of the eighteenth century, not the sixteenth; the two armchairs were Louis XVI rather than XV, and in *The House in Good Taste* she had described them as covered with Aubusson rather than Beauvais tapestry. Elsie was sometimes a bit vague about distinctions of this sort. She posed draped in a fur coat in front of the same drawing-room chimneypiece for a photographic portrait by Baron de Meyer.

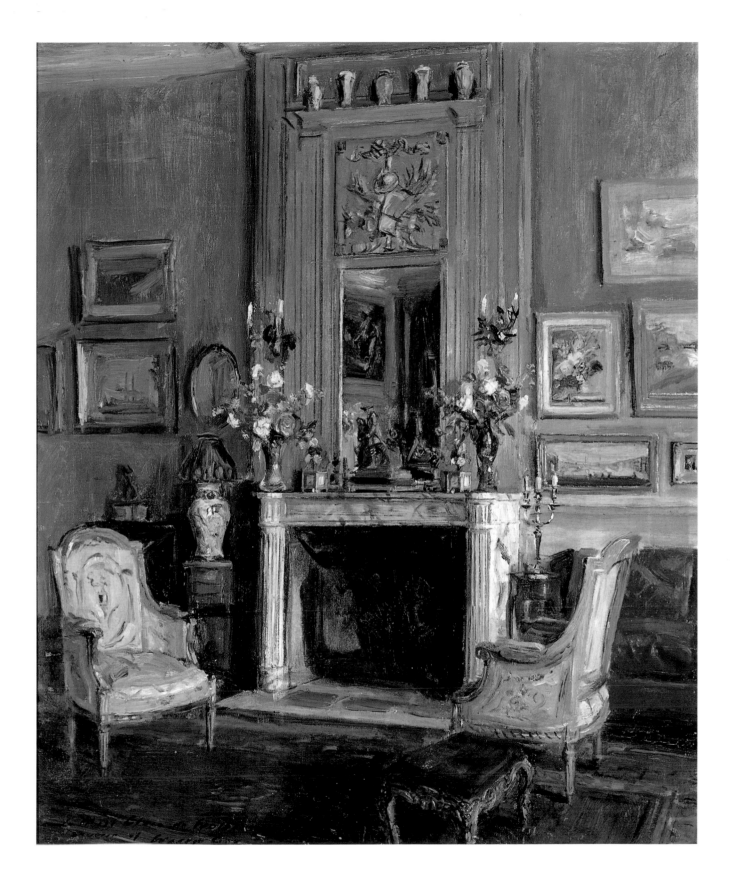

Elsie called the Fifty-fifth Street house the Little House of Many Mirrors. "The house is narrow in the extreme, and the secret of its successful renaissance is plenty of windows and light color and mirrors—mirrors—mirrors! . . . Nothing brings the glow of youth to a rejuvenated home like being able to look at itself in the glass from all angles. . . . In its proportions, balance, arrangements, furnishings, objets d'art, atmosphere, and suitability of purpose, [it] was as perfect a city house as the two of us could have had." But with the Villa Trianon claiming more of their time, the women were less often in New York and sold the house after World War I. The only object that Elsie saved from it was Walter's view of the drawing room.

She devoted herself to war work, both in America and France. "Elsie has made a successful propaganda for Ambrine [a treatment for burns] all over America, lecturing right and left, and has raised successfully a large sum to supply motor ambulances at the front for the immediate relief of the burnt soldiers." During this time Matilda saw more of the Villa Trianon as she was frequently in Versailles attending to her own charities. Two outbuildings were converted to convalescent homes for officers, who were entertained with concerts in the garden. "The convalescents are indeed fortunate who regain their strength in that lovely quiet spot." Matilda believed that the war had a deep effect on Elsie: "The atmosphere of pain, horror, and suffering in which she has lived for two years has developed her spiritually. I have watched the growth of her soul." But evidence of sustained spiritual growth was not compelling. "October 19th, 1916: To take tea with Elsie de Wolfe whom I found lying in a pink satin *déshabille*, on a luxurious couch, at the luxurious Ritz. She was most entertaining as usual. . . . She lives like a butterfly, from day to day."

In Matilda's eyes, Bessie, Elsie, and Anne were "the best company in the world—all working on intelligent lines, stimulating, and wholly different one from the other." But the war was a stressful time for these three strong-willed women, each now with different interests, and the trio disbanded. Bessie returned to New York, where she founded the Catholic Women's League and became active in social reform and politics. She took a small house in Sutton Place, where Matilda saw her whenever she was in New York. "It looks like a bit of Chelsea, overlooking the river, far from the scream and rush of the City. . . . [It] has a personal note absent from the palaces of the millionaires, where individuality is smothered in tapestries." There was a pretty garden that extended down to the river. Bessie continued to visit Le Bréau on her frequent trips to France and the two old friends became closer as the years went by. "Lunched with Bessie Marbury, by ourselves, so that we could say what we

liked," Matilda wrote in 1928. "With her infirmities, her will of iron carries her all through life's difficulties. This old friend is always interesting, even when I disagree with her, which is not seldom."

Anne Morgan organized the American Fund for the French Wounded, an international effort to provide aid for the soldiers and civilian population in the war-ravaged areas north of Paris. She operated the organization at the Château de Blérancourt, where the Gays visited her in 1917: "Thence to Blérancourt, where Miss Anne Morgan has established her work. She and her friends live in barracks built in the ruins of the Château of Blérancourt. The Château was destroyed in the French Revolution—but the two pavilions to the right and left of the majestic gateway remain. The epoch is pure Louis XIII. In one of these pavilions is the headquarters of the work. . . . There is a dormitory of 3 beds divided off by curtains . . . the other barracks are simple in the extreme; of course no modern conveniences. Here these luxuriously nurtured American women live, giving themselves up to their work of mercy. It is a poetic frame for these devoted women—the ruined château, lovely in its decay." Anne subsequently bought the château and surrounding property, restored part of it, and lived in one of the corner pavilions, which she had decorated by Elsie de Wolfe. After the war Anne founded the American Committee for Devastated France and donated the château to the town of Blérancourt. Today the building is the National Museum of French-American Cooperation, and several of Walter Gay's pictures are on display there.

Much to the surprise of Bessie and Anne and the Gays and many of their friends, Elsie de Wolfe married in 1926. The English diplomat Sir Charles Mendl fortunately enjoyed large and frequent parties as much as Elsie did. He co-hosted them with her at the Villa Trianon (and during World War II in Beverly Hills) practically until the day she died in 1950, at the age of eighty-five. Thanks to a strict diet of little food, daily exercise (headstands were her specialty), and the miracles of cosmetic surgery, Lady Mendl remained remarkably youthful to the end.

In the late 1930s the Villa Trianon, together with its contents, was acquired and leased back to Elsie by her friend and loyal patron, the French industrialist Commandant Paul-Louis Weiller, who had engaged her to decorate a number of his several dozen villas, châteaux, and palaces (friends called him Paul-Louis Quatorze). After her death, he preserved the house intact, down to the stationery on the desks, until he finally sold the contents in 1981, when some of the best pieces, including her pictures by Walter Gay, were acquired by the Elsie de Wolfe Foundation.

14. Edith Wharton

Edith Wharton and her husband, Teddy, came to the rue Ampère for lunch in April 1904. "Interesting, brilliant woman—why can't we meet oftener?" Matilda wondered. Since their childhood friendship in Newport and New York, they had seen each other only infrequently. The following year Matilda came for a three-day visit to the Mount, Edith's handsome country house in Lenox, Massachusetts. "It is copied from Belton, Lord Brownlow's seat in Lincolnshire," Matilda recorded in her diary. "The original house was designed by Christopher Wren. The exterior has all the chaste sobriety of that great architect's work. . . . The place is 120 acres, most charmingly *accidenté* in little knolls, on one of which is built the house. . . . The east front of the house, with the terrace staircase, most attractive, and time will make it more so. The green hall, with its Italian statues, very paintable, and very attractive. The statues, pictures, and tapestry are not of a high order, not worthy, indeed, of the decoration." She could not decide which was preferable: "a house too good for the contents, like this one; or a collection too good for the house, like our own."

Beginning in 1906, when the Whartons were increasingly in France, Edith and Matilda often had lunch or tea or dinner or just got together to chat. They went to the theater and to concerts, the former more agreeably than the latter. "Edith is absolutely unmusical but tries to understand, and nearly always likes the things that I don't care for." They studied Italian and attended readings of Dante together.

Edith loved Le Bréau and went there first for the day and then for longer visits. "August 25th, 1910: Edith and Teddy Wharton arrived for tea, to spend the night, the first time Edith had ever been more than a day visitor and I don't count day visitors, for they never see Le Bréau at its best." The next year Edith even thought of taking a house nearby. "In the morning motored with Edith to the poetic little Château du Ruisseau. She was keenly alive to its charm but had no desire to live there, and as the place is too tiny and modest, she could not lodge her household, or even herself. Intellectually, it suited her, but luxury plays too large a part in her scheme of existence for her ever to be able to lead the simple life. We are, after all, the slaves of chefs, butlers, and chauffeurs, our masters below stairs."

Of the many subjects Matilda and Edith Wharton discussed endlessly, Wharton's books do not seem to have been high on the list, perhaps because Matilda regarded them on the whole as "clever, but unpleasantly decadent." She thought *The House of Mirth* a "melancholy work" and did not share with Edith her doubts about the merits of translating it into French, which their mutual friend Charlie Du Bos, the future literary critic and biographer of Byron, was then in the process of doing. "I told him the French public would surely misunderstand both the characters and the *donnée* [background] of the book. He seemed to be prepared for this and said that he wanted to introduce Mrs. Wharton's talent to the small minority in France who could understand her. I suggested that this was probably composed of himself and two other people." She was quite wrong. The French translation was a huge success.

Matilda almost preferred Wharton's little-known poetry. "She gladdened me by giving me a little book of her poems—Browningy in form and influence, but personal in matter, and vibrating with deep emotion." Poetry in fact was one of their frequent topics. "Pleasant talk about modern writers, the English poets, etc. We disagreed with each other amiably—a proof of friendship and good breeding."

One subject that never ceased to fascinate them was the "eternal and ever-interesting comparison of Anglo-Saxon and French mentality." They both thought that the French had innate good taste and were superior in their reverence for the past, sense of continuity of traditions and "intellectual honesty." Edith Wharton got quite a lot of mileage out of these ideas: she expounded on them in 1918 in a lecture, which Matilda attended: "It was a lady-like lecture, but there was not much beyond the usual platitudes, occasionally seasoned by a little ironical bite. Edith's voice is weak, her English accent very strong." Later these observations featured in articles in *Scribner's Magazine* and *Ladies' Home Journal* and were finally incorporated into her book entitled *French Ways and Their Meaning*, which was intended to help American soldiers understand the people and customs of France. French ways were, naturally enough, of interest to many in the American expatriate community in Paris. Gertrude Stein, whom neither Edith Wharton nor the Gays ever met or cared to meet, although she lived only a few blocks from both in the rue de Fleurus, wrote about the French in her distinctive way in an essay entitled "The Difference Between the Inhabitants of France and the Inhabitants of the United States of America."

Other fertile subjects for Edith and Matilda included that perennial favorite, philistine American tourists: "They don't want to know anything

beyond the Hotel Ritz and smart foreigners." The unsatisfactory state of American women: "We had a nice talk about the idleness, lack of purpose and utter disregard of home ties and responsibilities of American women." And the perils of expatriotism: "Edith Wharton dropped in—talked of the deteriorating effect on Americans resultant from a long residence in Paris. Their intelligence seems to melt away, and they never seem to assimilate the intelligent side of French life. And yet we are both intelligent and assimilative—but the social conditions in Paris are unfavorable to our development, unless we have a definite basis, like a serious occupation, career, or pursuit."

Matilda Gay and Edith Wharton also had areas of particular rapport and confided in each other problems that were not always easily shared with others. As fellow dog lovers, they knew the grief that followed the loss of a pet. In this Matilda found Edith the most comforting and understanding of friends. To console Matilda on the death of a dog named Poilu, Edith wrote to her: "No press of business or height of temperature would have kept me from mingling my tears with yours over an anguish which so few feel to be one, but which *is*—so cruelly!—to those who love and understand the little four-foots. . . . You are right in saying that I 'understand.' At such moments may those who have the mysterious animal affinity communicate with each other, and share their sorrowful memories under the pitying eye of St. Francis. . . . Well, I feel for you with all my dog-like heart, dearest Matilda, and thank you for knowing that *I* was the friend to turn to the day that Poilu went." (By way of contrast, Elsie de Wolfe's way of dealing with a dog's death was to provide each with an identical tombstone dedicated "To the one I love the best" and promptly buy another poodle.)

In 1907 the Whartons rented for two years the luxurious apartment of George Vanderbilt in a grand Louis XIV town house at 58, rue de Varenne. They moved in 1909 to the house of Edith's brother in the place des Etats-Unis and then briefly to a suite at the Hôtel Crillon, where Matilda stopped in for tea one day: "Edith sat smoking cigarettes, surrounded by her little literary court, exchanging *mots* with them—a *mondaine bohémienne*." Matilda's forecast that Edith would miss the old-world charm and "smell of the Faubourg" proved accurate, and the following year the Whartons were back in the rue de Varenne, this time in an apartment in a building at number 53, near the rue du Bac. "Cosy talk with Edith about books, theatre, politics, current topics, and our respective and all-absorbing apartments," but Matilda thought the new apartment far from cosy. "It is large and comfortable, but ugly and without personality," lacking that favorite Gay quality, cachet, although she admitted that cachet and comfort were not easily combined.

Edith Wharton wrote, not quite accurately, in her autobiography: "My thirteen years of Paris life were spent entirely in the Rue de Varenne . . . rich years, crowded and happy years." The Gays passed many hours at 53, rue de Varenne, but Matilda began to complain about Edith's dinner parties. "Edith is a nervous, rather fussy hostess, so I am never quite calm in her house. . . . There is always that '*à qui mieux mieux*' at Edith's—a sort of intellectual fencing match," the thrust and parry of which Matilda did not find agreeable. She almost preferred coming in after dinner. "I don't in the least mind being a toothpick. One is always received with the enthusiasm that a new face brings to a dinner when the conversation has begun to flag."

Edith was much more fun at other people's parties. One evening at the Princesse de Polignac's, they sat together and "analysed all the pretty women, and the old and ugly ones as well." But best of all was to see her alone in Paris or at Le Bréau, where she was a different person, confiding and relaxed. "How I love to get Edith in *tête-à-tête*. She is completely transformed when we are not alone." One of Edith's less attractive traits when she was with an entourage of friends, as was often the case, was an oddly forced joviality. "Edith has got into the habit of turning all subjects into jest—a sort of malady of laughter."

Teddy Wharton occasionally went to Le Bréau on his own to shoot with Walter, but the Gays became increasingly concerned with his alarming, manic behavior. Matilda tried to comfort her distraught friend. "Spent the day with Edith Wharton, walking about the park, sitting over the fire, and talking of many things. She became very confidential over her tragic domestic situation. It makes one's heart ache, the hopelessness of her husband's malady, which can only be remedied by the Great Physician. And, to his misfortune and hers, his physical health is perfect." Matilda was astonished that she was able to continue writing in the midst of such distress. "In the afternoon to see Edith, in bed with a cold. The manuscript of her last novel, 'The Custom of the Country,' lay on a table by her bedside. Only extraordinary courage and energy could enable her to work under the tragic conditions of her domestic life." The climax came on December 4, 1912, when Teddy appeared suddenly at the gates of Le Bréau. "He was dressed like a roaring blade of 20; he talked incessantly about himself, his health, his clothes, and his purchases, and is as mad as a March hare. He told us that he had left Edith for good—it must be an enormous relief to her." Matilda went to see Edith two days later in Paris. "Long and painful visit to this poor distracted woman, who has to face the awful problem of saving a more than half-crazed husband from his own folly and danger. Her agony of mind and suspense were hard to witness, and one feels so helpless."

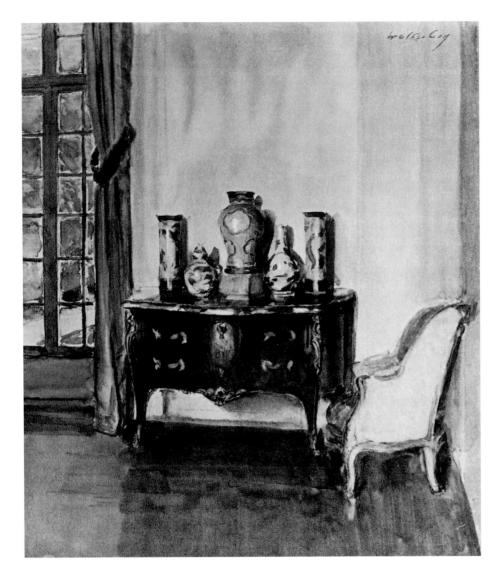

74. Walter Gay. *Interior, Bréau*. Watercolor. Photo reproduced from Edith Wharton, ed., *The Book of the Homeless*, New York, 1916

They were divorced the following year.

During World War I, much of Edith Wharton's time and energy was devoted to war-relief charities. She created both the American Hostels for Refugees and the Children of Flanders Rescue Committee, for whose benefit she published in 1916 *The Book of the Homeless*, a compilation of prose, poetry, musical scores, and illustrations. With an introduction by Theodore Roosevelt, the book included recollections by Joseph Conrad, Henry James, and Paul Bourget; poems by Paul Claudel, Jean Cocteau, Thomas Hardy, William Dean Howells, and W. B. Yeats; portraits by Léon Bakst, Jacques-Emile Blanche, Renoir, and Sargent; a landscape and seascape by Monet, and a sketch by Rodin. Walter Gay's contribution was a watercolor view of his favorite subject at Le Bréau (fig. 74). Although the book raised only a modest sum for the two charities, it was nonetheless a notable accomplishment at a time when Wharton was exhausted from relief work. As she grew thinner and paler from overwork and had first pneumonia and then a heart attack, her health became a major source of worry for Matilda. The Gays contributed to the Children of Flanders Rescue Committee and helped out with another of Edith's charities, the Franco-American General Committee, although Matilda concentrated her efforts during the war on her own two charities for Belgian orphans in Versailles.

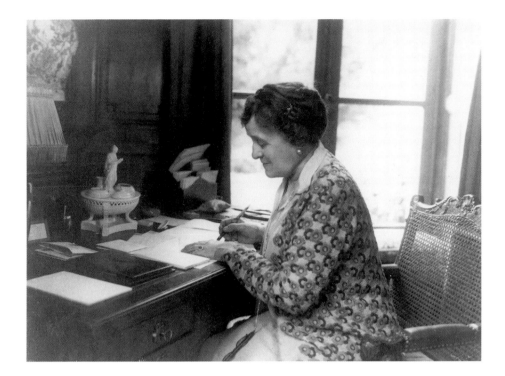

75. Edith Wharton at the Pavillon Colombe in the 1930s. Photo: Collection of American Literature, Beinecke Rare Book and Manuscript Library, Yale University

After the war, Edith Wharton wanted to escape the noise and turbulence of Paris: "a kind of continuous earthquake of motors, buses, trains, lorries, taxis, and other howling and swooping and colliding engines, with hundreds of thousands of U. S. citizens rushing about in them and tumbling out at one's door," she wrote to Berenson. In the quiet village of Saint-Brice-sous-Forêt, near the Forest of Montmorency she bought a small estate with an abandoned eighteenth-century pavilion. In her autobiography, *A Backward Glance,* she described how she came across it. "In motoring out to visit our group of refugee colonies in the north of Paris, I had sometimes passed through a little village near Écouen. In one of its streets stood a quiet house which I had never noticed but which had not escaped the quick eye of my friend Mrs. Tyler. She stopped one day and asked the concierge if by chance it were for sale. The answer was a foregone conclusion: of course it was for sale. Every house in the Northern Suburbs of Paris was to be bought at that darkest moment of the spring of 1918."

She brought the Gays to see the place in July. "After luncheon Edith motored us out to Saint-Brice, a little village beyond Saint-Denis, where she has bought a little 18th-century country house. The house stands in grounds of 7 or 8 acres, charmingly laid out, but much overgrown and neglected. The house has a *cachet* of its own with its little simple *boiseries,* its stone baskets of fruit

on the corner, and its railing on the roof. But there is a wild field for expenditure, and what with diminished incomes, and lack of labour, the *installation* will be a problem. But it will be a healthy toy for Edith, and an accessible spot where she can rest her tired brain." In fact the installation wasn't a problem at all, and when the troops of workmen (there being no lack of labor) finished a year later, Edith moved in. "No one fully knows our Edith," Henry James had written earlier, "who hasn't seen her creating a habitation for herself." It was for her the perfect house. "As soon as I was settled in it," she wrote, "peace and order came back into my life" (fig. 75).

The Gays came to visit shortly thereafter. "To St. Brice, in Seine-et-Oise, to take tea with Edith Wharton in her newly installed villa. . . . It is a lovely little pavilion of the 18th century, built for two Italian *danseuses de l'Opéra* the Colombe sisters. The little garden is very attractive, with the potager at the end. Edith has done wonders in a comparatively short time. . . . The furniture is not in keeping with the house—it is characterless and much too large, the remains of Edith's houses in New York and Lenox. The house itself is a gem—but it will never have the proper setting. . . . But it is a new toy for that restless, agitated soul—and soothes her for the moment. The approach through St. Denis, is deplorably bad—and there is an undesirable populace there. There is a beautiful stone vase in the garden, on its original pedestal, bought from a neighbouring park. It is out of place in such a small garden. Had the little place fallen into other hands, it could have been made a gem. But it makes Edith happy for the moment—and that is, after all, the main point." While Matilda was writing this, Walter was painting a view of poppies in the garden that he gave to Edith, who hung it prominently above a sofa (fig. 76).

Built in 1769, the house was called the Pavillon Colombe. Although Edith liked to describe it playfully as "a tiny bungalow," "my little châteaulet," and "my little shanty at St. Brice," it was not as small as all that, with six rooms on the ground floor, a principal bedroom and several guest bedrooms upstairs, servants' rooms on the third floor, and separate quarters on the grounds for her butler and chauffeur (fig. 77). She filled it with period and reproduction furniture in the Louis XV and XVI styles, porcelain lamps with fringed shades, books and bibelots on every table, and vases of flowers in every room. It was all immensely welcoming and attractive, if perhaps old-fashioned and a bit dowdy. Had Elsie de Wolfe been invited, which of course she never was, she would not have approved.

As Edith Wharton frankly acknowledged in her autobiography, in her own houses she mostly ignored the rigorous rules on the arrangement of rooms

OPPOSITE:

76. Walter Gay. *Poppies, Pavillon Colombe*, 1919. Oil on canvas. Private collection

130

that she and her coauthor Ogden Codman had laid down in 1902 in their influential book *The Decoration of Houses*. In total disregard of their dictum that furniture must be placed in accordance with the architecture of the room, here settees were shoved into corners, tables put in front of doors, and chairs placed haphazardly.

Walter painted several views of the long, high drawing room in the center of the house (figs. 78, 79). Aside from the salon at Le Bréau, it is the only room that he painted repeatedly and he clearly found it, and the Pavillon Colombe, a sympathetic subject, even though he shared Matilda's reservations about Edith's taste. They were not alone among her friends on this delicate matter. Edith's co-tastemaker, Ogden Codman, wrote in a letter: "The big salon at Mrs. Wharton's . . . is of a cold hard Louis Philippe gray, with *bois naturel* furniture, covered with quite the ugliest *cretonne* I ever saw, chinese but much europeanised flowers and hideous colour. Walter had painted the room a lovely soft yellowish gray, and had put in a sofa of painted wood ('la vieille peinture' as dealers would say) covered with a charming material. [The Gays] begged me not to tell Mrs. Wharton But they do not think she has much taste, no eye for colour. Alas I must quite agree to both. And she is not clever enough to get someone to help her." Although Mrs. Wharton seems to have been unaware of what her dear friends thought of her taste, she could hardly have failed to notice that Gay's pictures improved her rooms and she must have had no objection to their being sold and published. In 1928 and again in 1930, Walter included views of the Pavillon Colombe in his exhibitions at Wildenstein in New York. The picture about which Codman wrote was published in Adolf Feulner's *Historic Interiors in Color* in 1929 and again in the magazine *Studio International* in 1931, where it was called "The 'White Salon' at St. Brice."

In his view of the paneled dining room at the Pavillon Colombe, Walter carefully limited the palette to blues and yellows: the yellow wash of the wall and stone-flagged floor and a large arrangement of yellow flowers in the marble basin of the niche with an invented blue-and-yellow carpet to echo the blues on the wall moldings and curtains (fig. 80).

During the morning, Edith Wharton wrote undisturbed in her bedroom, leaving her guests to read in the library or walk along the nasturtium-bordered paths to the rose garden or by the box hedges of the parterre and through the orchard. About noon she appeared to look after her company and plan the activity for the day. After dinner, the evenings were spent in the library reading poetry or reminiscing. One of her friends described it: "Here was such a high goal of perfection in food and wine, in talk, books, old furni-

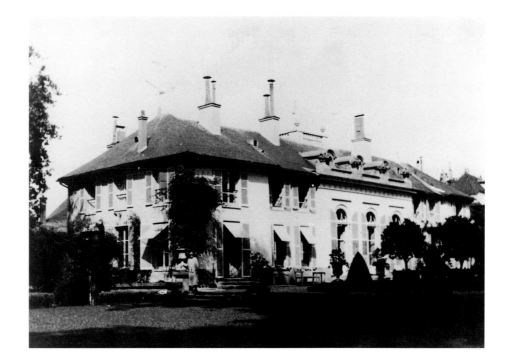

ture, pictures, and the art of living, that to savour it truly exerted one's highest mental faculties."

During the summer and autumn through the 1920s the Gays and Edith Wharton continued to exchange visits between the Pavillon Colombe and Le Bréau. Edith spent the rest of the year at a castellated villa called Sainte Claire in Hyères on the Riviera, where Walter and Matilda visited in February 1924: "At Toulon Edith's motor met us, and we drove through a lovely winding road landing at Edith's sunny terrace of Ste. Claire, and were immediately folded in her hospitable embrace. The house is built on the site of a convent of Clarisses, of which two pavilions, much renovated, remain. Above are the picturesque ruins of the medieval castle, and a wide and lovely view spreads before you. Every possible and conceivable comfort is provided for the body and Edith's brilliant conversation is rich nourishment for the mind. In the afternoon climbed up with her to the ruins, which she has leased, with the house, for her lifetime. Beautifully kept terraced gardens lead up to the top of the hill. Edith seems happier here than at St. Brice; it is indeed a lovely place." After several days of local excursions, they were very sorry to leave. "It is our day of departure, alas! from this heavenly place, which we have seen for the first time, under the best of auspices—the affectionate hospitality of an old friend who unites care for the body with nourishment for the mind. Would that she could feed her own soul!"

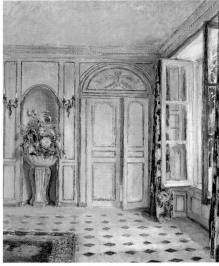

78. Walter Gay. *Salon, Pavillon
Colombe*. Oil on canvas. Private
collection

79. Walter Gay. *Salon, Pavillon
Colombe*. Oil on canvas, 21 x 18".
Private collection

80. Walter Gay. *Dining Room,
Pavillon Colombe*. Oil on canvas.
Beacon Hill Fine Art, New York

15. Henry James

81. John Singer Sargent. *Henry James*. Oil on canvas, 33½ x 26½".
By courtesy of the National Portrait Gallery, London

HENRY JAMES WAS STAYING IN PARIS WITH Edith Wharton in March of 1907 when Matilda came to visit. "My first meeting with this gifted writer who has done so much missionary work for his countrymen, and who is so misunderstood by the great American multitude. I found him exceedingly agreeable, a brilliant talker, in spite of a little hesitating self-consciousness. His appearance is that of a benign ecclesiastic; the dress of a layman hardly suits his face of an indulgent father-confessor." The next day she saw them both again at a lunch where James talked about a particularly resonant subject. "Henry James spoke of Americans living in Europe. He said that he was a born European, and that the poison of the Old World entered his soul through having been sent to school over here. The soul was of course propitious. He described how, as a little chap, his dream had always been to live in Europe—and when he could do so he carried out the project. . . . Looking at the question on the other side, however, he spoke of the existence of an American in Europe as without roots, and parasitical—a social orchid." She estimated that he must be about sixty (he was sixty-four) "but alert, bristling with interest in life and things, and that *jeunesse du coeur* that defies age and trials."

Matilda invited James and Edith Wharton to dinner the next week at the rue Ampère, where his "spirit and bonhomie" charmed everyone and where again he addressed the issues of living in France. "[He] talked about France and the fascination and influence the country, its literature, and its spirit had always had for him. As a young man he had been tempted to live here, but after

a year and a half he gave it up, as he felt the necessity that a literary man is under of living in the country of his own language, otherwise he cannot write a pure style, as the foreign element is sure to creep in." Finding that they had much in common, the Gays and James began to see each other on a regular basis. After Edith Wharton and Henry James returned from their trip through France the following month, they gave Matilda an enthusiastic account. She was thrilled to hear the author of the book that had inspired her first trip in Europe many years before, James's *Little Tour in France*, talk so well about the country she so adored.

Matilda Gay and Edith Wharton bemoaned how few people actually read his work. "We spoke of the obtuseness of our generation, who are deaf and blind to the genius of Henry James—he writes too well to be appreciated by so flippant and hurried an age. No one can read him who does not make an intellectual effort, and no one wants to make that." Just how much of an effort Matilda herself wanted to make and which of his novels she actually managed to read is unclear. In her diary, where she noted nearly every book and play she ever read, the only James titles recorded were *The Ambassadors*, *The Americans*, and *The Spoils of Poynton*.

But this did not impede her mounting enthusiasm, which was showing signs of overheating. At a dinner at the Whartons in April 1907, Matilda "had a long and interesting talk with Henry James, who amiably allowed me to cross-examine him about the source and suggestion of his books. I wonder if he doesn't think me a bore in asking so many questions?" One does wonder. She thought, quite mistakenly, that "intense admiration is never wholly displeasing even when expressed by a quantity of interrogation marks." As their friendship developed, the star-struck element dissipated. At this point Matilda concocted a somewhat strained comparison between James and her husband, which she wisely decided not to pursue. "He certainly seizes the 'soul of things' to a remarkable degree: just what Walter Gay does in painting."

James invited the Gays to his house in Rye in Sussex. "The great Teacher lives in a charming little Georgian house on the hill, which, though in the heart of the town, has a large garden adjoining it. The interior is cosy, refined and liveable—just such a nook as one would imagine Henry James to have arranged. His work room is in a little addition, approached by a flight of steps from the garden, and is most cheery, with a deep bay window at one end. There are books and more books, black-and-white on the oak studded walls and blue-and-white on the tables and mantelpieces. We sat long over a late lunch, at which we ate a great deal, and laughed and talked a great deal more. Mr.

James set us an example of sobriety and moderation in the pleasures of the table, which we admired but did not imitate. We talked about England, France, America, friends, and relations—and James, while drawing us out, always supplemented our answers to his questions by expressing our ideas infinitely better than we did. His very hesitation seems to make his sallies more precious, as it gives you time to prepare for them. . . . And yet, with all the keenness of a practised psychologist for human weakness, there is no drop of gall in his irony—it is always playful. . . . He is a most picturesque figure, the gifted writer to whom we all owe so much—and his mellow surroundings are a fitting frame. He has so much flavor that one forgets his American birth and education. They are so swamped in English influences that he does not jar in the landscape of the mother country."

James was back in France in May 1908 when he and Edith Wharton came to lunch with Walter and Matilda. "Henry James was delightful as usual— I have never met any one so *souple*—he lends himself to one's mood, whatever it happens to be." Also present was their mutual friend Eliot Gregory, who made a prescient forecast: "Gregory said that the literary friendship of Henry James and Edith Wharton would be chronicled in literary history, and form the subject of future essays, like that of Madame du Deffond and Horace Walpole, only with the ages reversed."

The Gays went to see James again in Rye the following summer. "It is always a treat to see the Master, but I like him best of all in his own frame at Rye, a most fitting environment for the great man of letters. . . . The tea-table was set under a huge old mulberry tree—and there we sat and chatted with the marvelous man, whose nature is as gentle as his intellect is strong." They were concerned to see his visibly advancing age. "How one resents those pitiless years showing themselves on anyone who has given us so much as Henry James!"

His declining health was even more apparent when they next saw him in New York in January 1911. "It was good to see an American-born European (like ourselves) and talk it all out. Mr. James looks as though he had been through a good deal—he has, poor man—a long illness, followed by the sorrow of his brother's death, straightened means and loneliness—and with all this so gentle, so kind, so charitable, a subtle being, who sees clearly all human weaknesses, without malice."

The Gays and Henry James shared their concern about Teddy Wharton, whom they discussed in London in January 1913. They told him about Teddy's disturbing visit to Le Bréau the previous month, which James in turn

described in a letter to Mary Cadwalader Jones. "The Walter Gays gave me the most extraordinary account of [Teddy's] dashing out to them in the country from Paris . . . for very calumnious, but above all childishly, or rather crazily, swaggering purposes; during which one of the first things he did was to say: 'Have you seen my gold garters?' and then to whisk up his trousers and show them in effect his stockings held up with circles of massive gold!" That same day James wrote to Edith: "I saw dear little delicate & delightful Matilda Gay yesterday (looking like a kind of *virtuous* ornament *de l'ancienne cour*) & we talked of you. . . ."

Matilda was struck by the difference between James's books and his temperament. "Henry James is so unlike his books that one can hardly realize he is their author. His books give one the impression of a being bored to extinction, sharply, and not charitably alive to human weaknesses and foibles, fastidious to a fault, and worldly beyond measure. Mr. James is gentle, kind, interested in everything and everybody, with a tremendous capacity for friendship, and with a satire, keen, but not biting. His 'Dr. Johnson' manner is the stamp of the literary Londoner, formerly acquired, now second nature. His wonderful eyes dart out piercing glances from time to time, all the more telling as the lids are dropped between times. A very remarkably interesting figure, the great psycho-novelist."

The Gays sent James a congratulatory telegram on his seventieth birthday. Matilda wrote in her diary: "It must have been a very emotional birthday for the dear man," as indeed it was. They were among 269 of his friends who subscribed to a fund (no one was allowed to contribute more than five pounds) organized by Edith Wharton to pay for two gifts: a silver-gilt Charles II porringer and dish for the author of *The Golden Bowl* and a portrait, which Sargent painted during ten sittings at his Tite Street studio in May and June and which brilliantly caught James's "Dr. Johnson manner." It pleased the sitter, who wrote that it was "Sargent at his very best and poor old H. J. not at his worst; in short a living breathing likeness and a masterpiece of painting" (fig. 81). James felt that the portrait really belonged to his admirers and willed it to the National Portrait Gallery, where the Gays saw it in the summer of 1925 and thought it so good that it made the other portraits in the room look a little sick in comparison. Sargent as an old friend of Henry James refused the honorarium and arranged that it be used to commission a bust of the author by the young sculptor Derwent Wood.

James was looking forward to another visit from the Gays in October of that year when he wrote to Edith Wharton: "I send my most affectionate love . . .

very, very particularly to the sublime Walter Gays, who are clearly winning their immortality." And again a few days later: "Posted here in London your letter was by the Walter Gays, whom I hunger and thirst for. . . . I am hoping at any minute to get into communication with [them] and to settle it that I pass a priceless hour or two with them on Monday. Heaven grant they be here for some days. . . ." They had lunch together on October 18, which James described two days later to Edith: "I had with me two days since also the dear little Walter Gays, who lunched here and were full of thrilling report and picture. They are indeed an admirable little pair."

Their next meeting was in October 1914, only a month after the beginning of the war, "at his little bachelor snuggery in Cheyne Walk, Chelsea. The Master folded us in his arms, and kissed us on both cheeks. He is full of war emotions, both for England and France. . . . [He] was lyric in his admiration of the French; he said he always knew they had *all* the qualities. The two short hours spent with the great thinker were most stimulating. He has had such a large part in our education—a benefactor to the world, and kindly and affectionate withal." He wrote them back at Le Bréau to thank them for their visit: "It's splendid of you to have come over to us—but you are always splendid!" and closed "your affectionate old Cousin, Henry James."

In 1915 James gave up his American citizenship to become a British subject. Matilda approved, but Edith Wharton thought it was a mistake, as did some of James's other friends. Sargent, Matilda reported, said that "Henry James had committed suicide on President Wilson's doorstep." But it hardly mattered as he was now in such poor health. "He suffers from angina pectoris," Matilda wrote in August, "and also largely from the solitude of his life." The Gays saw him in London twice that month, once with Mary Cadwalader Jones at the Ritz. "When Mr. James came into Mrs. Jones' sitting-room he held me in his arms and kissed me on both cheeks. I said 'Mr. James, you are the first Englishman I have ever kissed.' He replied, 'I hope that you will make up for it by kissing me very often.'" But that was not be. He suffered a stroke four months later and died the following February. Matilda wrote sadly in her diary on February 29, 1916: "Henry James's sufferings are at an end; he passed away yesterday at the age of 73, and one would not wish him back. His great soul was racked to the foundations by the tempest of the war, and sank under the strain. For four months his life has been a living death for himself, and a source of intense pain to his friends who watched sorrowfully the ruin of that wonderful intellect. His charity was equal to his brain: it is a precious memory to have known him, for we shall not look upon his like again."

16. Jacques-Emile Blanche

82. Jacques-Emile Blanche. *Self-Portrait*. Oil on canvas. Galleria degli Uffizi, Florence

HENRY JAMES HAD SAT FOR ANOTHER PORTRAIT FIVE YEARS BEFORE the Sargent, also at the instigation of Edith Wharton, this one by Jacques-Emile Blanche. But he was not pleased with the picture and asked that it be repainted. The Gays saw it soon thereafter at Blanche's house in Passy. "Blanche took us up in his studio, to show us the portrait he has just finished of Henry James—a very satisfactory, somewhat realistic likeness of the great Master, who must have been difficult to portray, with the intense subtlety of his medallion face." When the Master finally saw it again in London, he hardly recognized it, but decided that it at least had "a certain dignity of intention."

On the same visit in 1909 Matilda saw the portrait that Blanche had painted of her nineteen years earlier. She had been no easier a sitter than Henry James. "I stood looking wonderingly at it, so impossibly remote from me now. Not only physically, but mentally and morally are we strangers, myself and my old self. I like it better as a likeness than I did then, and rather regretted having loftily returned it to Blanche, who bore a bitter grudge for many years."

Although primarily a portrait painter, Blanche also did views of interiors, which annoyed Matilda. "Blanche is doing imitation Walter Gays, a series of interiors, with a certain skill, but without soul. His rooms are empty, although rather too full of furniture." Inevitably, this opinion did not endear Blanche to the Gays and given the mutual distaste of both parties, it is rather surprising that the Gays saw as much of him as they did. "Blanche is secretly unfriendly to us, but thinks it well to be outwardly warm." At times Matilda could hardly stand him. "[He] is very clever, and anecdotal, but when I shake hands with him, it feels like shaking the fin of a fish; there is something so cold and slimy about him—and quite as slippery as though he lived in the water." Blanche had a malicious tongue and "a saurian element" that made her uncomfortable. "I know that the sting is sure to come after I leave." Madame Blanche was "a good bourgeois soul, well under the domination of her brilliant and imperiously egotistic husband, who, all the same, is an excellent spouse," Matilda wrote. "So the man whom all his friends (!) and acquaintances call a snake, has his good domestic side" (fig. 82). Edith Wharton, on the other hand, genuinely liked

Blanche and got him to contribute three of his portraits (Hardy, George Moore, and Stravinsky) to her *Book of the Homeless*.

However unattractive Jacques Blanche was to the Gays, he and his wife were considered good hosts and their house in Passy "a centre where everyone goes willingly, for they know how to have you." The house reflected Blanche's anglophile tastes. "[It] is built on the right of a large garden . . . and the interior decoration is entirely English—from within, one would fancy one's self in Chelsea," Matilda wrote. "The Salon is very large, and all the other rooms are a good size—a small house, with large rooms—the ideal habitation, to my mind." He had an unusual mixture of old masters and modern pictures: "among rather mediocre things were a fine and interesting Constable, a beautiful Degas—in the dining-room, two amusing little Longhis." The Gays were always particularly interested to see pictures collected by other artists. They were also particularly interested when those pictures were inferior. "Blanche has bought lately two English portraits at the Hôtel Drouot, for a mere song. He labels them with fine names, but they are not of a high order."

The Blanches visited Le Bréau only once, in 1911. "As usual, with strangers, they were breathless over the general air and beauty of Le Bréau," Matilda reported. "'It is dignified!' said Blanche, in his French-English, meaning imposing."

Blanche gave many of his portraits to the museum in Rouen, where the Gays saw them in 1933: "After lunch to the Musée de Peinture, where we looked at the collection of portraits of celebrated literary men and artists by Jacques-Emile Blanche, given by him to the Musée. They are very clever, very skillful, and have a personality of their own. As W. G. said, Blanche had painted all his friends and enemies." If pushed to say in which camp the Gays saw themselves, they would have had little trouble in choosing.

In addition to painting, Blanche was a prolific author. In *Les Arts plastiques*, he compared Walter Gay's interiors with those of Maurice Lobre (as had Sargent). He wrote three volumes of essays, *Propos de peintre*, on painters from Jacques-Louis David to his contemporaries, with a preface by Marcel Proust, who described Blanche as one whose sole ambition when young was to be "a much sought-after man of the world," an ambition that he never quite relinquished, as revealed in his two volumes of unreliable memoirs, *Portraits of a Lifetime* and *More Portraits of a Lifetime*, about his life in society. Published after Walter's death, they contain no mention of the Gays, which probably mattered not at all to Matilda.

17. Egerton Winthrop

THE COSMOPOLITAN LAWYER EGERTON WINTHROP CAME TO THE opening of Walter's exhibition at the Galerie Georges Petit in 1908 with his friend Edith Wharton. An American who lived in both New York and Paris, he was also Wharton's mentor and frequent traveling companion. She described him affectionately in her autobiography as "the lover of books and pictures, the accomplished linguist and eager reader, whose ever-youthful curiosities first taught my mind to analyze and my eyes to see." A bit unfairly, she put him into *The Age of Innocence* as the snobbish and gossipy Sillerton Jackson.

Sargent painted Winthrop standing stiffly in evening dress, holding his top hat (fig. 83). This diner-out and ball-giver, who was at home on both sides of the Atlantic, had a curious mix of worldly sophistication and shyness. Prone to unpredictable self-consciousness upon meeting strangers at parties, he would sometimes stumble across a footstool or crash into a nearby table.

Matilda described him as "the very agreeable Egerton Winthrop, full of interest in all matters artistic." He owed his artistic education, she thought, to his long residence in Paris and was that rarest of men, a true connoisseur. He also maintained a house in New York at the corner of Thirty-third Street and Madison Avenue, where he gave a dinner in the Gays' honor in the winter of 1911. "Winthrop's ancestors, the Governor [of Massachusetts] and Peter Stuyvesant looked down at us from the wall, and gave a dignified refinement to the place. Mr. Winthrop was in very good form and is a delightful host," Matilda wrote.

83. John Singer Sargent. *Egerton Winthrop*. Oil on canvas. Private collection

A month later Walter completed an interior of his drawing room filled with Louis XVI furniture, sculpture, and porcelain (fig. 84). Edith Wharton thought this room was "the first in New York in which an educated taste had replaced stuffy upholstery and rubbishy 'ornaments' with objects of real beauty in a simply designed setting." She was right in the sense that it was one of the earliest examples in New York of a Louis XVI revival room, and there was no question that the French furniture, mounted vases, and Sèvres, Chelsea, and Chinese porcelain were objects of real beauty, but only Edith Wharton (and possibly Ogden Codman) could see this as a simply designed setting. George William Sheldon included it in his book *Artistic Houses: The Most Beautiful and Celebrated Homes in the United States*: "Few apartments in this city have been treated with such persistent determination to reproduce in all respects the forms, color, and feeling of a particular era." Which era did not greatly matter to Egerton's architect, Richard Morris Hunt, who did not think it at all odd to insert a Louis XVI–style drawing room into a Second Empire–style house.

Gay painted the room illuminated by sunshine on a bright February morning, when it looked very different than on party evenings, the glamour of which dazzled Sheldon: "When, at night, beneath the dancing shimmer of the crystal chandeliers and sconces, the room receives the added brightness of the handsome toilets of fair women, the full splendor of the *tout ensemble* may more easily be admired than described."

Walter and Matilda continued to see Egerton Winthrop in Paris. After a lunch at Edith Wharton's in 1912, Matilda wrote, "Mr. Winthrop was delightful as usual—an easy, cultivated *homme du monde* who, in spite of his seventy years, does not grow musty." He did, however, occasionally get into a muddle, as happened on his one visit to Le Bréau, when he lost his way and did not arrive until after lunch. "This contretemps, happening to such a particular and orderly person as Winthrop, put him out even more than ourselves. So his long planned visit to Le Bréau was somewhat marred. We had a cheery talk all the same with this agreeable and distingué person. His sense of humor is keen, altho' his intellect is not of a high order." About his intellect, Matilda was quite mistaken. But she was not mistaken in seeing him as a survivor from an earlier, better time, as she wrote after his death in 1916: "He was a figure of the type of distinction that has almost passed away in this age of rough accents and rougher manners. We shall miss him as an aristocratic background over there. He had old world breeding which did not evaporate in an atmosphere of slapdash."

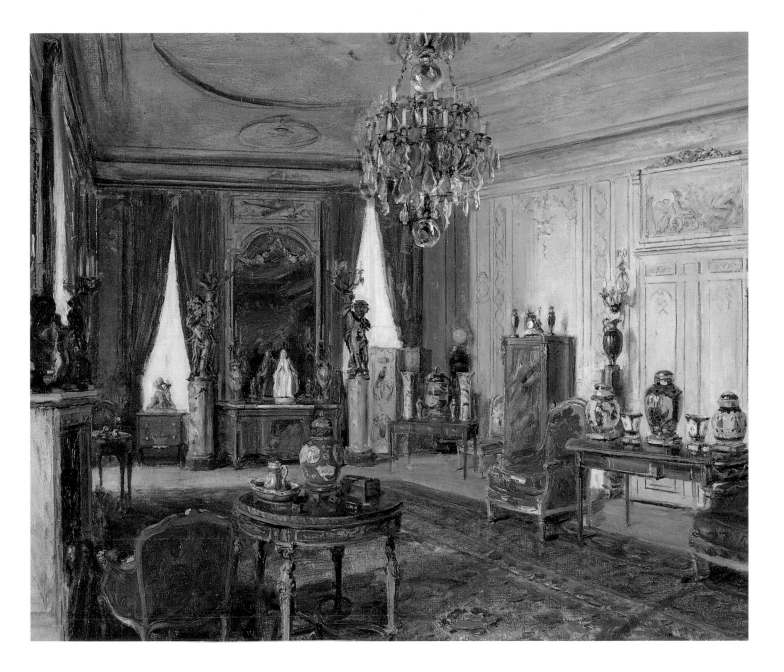

18. Henry Adams

MANY OF THE GAYS' FRIENDS DESCRIBED WALTER'S PERSONALITY AS "gentle," but only one had the insight to apply that adjective to his art. Henry Adams wrote to Elizabeth Cameron in August of 1899: "These artists love to wallow in their ailments, and to hug their devils, blue, black, or parti-colored. The only well-balanced one is Walter Gay, and he is so gentle an artist!" The comparison was specifically to the deeply neurasthenic sculptor Augustus Saint-Gaudens, whom Adams had just seen, but it applied equally well to a number of other prominent artists whom Walter knew. Adams had just visited the Gays at Fortoiseau. "I passed Sunday at the Walter Gays. . . . They were very kind and nice, and the place looked very pretty though burned and dry and even hot this morning."

It had not been an entirely successful visit because of tension over the Dreyfus case. "The Gays had very little to say, and were deeply absorbed in the Dreyfus business, which I have not the patience to read or discuss." The case of Alfred Dreyfus, charged with treason, had polarized opinion in France and was an awkward issue for Walter and Matilda, who believed he was innocent and saw themselves as Dreyfusards living in a strongly anti-Dreyfusard community. "We never dared to open our lips, but hugged our opinions in private," Matilda wrote. When the case was finally settled in 1906 and Dreyfus acquitted, they were enormously relieved.

From time to time Henry Adams sought Walter's advice on paintings. He was considering a picture by Claude Lorrain when he wrote to Elizabeth Cameron, "Walter Gay, whom I asked to examine it, could find nothing the matter except that it was cheap." So he proceeded to buy it. "My meals grew so solitary that I needed a companion, and the Claude is a regular Sévigné or St. Simon." It is now in the Allen Memorial Art Museum at Oberlin College, where it is catalogued as a painting by a follower of Claude.

Adams particularly liked Le Bréau and became a frequent guest. "Henry Adams came down from Paris in his auto—delightful to have him all to ourselves," Matilda wrote in 1905. "He talked of American and social conditions very pessimistically. He said that our country had grown too large, as a problem of energy, to be controlled." On this visit he presented them with

85. Mabel Hooper La Farge. *Henry Adams*, 1917. Watercolor. The Houghton Library, Harvard University, Cambridge

a copy of his book *Mont-Saint-Michel and Chartres* which became their Baedeker on their frequent trips to Chartres. They admired his poetical strain but felt that the book would have benefited from less of his "sudden Adams crankiness." June 1906: "Sauntered with Mr. Adams in the park. At lunch he was full of his usual brilliant paradoxes." June 1907: "Mr. Adams remained to dine and sleep—and we spent a delightful evening with this quaint philosopher and perfect gentleman—one of the elect of the earth." He was shy about speaking French "yet he loves France and knows more about the country than the natives do."

Fluency in French among their non-French friends was a subject of abiding interest for the Gays. Walter himself never quite mastered it, in reference to which a friend of theirs said to Matilda, "Never mind, he *paints* French." Matilda was much better at it, but not quite good enough to keep up at dinner parties when the conversation turned to politics. She was sometimes self-conscious about her accent. One afternoon at Le Bréau she was reading

poetry aloud to her neighbor Edouard de Trévise, "and his perfect good breeding kept him from giggling over my funny French accent." After many years in France, her English, on the other hand, developed an odd foreign accent.

One of Adams's visits to Bréau, a September weekend in 1909, is recorded in two accounts (his and Matilda's), which reveal just how different their perceptions could be. Matilda's version: "Sept. 18th. Mr. Adams arrived in time for dinner, delightful and rare. At dinner [Eliot] Gregory said that if all the happy marriages in the world were suddenly dissolved by divorce, that everyone would quickly marry again, and *not* espouse their former partners. 'I am not sure of that,' replied Mr. Adams, 'I know too well the imbecility of human nature!' Pleasant evening with all these agreeable men [Adams, Gregory, and James Hyde]. Sept. 19th. The Ralph Curtises, Mrs. Cooper Hewitt, and Bernard Berenson motored down from Paris to breakfast. . . . It was a successful gathering of clever people, differing in ideas, but all possessed of the faculty of making themselves agreeable, or of making an effort to do so: *faisant des frais*—to me always the test of good breeding."

Henry Adams's version: "My visit to Le Bréau was a great success for weather. I had two exquisite September days, and the shadows were all in softest violet. The figures failed to make perfect harmony with the atmosphere. I found James Hazen Hyde and Eliot Gregory to receive me. I ought to add that they were self-invited, and I doubt that they would have chosen me to entertain them, but they would certainly have preferred me to the Ralph Curtises who came down to lunch the next day, with Mrs Cooper Hewitt and Berenson. . . . As Eliot Gregory and Ralph Curtis do not speak, they have to be kept apart, and it was lucky that Mrs. Wharton went there on Saturday instead of Sunday, not to make a three-cornered cat-fight."

On one occasion in 1914, Adams's arrival in the country came as quite a surprise. "To my amazement, Mr. Adams, Miss Adams, and [his friend] Miss Tone arrived about one o'clock for luncheon, finding me under the lindens, in floating hair and a white bed-gown, utterly unprepared for them either with food, or in my toilette. They had sent me a warning telegram in the morning, which never arrived. . . . We sat in the kiosk and laughed over the incident, Mr. Adams very modestly turning away his glance from my very negligent attire."

For the Gays his visits were never long enough, his departures always came too soon. "Mr. Adams returned to Paris with the ladies, always much regretted at Le Bréau. We have no guest as interesting as this wonderful man, whose modesty is as great as his talents." He also enjoyed little afternoon gossips with Matilda in Paris, both in his apartment in the avenue du Bois (today

the avenue Foch), which she described as "the nest of a gentleman and scholar, with its porcelains, its carefully selected furniture and books," and in hers. "Mr. Adams dropped in, and we talked over cosily all kinds of things, including the temperaments of mutual friends. Mr. Adams declared that neither Sargent nor Henry James had any."

In 1914 Adams asked the Gays to help him find a house to rent for the summer. They selected the Château de Coubertin, near Saint-Rémy-lès-Chevreuse. "The house is very *sympathique*—a gentleman's home, and therefore a fitting frame for the aristocratic (in the best sense) Mr. Adams. . . . The little chapel, separate from the house, has been converted into a library, where [he] mouses among the fine collection of classics."

Matilda and Edith Wharton puzzled over Henry Adams's preference for the company of dim women, accurately seeing themselves as the exceptions. "In speaking of Mr. Adams and his high order of intellect, we talked over the curious fact that men of that sort so often do not care for their intellectual equals, like people who prefer their social inferiors, but that he seemed to like the society of rather flippant women, or at least of women who didn't understand what he was talking about. When he does meet a serious-thinking woman he is rather bored with her." Matilda visited him twice in Washington in "his cosy nest on La Fayette Square," where she enjoyed seeing him surrounded by his books and drawings, including, rather to her surprise, a facsimile of a drawing by Watteau in the Gays' collection. "Mr. Adams's house is like himself—tasteful, comfortable, with an element of subtle daintiness. His watercolor collection is very choice. There are fine porcelains everywhere—a good little Turner, in the Claude manner, a Sir Joshua portrait of himself. Mr. Adams is as enchanting as ever—he is even charming when he's cross, which is certainly a severe test of personal attraction."

Adams died in 1918, and two years later, when the Gays were next in Washington, they went to see his grave in Rock Creek Cemetery. "Or rather the monument erected over that of his wife so many years ago, and under which he lies. It is the figure of a woman in bronze, her head covered by a veil, sitting on a stone seat. Many meanings have been read into the symbolism of this figure. I could see none in particular. It is a beautiful work of art. One thing is certain—there is neither faith nor hope expressed—perhaps a dreary doubt? There is neither inscription nor slab to mark Henry Adams's last resting place."

19. Alfred Sommier

HENRY ADAMS WAS ON A TOUR OF LOCAL CHÂTEAUX IN 1908 WHEN HE "ran over to Vaux and breakfasted. We found Walter Gay there, sketching, but no one else except M. Sommier, the owner; so we had it all to ourselves; and he drove us round the grounds afterwards, and turned on the water, as though we were Mme. de Sévigné. It was the coronation of my campaign of tourism—the last triumph. . . . M. Sommier carefully explained to us that it was not a large house; that the front measured only 70 meters [233 feet]; and that he had only twelve *chambres-de-maître* [master bedrooms] to spare. Of course the grounds are extensive, and the canals like Versailles. As I supposed, in mere size the house is hardly a first-class one by English standards; but in architecture it is easily first, and in decoration it has no rival that I know. So much of the old work survives that Sommier has been able to keep his restoration very well within bounds."

Vaux-le-Vicomte (fig. 86) is generally regarded as the most splendid private château in France, but it was far from splendid when the industrialist Alfred Sommier bought it in 1875. Grandson of a baker from the Yonne, he

86. Vaux-le-Vicomte. Photo reproduced from Patrice de Vogüé, *Vaux le Vicomte*, Paris, n.d.

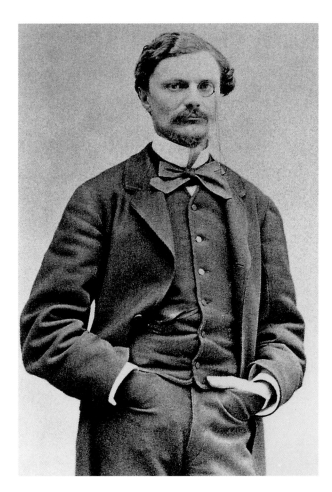

87. Alfred Sommier. Photo reproduced from *Vaux-le-Vicomte*

made a vast fortune in sugar refining and spent not a small part of it on the restoration of the house and gardens (fig. 87).

However ironic the pose of Sommier in regard to the size of Vaux, in fact by château standards, it is not enormous. But it seemed far too splendid to Louis XIV on the night of August 17, 1661, when he attended the housewarming party of the man who had just built it, his finance minister Nicolas Fouquet: six thousand guests, a new comedy-ballet composed for the occasion by Molière, party favors such as diamond tiaras and saddle horses, and a magnificent fireworks display. Three weeks later the king had Fouquet put into prison for *luxe insolent et audacieux* and removed the pictures, tapestries, furniture, silver, marble statues, and more than a thousand orange trees from the garden to the royal palaces. He also removed Fouquet's architect, Louis Le Vau, the decorator Charles Le Brun, and the garden-designer André Le Nôtre to work at Versailles.

During the Fortoiseau years, Walter Gay and Alfred Sommier became shooting chums. Beginning in 1902 Walter shot at Vaux nearly every year and continued to do so after the house passed to Sommier's son in 1908. Soon the Sommiers were the Gays' favorite neighbors and invited them often for dinners which ranged from small "en famille" evenings to larger parties that included many mutual friends. The bright and amusing and only occasionally grumpy Alfred Sommier was a wonderful host with an endlessly fascinating range of topics: politics, history, love ("all a question of imagination," Matilda reported, *"a mirage du cerveau"* [mental mirage]). "I wish I spoke French better, in order to enter the lists with the brilliant, though paradoxical master of Vaux." After dinner they retired to the library or one of the salons where the men assembled on one side of the fireplace, the women, much to Matilda's annoyance, on the other, "à la française."

The Gays sometimes brought guests over as well. Bernard Berenson, spending a weekend at Le Bréau in October of 1908, was fascinated by his visit to Vaux. "W. G. took Berenson to Vaux, who dined alone with us and talked

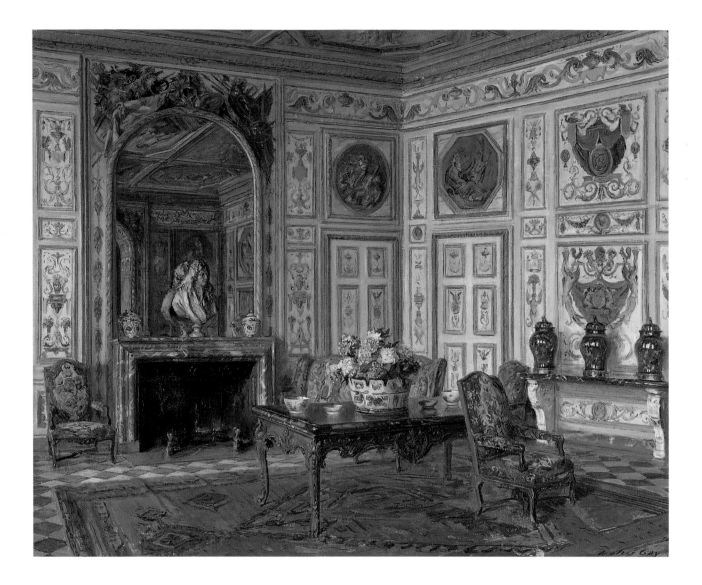

88. Walter Gay. *Summer Salon (now the Dining Room), Vaux-le-Vicomte*. Oil on canvas. Private collection

most delightfully of that wondrous place. He said that Vaux was a 'translation,' not an adaptation, of Italian late renaissance. Adaptations always look out of place and exotic, whereas a translation is imbued with the spirit of the country."

Walter painted two of the principal rooms at Vaux. The picture he was working on when Henry Adams came in 1908 was a view of the room that was then used as a summer salon (fig. 88). "W. G. began an interior at Vaux-le-Vicomte, and spent the day there. He came back happy and tired, having met at breakfast the Prince and Princesse Borghese, delightful in manners and ruined in fortune." Lavishly decorated by Le Brun with arabesques in the style of Raphael's loggias at the Vatican, it is today shown as a dining room. Several days later: "W. G. brought back his finished interior from Vaux, one of his most

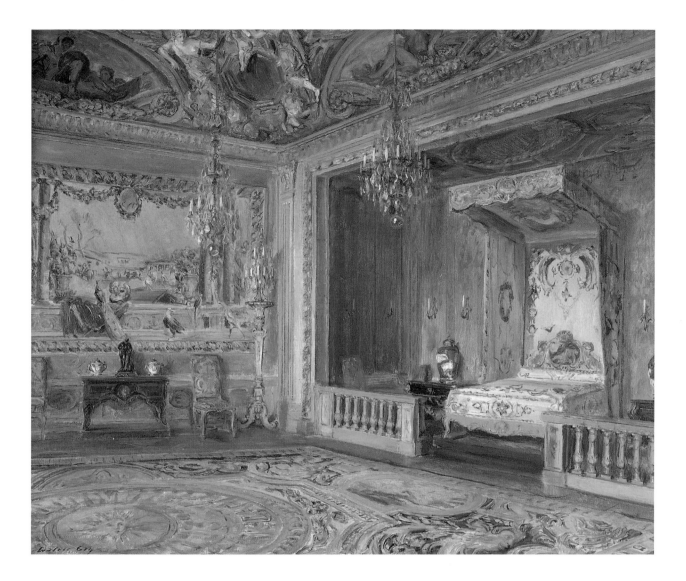

89. Walter Gay. *The King's Bedroom, Vaux-le-Vicomte*. Oil on canvas. Private collection

successful works. He has enjoyed immensely painting there, in the society of M. Sommier; but he is fagged out and his head troubles him—nervous fatigue after the strain of the picture." That same night they were back at Vaux and after dinner retired to the room where Walter had just finished painting. "We admired again the beautiful frescoes. Madame Sommier and her son admitted that from living at Vaux all these years, they had become blunted to its beauty—they did not notice it—*à force de la regarder*," Matilda wrote. Sommier bought the picture for 4,000 francs [$800] and sent Walter a thoughtful note thanking him for the pleasure he had received from "this picture which is without contradiction one of the best from your brush."

The king's bedroom, the grandest state bedroom in France outside of

Versailles, has a combination of stucco sculpture, gilding, and painting that represented a new style of Baroque decoration in 1661 (fig. 89). Sommier furnished it with a Régence bed hung with tapestry flanked by commodes by André-Charles Boulle and a Savonnerie carpet from a series woven for the Grande Galerie of the Louvre. On the far wall hung the Gobelins tapestry of Versailles from a set designed by Charles Le Brun depicting the royal residences. No French king ever slept at Vaux.

Walter's interiors were painted by daylight, but the house was much more atmospheric at night when it was lit (as was Le Bréau) entirely by oil lamps and candles. "Vaux is perhaps more superb at night than in the daytime, for there is more of the atmosphere of the past in the dimly lighted rooms," Matilda wrote. Sommier refused to install electric light, for fear the old beams and rafters would catch fire.

Matilda never tired of visiting Vaux. "Every time I go [there] I have a fresh surprise at the beauty of the place; as often as I have been there it always gives me a renewed enjoyment." It was hard to decide which was more beautiful, the house or the extraordinary gardens. After tea on an August day in 1907, the Gays sat on the stoop and "enjoyed the magnificent gardens, now in all the glory of their bloom. Monsieur Sommier said that when he bought Vaux 30 years ago, the gardens were in ruins. He restored them after the engravings of Israel Silvestre, the engraver of Louis XIV."

He made it sound simpler than it actually was, for the gardens had in fact nearly disappeared. When Sommier acquired the house, it was surrounded by wheatfields with herds of cattle drinking from water holes that had once been ornamental ponds. He reconstructed the terraces, rebuilt the ponds, installed twelve miles of pipes for the fountains, and replanted the hedges, box trees, and yews in what was the largest private garden restoration ever undertaken in France.

A few days later the Sommiers took the Gays in a carriage to the end of the gardens, about a mile from the house, "as far as the gilded 'Hercules'; from there we walked to the Château d'Eau, the *grandes eaux* playing in full force, a magnificent sight—'la Fête de Vaux,'" Matilda described. They looked back across the terraces and *allées* of Le Nôtre's masterpiece and marveled at the great moated château bathed in the mellow September light.

Matilda felt a particular rapport with Alfred Sommier, whom she liked to tease when his wife was not around. She recorded their conversation one evening at a dinner at Edith Wharton's in 1908: "I said to him 'I am replacing Madame Sommier this evening.' He replied, like a flash 'Until what hour,

Madame?' 'Until whatever hour you would like, Monsieur,' and then we both laughed merrily over our naughtiness."

When Alfred Sommier died suddenly at the age of seventy-four in December 1908, Walter and Matilda were deeply saddened. "It is impossible to realize that that brilliant intelligence, the creator of Vaux, with his many-sided mind and his youthfulness of spirit, has gone so swiftly out into the silence. . . . With the death of Monsieur Sommier there passes away one of the most remarkable men of France—and the soul of his beloved Vaux has taken flight with his own."

Madame Sommier admitted to Matilda that she had never had any deep attachment to Vaux and had always longed for a simple life. "It is indeed the triumph of character over environment that Madame Sommier should be perfectly insensible to the beauty of Vaux, but then she is fundamentally inartistic. She cares only for the beauties of the soul—and are they not higher, and rarer?" She moved shortly thereafter to a small house near Bréau, the "hideous but comfortable" Villa Croix St. Jacques, and turned Vaux over to her son and daughter-in-law, Edmé and Germaine Sommier.

They proceeded to make some basic improvements, including, in 1912, electric light. "Far from injuring the style of the chateau, the fixtures are so admirably arranged that the beauty of the wall-paintings and the ceilings are now seen for the first time, while at the same time, the light is discreetly shaded," Matilda reported.

The Gays were absolutely aghast when they were told about another important change. "[Germaine] Sommier described all the modernising in the way of plumbing which her husband had just finished at Vaux, and told me . . . that until this very necessary improvement, all the drainage had flowed into the moat! Think of an open cess-pool around one's house! She said this was almost the rule in France, and cited several châteaux in the neighborhood. The French are still indifferent to the dangers of such a system, and it doesn't seem to hurt them. But *because* we are afraid of it, it would poison *us*!" Very shortly thereafter the Gays commenced extensive plumbing alterations at Le Bréau.

The young Sommiers were friendly and hospitable and the Gays continued to dine there, but it was never quite the same without Alfred Sommier. "The place is haunted by the personality of the extraordinary man who resuscitated the artistic chef-d'oeuvre of Louis XIV's epoch, and I saw poor Monsieur Sommier everywhere," Matilda wrote. "As I sat there, I almost fancied that he might come in at any moment; he was so identified with his beloved Vaux. His personality filled it—and it is so empty now!"

20. Comte de Vogüé

SOMMIER'S DAUGHTER, COMTESSE ARTHUR DE VOGÜÉ, WAS SO PLEASED with Walter's pictures of Vaux that she asked him to come and paint at Commarin, her château in Burgundy. The Gays stayed there for four days on a trip through Burgundy in October 1910 and were enchanted with the house. "Arrived at the Château of Commarin, where we were warmly received by the delightful châtelains. . . . This lovely place, parts of which date from the year 1000, has the rare distinction, in France, of never having left the family. The present château was built in the 17th century, but the feudal towers are incorporated into the main building. A moat, that most becoming architectural feature, surrounds the house," Matilda wrote. "The beautiful park is full of fine old trees. The house is filled with fine old furniture, tapestries, boiseries, and family portraits. All these things have grown here—and this very fact gives an additional value to the objects." The attics were stuffed with furniture and tapestries for which there was no room in the house. "It is a real museum of antiquities, besides being a family seat, whose owners are passionately fond of it. All this lends it a special character."

They found that they liked the owners as well as the house. "Comte A. de Vogüé is very intelligent, very artistic and *bibelotteur*, very *mondain*, with an atmosphere of smart club man united to the seigneur of an ancestral domain— a charming combination. Madame de Vogüé is sweetness and refinement itself."

Walter completed a watercolor interior of "the beautiful little Louis XV salon at the end of the house, with boiseries in oak of a lovely warm brown colour." He later painted another version of this picture in oil for his exhibition at Wildenstein in 1913 (fig. 90). With a red lacquer commode loaded with blue-and-white porcelain, more porcelain on the chimney and console table, and a cartel clock on the mirror above, it was a room that in many ways recalled Le Bréau.

Arthur de Vogüé was a bit deaf, and one of the other guests, his elderly cousin, the Marquis de Vogüé, even more so. "We all bawl at the top of our voices," reported Matilda, who was never at her best with the deaf. This, on top of the endless conversation, sent her to bed one night half dead with fatigue,

90. Walter Gay. *The Boudoir,
Château de Commarin*. Oil on
canvas, 21½ x 18⅛". Private
collection

complaining that "the French have iron pipes in their throats—their vocal chords are never weary." Walter had heard before this particular grievance about the indefatigably chatty French from his wife, who could talk for hours without drawing breath, and he would hear it again, often.

In the end the Gays felt that their stay at Commarin had been "one of the delightful experiences of our lives. Apart from the historic interest of the family seat, with its architecture, furniture, archives, and souvenirs, the rare distinction of our hosts, the charm, good looks, and intelligence of Madame de Vogüé, the perfect harmony between herself and her husband, *their* harmony with their surroundings, the artistic appreciation, wit, and easy manners of M. de Vogüé, make a combination refreshing to the soul." They left Commarin with sincere regret, as Matilda noted. "All our pretty parting speeches were true."

Madame de Vogüé hung Walter's picture prominently in the salon of their Paris house in the rue de Martignac, a house that Matilda thought looked like a wing of Commarin. In 1914 it moved to the Vogüé's new house on the quai d'Orsay that looked nothing like Commarin.

This was a house that the Gays rather unfairly criticized, primarily because it had not been decorated by Alfred Sommier, who had by then been dead for six years. "They are proud of it, and everyone compliments them, but her father, M. Sommier, would never have decorated a house like that. The only good things there are two fine tapestries inherited from her father. Madame de Vogüé has inherited her father's wit and her mother's taste. She is a very attractive and interesting young woman, however, and M. de Vogüé a very charming man." Charm notwithstanding, they had committed an act in the building of the house that the Gays muttered about for years thereafter. In the garden was the "famous plane tree of Beaumarchais, said to have been planted by him to amuse the young daughters of Louis XV. . . . The archaeological society of the 7th arrondissement has visited and catalogued the tree in their notice on the antiquities of Paris, and begged [them] not to cut it down, which was promised. But the branches of the tree are growing into the windows of Madame de Vogüé's rooms and keep the sun entirely out, making the place quite unlivable. So, true to the letter of their promise, they do not *cut down* the tree, but they are poisoning it with injections of mercury, and its death will be attributed to the cutting into the roots by the foundations of the house! What Machiavellianism! When it is a question of the comfort of the moderns, the antiquities are doomed," lamented Matilda, who didn't even want to think what Alfred Sommier would have made of it.

21. Comtesse Robert de Fitz-James

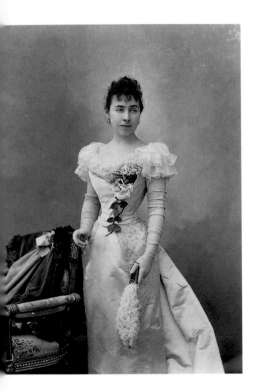

91. Comtesse Robert de Fitz-James. Photo by Paul Nadar, Caisse nationale des monuments historiques et des sites © Arch. Phot. Paris

THE GAYS WERE PLEASED TO FIND AN OLD FRIEND STAYING AT Commarin during their visit. "The kindly and genial Mme de Fitz-James, with her absolute frankness and sincerity, has added an agreeable note to Commarin," Matilda recorded. Comtesse Robert de Fitz-James, known as Rosa among her friends, was a prominent Parisian hostess (fig. 91).

The comtesse was a close friend of Edith Wharton, who wrote an affectionate account of her in *A Backward Glance*: "[She] was a small thin woman . . . with a slight limp, which obliged her to lean on a stick, hair prematurely white, sharp features, eager dark eyes and a disarmingly guileless smile. . . . She spoke English almost perfectly and was always eager to welcome any foreigners likely to fit into the carefully adjusted design of her *salon,* which, at that time, was the meeting-place of some of the most distinguished people in Paris." Bernard Berenson called her "the best hostess I have ever known."

Matilda explained the simple secret of her warm hospitality: "She is not only glad to see you, but she knows how to express it." The Gays liked the refreshing absence of French formality (she was Austrian) in her apartment in the rue de Grenelle. But they regretted that this kindhearted friend was not more appreciated. "Madame de Fitz-James is pretty generally neglected by her guests," Matilda wrote. "Smart Society likes to go to her house and overlook the hostess, which is very ill-bred, as smart society is so often. . . . Her guests do not take enough trouble about her. They go there to see each other. She knows this, speaks of it with a startling frankness, and—invites them again." She was uncomfortable in other people's houses and rarely lunched or dined out.

Matilda and Edith both thought that there was something compulsive about Rosa's entertaining, as though she were trying to alleviate an underlying loneliness. "As with most of the famous hostesses I have known," Edith wrote, "her hospitality seemed to be a blind overpowering instinct, hardly ever to be curbed, and then only with evident distress." On one rare occasion when Rosa and Matilda were alone, she broke into tears and spoke about her sense of insecurity. Matilda consoled her and asked her to play some Bach and Schumann on the piano. "She has a lovely touch, and her nervous suffering oozed out of her fingers while playing."

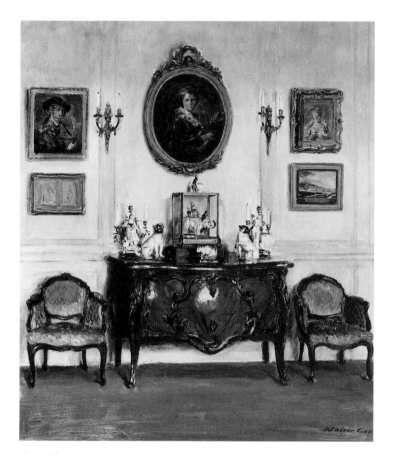

92. Walter Gay. *Salon of Comtesse Robert de Fitz-James*. Oil on canvas. Casa Amesti, Monterey, California

In 1913 she moved to a larger apartment in a modern building in the rue de Constantine, which Edith Wharton found too impersonal: "The three drawing-rooms, which opened into one another, were as commonplace as rooms can be in which every piece of furniture, every picture and every ornament is in itself a beautiful thing, yet the whole reveals no trace of the owner's personality. In the first drawing room, a small room hung with red damask, Madame de Fitz-James, seated by the fire, her lame leg supported on a foot-rest, received her intimates." Walter signed his view of this room with an inscription that reveals his fondness for their generous and troubled friend (fig. 93).

He also painted a view that delighted her of her large drawing room where guests assembled before dinner, which showed some of her mounted eighteenth-century porcelain and old-master pictures on the pale walls (fig. 92).

Matilda found her rooms arranged with "a comfort that is not French" and thought that her pictures and eighteenth-century furniture showed to better advantage here, although she, like Edith, missed the atmosphere of the previous apartment that had the appeal of an old house. When Rosa's friends congratulated her on finding a much sunnier apartment, she answered, "Oh, no; I hate the sun; it's such a bore always having to keep the blinds down."

"I linger with a kind of piety over the picture of that pleasant gray-panelled room, with its pictures and soft lights, and arm-chairs of faded tapestry," Edith wrote. "I see . . . in and out among her guests Madame de Fitz-James weaving her quiet way, leaning on her stick, watching, prodding, interfering, re-shaping the groups . . . yet somehow never in the way, because, in spite of her incomprehension of the talk, she always manages to bring the right people together and diffuses about her such an atmosphere of kindly hospitality that her very blunders add to the general ease and good humour."

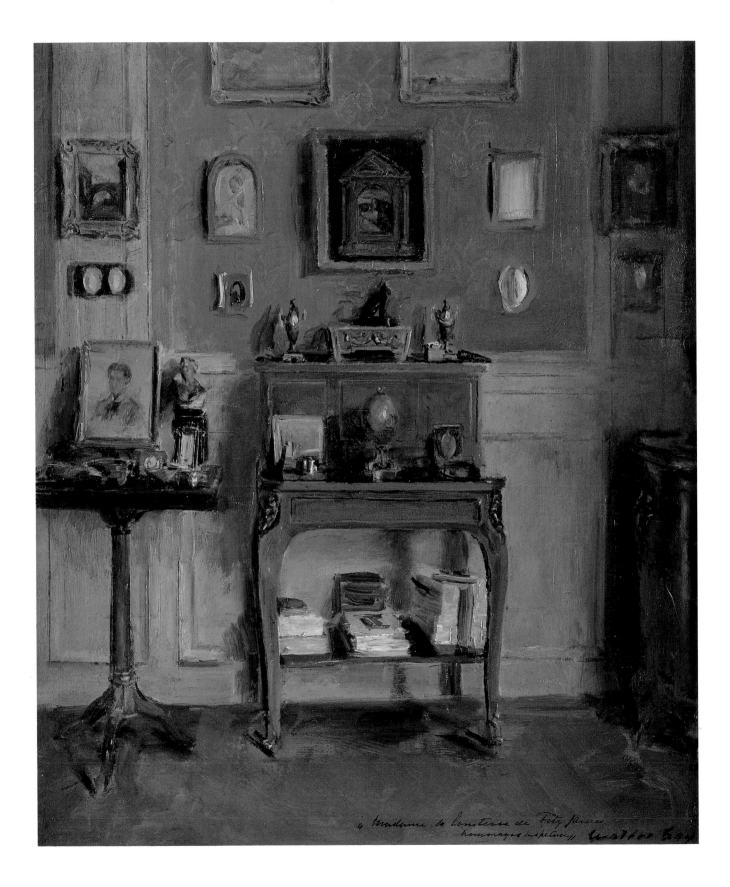

22. The Marquise de Ganay

Along with the sommiers at Vaux-le-Vicomte, the neighbors whom the Gays saw most frequently were the Marquis and Marquise de Ganay at the Château de Courances. Monsieur de Ganay and Walter were frequent shooting companions. "The pleasantness of the Ganay household is that it has the cosmopolitan character inseparable from a sporting life—one is forgiven for being a foreigner. They see so many that they understand us. Being the offspring of international marriages themselves, it makes it easier for them to do so than if they were wholly French," Matilda explained. Emily de Ganay was an American, the former Emily Ridgway of Philadelphia. "She is a perfect type of a Parisian *mondaine* with indefatigable interest in philanthropic and sociological works." She and Matilda enjoyed discussing their favorite topics: love, matrimony, and illusions. "There is always a good deal of unconscious autobiography in these philosophical conversations," acknowledged Matilda. "Courances is the most agreeable and easiest house in the neighborhood—and what we call the 'French ice' does not exist there." Quite the contrary, in fact, as Emily de Ganay was always charming, gracious, and hospitable. She was delighted when the Gays bought Le Bréau and sent over two swans for their moat as a housewarming present. Even when Emily was away, Matilda felt perfectly comfortable in visiting. "How much more amusing it is to visit people's houses in their absence—even when you like them, as in the case of the charming châtelaine of Courances."

The Marquis de Ganay, on the other hand, was not always charming, gracious, and hospitable. One night at dinner, "Ganay bore up courageously under the burden of sitting next to me—but it is always a heavy task for the *beau sabreur* [handsome swordsman], whose tastes are only for the young and very coquettish. Were it not for the very warm reception of Madame de Ganay, I do not think that Courances would see me often." Matilda suspected, probably correctly, that the Marquis and his sons thought her a bore.

After buying Courances in 1895, the Ganays had extensively renovated the interiors and added a new wing by the architect Gabriel-Hippolyte Destailleur. "Courances itself is entirely rebuilt, but they have cleverly furnished it with decorations, mantelpieces, and tapestries of the olden time, so

Opposite:

93. Walter Gay. *Interior, Comtesse Robert de Fitz-James*. Oil on canvas. Inscribed: "à Madame la Comtesse de Fitz-James, hommage . . . Walter Gay." Private collection

161

that it looks like an old house inside, and a new house outside," Matilda recounted.

The approach up the grand avenue flanked by canals and rows of plane trees was impressive (fig. 94), but those who preferred unrestored châteaux did not always care for Courances. Predictably the harshest critic was Henry Adams, whom Matilda brought over after lunch on a warm June day in 1907: "The house is poor The bric-à-brac—*boiseries*, tapestries, and *singeries*— excessively rare and fine; costly to a fault; styles to despair; but a large Louis XIII house without an entrance or a staircase; and in every guest bedroom a bath *beside the bed*. Of course electric lamps and telephones attached both to bed and bath and everywhere an inch of space could be spared. Even at Newport, it would seem American-mad, but funny. In the heart of France—and a rather French France—it is *plutôt* anarchic. It wants only the bomb."

In 1904 Walter painted two interiors at Courances, one of which, a view of the green *boiserie* salon, the Ganays particularly liked. His other picture there was done in 1909, the view of the library that was bought by the State when he exhibited it at the Salon the following year (fig. 95).

Much of the appeal of Courances for the Gays was in the beautiful park and gardens dotted with basins, canals, and spring-fed ornamental lakes, the famous "Eaux de Courances." Matilda loved wandering about in this "abode of the gods. I never become accustomed to the delicious Fragonard quality of the 'Eaux de Courances'—it is forever new." On one memorable afternoon during the war, Matilda Gay and Emily de Ganay took a long walk in the park, "where [she] showed me unknown and picturesque corners: the water-mill, which looks like an old engraving, the dairy, a little pavilion, a romantic hidden bridge over the river École, with a view of the château in the distance. Afterwards, intoxicated by the beauty of the

94. Château de Courances. Photo reproduced from Henry Soulange-Bodin, *Châteaux anciens de France*, Paris, 1962

OPPOSITE:
95. Walter Gay. *The Library, Courances*, 1909. Oil on canvas, 25 ¹/₂ x 21 ¹/₄". Inscribed: "Courance 1909." Musée d'Orsay, Paris, on deposit at the Musée national de la coopération franco-américaine, Blérancourt. RF 1977–442

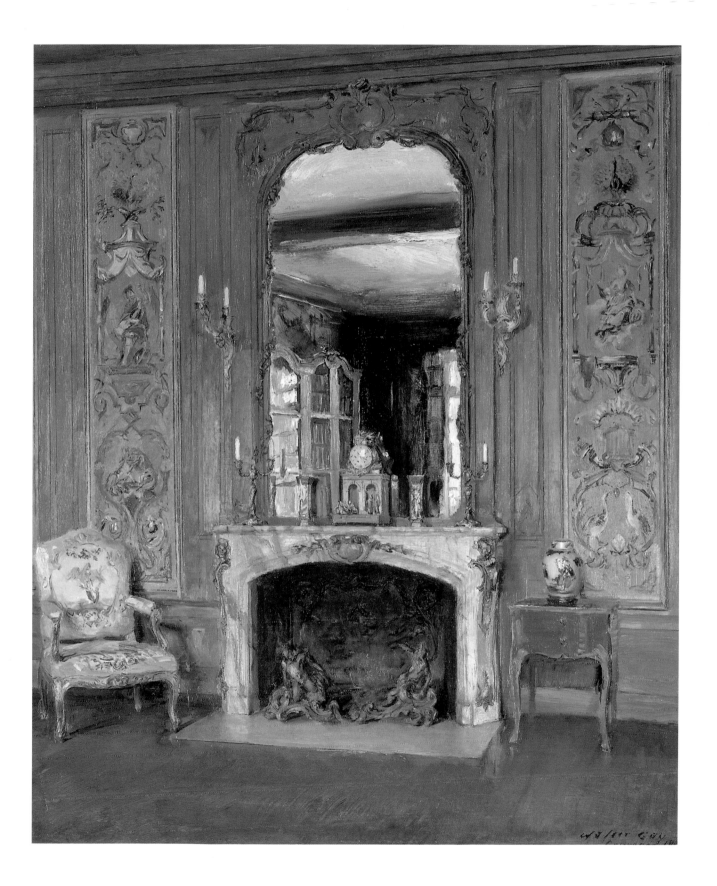

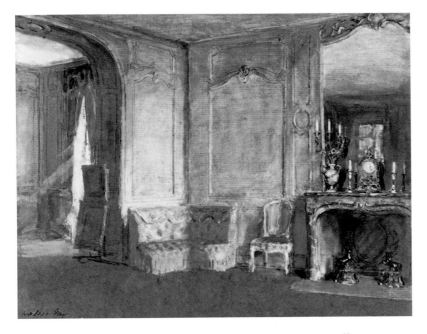

96. Walter Gay. *Salon, Bréau*. Watercolor and gouache. Private collection. Presented to Hubert de Ganay at Courances in 1921

scene, I strolled in the park alone, to feel the fairies and hamadryads rustling in the leaves. There is a vista on the left of the great *pièce d'eau* back to the château that must lead straight to fairy land. We dined out of doors, in the light of the setting sun."

They went often to Courances during the war to cheer up Emily de Ganay, whose husband and three sons were at the front. As at Le Bréau, the garden was overgrown and neglected, the paths were filled with grass, and the house was quiet. "The blight of the war is over Courances—the suspense, the possible anguish, and the silence make an atmosphere strangely discordant with the memories of past gay frivolity, pleasure-seeking, and worldliness. . . . Each time I go to Courances, I leave with the same impression, that of a brilliant centre whose glory has departed," Matilda wrote.

But already in 1919 the châtelaine was out rebuilding the gardens. "She cannot help spending on Courances, in spite of their altered fortunes. . . . Madame de Ganay remains always the pluckiest of women, cheery, and prepared to meet life's trials with a disarming smile. She describes Ganay as being transformed into a country gentleman, the best thing that could happen to him. After many years of fitful, feverish, rather wasted existence, they will both end well. I have a real affection for Madame de Ganay."

Walter sent one of her sons, Comte Hubert de Ganay, a view of Le Bréau in 1921 as an engagement present (fig. 96). "Nothing in the world pleases me more than the splendid gouache you sent me," he responded. "I can't tell you the state of excitement I was in when I got it and I at once telephoned to my fiancée to tell her what a charming picture you had sent me. What pleased me so much too is to think you gave me an interior of Bréau, that place I like so much and where I always delight in going. You were really too kind in spoiling me that way but I want you to know how grateful I am to you and to Mrs. Gay for your kind thought."

23. Paul-César Helleu

97. John Singer Sargent. *Paul Helleu*. Pastel on paper,
19 ½ x 17 ½". Harvard University Art Museums. Bequest of
Mrs. Annie Swan Coburn, 1933.18

THE PAINTER AND ETCHER PAUL-CÉSAR HELLEU (fig. 97) and his wife, Alice, were very fond of the Gays. When their daughter Hélène was born, they asked Matilda to be her godmother. But the reciprocal feelings of the Gays were rather more qualified. Walter preferred Paul to Alice, and Matilda strongly felt the opposite. When Matilda and Alice got together, the conversation was almost entirely devoted to Alice's complaints about her matrimonial difficulties, Paul's egotism, and his sundry antics.

Helleu did two drypoint etchings of the Gays together. In one Walter examines a portfolio of prints in Helleu's apartment as Matilda stands behind him and looks on, resting her arms on the back of his chair. In the other, Walter is painting an interior of the apartment as Matilda sits watching (fig. 98). Upon seeing one of these etchings at Le Bréau, a well-meaning but ingenuous acquaintance commented that, while Helleu was a talented painter, he was essentially a "fantaisiste." Matilda, utterly without vanity, merely laughed. She was well aware that Helleu had transformed her into yet another of his elegant society beauties, women whose flattering portraits became the source of his fame. He could crank them out in an hour and a half. Helleu had studied in Paris with Jean-Léon Gérôme and at the Académie Julian. Comte Robert de Montesquiou became his patron, introduced him into French society, and wrote the book that remains the standard study on his work: *Paul Helleu: Peintre et graveur*. When the Helleus visited Le Bréau in 1908, Matilda was pleased by the difference between Paul and his patron. "Helleu was a striking contrast to Montesquiou, in that he appreciated to the fullest extent the beauty and charm of Le Bréau—and nothing escaped his connoisseur eye. It was a pleasure to go over the house with him."

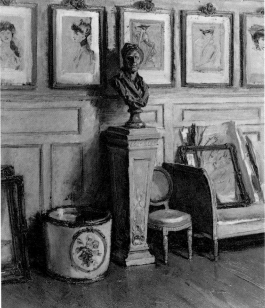

98. Paul-César Helleu. *Walter and Matilda Gay*. Drypoint etching. Private collection

99. Walter Gay. *Le Buste, chez Helleu*. Oil on panel, 21 x 17 3/8". Private collection

100. Walter Gay. *Chez Helleu*, c. 1902. Oil on cardboard, 21 5/8 x 18". The Pennsylvania Academy of the Fine Arts, Philadelphia. Joseph E. Temple Fund. 1903.3.1

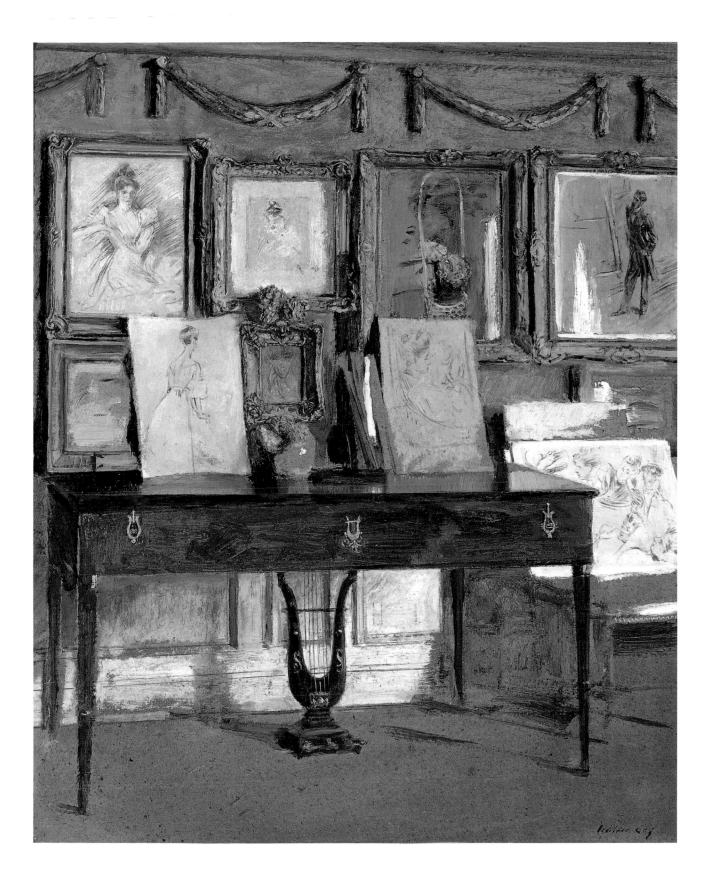

Sadly he allowed his facile drypoint portraits to overshadow his other works, mostly seascapes and flower pictures. He became a passionate Anglophile (what the French call "le snobisme anglo-saxon"), owned a succession of yachts, which he sailed over to Cowes in the summer, and served as the model for the painter Elstir in Proust's *À la recherche du temps perdu*.

Helleu shared the Gays' passion for the eighteenth century. "Helleu came in after lunch, in very good spirits, and more enthusiastic than ever over our things," Matilda wrote. "He is a mystic of the 18th century—and knows what he worships, which all mystics do not." But he also appreciated the art of his contemporaries in a way that the Gays did not and collected paintings by Gauguin, Monet, Renoir, Boudin, and Cézanne.

He and Walter frequented the same old frame shops in Paris, and he relished showing his new acquisitions. "Helleu . . . showed me two beautiful Louis XVI frames he had bought, after having yearned for them 22 years," Matilda wrote in 1909. One of the several views Walter did of the Helleus' apartment shows the empty frames that were left on sofas, stacked against the wall or wherever space could be found (fig. 99). He also had special frames made for the portrait etchings, which he displayed hung closely together in this room.

Helleu's attempt to impose some sort of decorative order in their apartment in the avenue Bugeaud by applying carved draped swags to the walls had little success because there was just too much art. Framed and unframed pieces flowed onto the piano and the furniture, as Gay showed in the view he sold to the Pennsylvania Academy of the Fine Arts in 1903 (fig. 100).

In another room, which was painted completely white, Helleu displayed some of his English and French prints and drawings. The white color scheme (walls, curtains, and upholstery) employed in much of the apartment achieved some notoriety and was admired by Whistler and Oscar Wilde. Mallarmé once addressed a letter to Helleu: "Au 55, avenue Bugeaud / Le gracieux Helleu / Peint d'une couleur inconnue / Entre le délice et le bleu" [At 55 avenue Bugeaud / the gracious Helleu / paints with an unknown color / between delicious and blue].

The Helleus later moved to larger quarters in the rue Emile-Menier, where Matilda visited them in 1911. "To see Madame Helleu whom I found with her gifted but impossible spouse, now suddenly grown into a yellow, withered old man. Helleu's *esprit* is always the same, but his artistic prestige is on the decline, and I am afraid the poor man knows it." Walter still found Helleu witty and interesting. Matilda was glad she wasn't married to him.

24. Bernard Berenson

101. Bernard Berenson. Photo: Collection of American Literatur, Beinecke Rare Book and Manuscript Library, Yale University

DURING THEIR STAY IN FLORENCE IN THE SPRING OF 1906, THE GAYS drove out to Settignano to visit Bernard Berenson (fig. 101) and his wife at their Villa I Tatti: "a dainty villa in neatly kept grounds, with a charming view," Matilda wrote. While it was a far cry from Le Bréau, the three-story sixteenth-century rural villa, which the Berensons were then leasing, was not exactly "dainty," and it became even less so the following year when they bought it and began extensive restorations and additions. "His collection of early Italian masters showed careful selection, but included nothing of the highest order, though there was one little predella fragment that tempted me. Berenson very intelligent, but not prepossessing. Mrs. Berenson very pleasant." Berenson's wife, Mary, made an agreeable impression on Matilda on other occasions as well. "Very intelligent, sane, and well balanced, *une bonne bourgeoise*, physically. One would never dream that this highly respectable lady had once 'thrown her cap over the mill.'" Berenson had just finished the text of his book *The North Italian Painters of the Renaissance*, which was published the following year as the last in his series of four books on Italian Renaissance painting. These were later gathered into a single volume that became the bible of Italian art, *The Italian Painters of the Renaissance*.

In his early years in Italy, Berenson was supported by Mrs. Isabella Stewart Gardner, the Boston collector whom he advised on pictures. Mrs. Gardner came twice in 1906 to see the Gays at Le Bréau. "Mrs. Gardner in the best of spirits, and as youthful in interests as possible. Her three-score-and-ten [she

169

was actually sixty-six] sit lightly on her auburn wig—a very agreeable woman." Many years later, in 1930, the Gays heard more about Berenson and Mrs. Gardner on a tour of her museum in Boston with its director, Morris Carter. "Mr. Carter was quaintly humorous, particularly about Berenson, whom he described as 'saurian'; he related several stories of Berenson's strategical performances in his life of an art dealer. He was made by Mrs. Gardner, who believed in him."

Berenson worked as a consultant to the dealer Joseph Duveen, finding pictures and providing attributions. The Gays saw him in Duveen's New York gallery in 1915. "Met Berenson there, pale and feverish from a night train, but very interesting and agreeable. Duveen paid Walter Gay the compliment of asking him to paint an interior of the collection—a demand cheerfully accepted."

The Berensons and the Gays had many friends in common (Ralph Curtis, Elsie de Wolfe, Edith Wharton, Henry Adams, and Rosa de Fitz-James, to name but a few) and frequently saw each other at the Villa Trianon, the Pavillon Colombe, and at parties in Paris and New York. Berenson stayed a few times at Le Bréau, after one of which he wrote to his wife, "My dear, it is a dream of your and my kind of thing. Of course far grander than anything we can ever hope to attain."

On the whole the Gays liked Berenson. "He is a *sensitif* and a very rare man, so appreciative of all the things we love and care for," wrote Matilda. But he had several shortcomings: a somewhat oily manner, a tendency to pontificate, and a habit of speaking meanly about his friends. After one of his visits, Matilda wrote, "Berenson is a delightful talker and has a quaint and original mind. But I prefer that our subjects should be things, and not people, for when he talks of people his tongue is dipped in venom. . . . He is a delightful companion when he does not massacre his friends." A peculiar criticism coming from one who was hardly free from this tendency.

Walter would have been astonished and more than a bit embarrassed to read what Berenson thought of him. Matilda sent Berenson a copy of Walter's *Memoirs* the year after he died and received the following response: "Few painters have done for a room what Chardin did for still life. Both he and your husband put into what they did something as exquisite, as transfigured, and establishing something as complete and harmonious between picture and spectator as Giorgione and Raphael did in figure compositions." As she read it, Matilda must have thought him completely mad.

25. Madeleine Lemaire

102. Madeleine Lemaire. Photo by Paul Nadar, Caisse nationale des monuments historiques et des sites © Arch. Phot. Paris

ON A WARM SEPTEMBER MORNING IN 1907, THE GAYS drove up the grand *allée* of chestnut trees to the Château du Reveillon to discover a place of utter enchantment: "a dreamy Louis XIII château, far from everywhere, buried in its own 1500 acres of land," Matilda wrote. "The old château keeps its *parfum du passé* more than any other place I have known. The faded wall-paintings in the salon, the huge rooms, . . . the exterior with its grand air, rising suddenly out of the plain, all make it a story-book château, where Balzac would have dreamed tragic tales. . . . The deep moat has only a little water left—but its very overgrown state gave a poetry to the place. Life had stopped there so long ago—we seemed intruders."

Which, of course, they were not. They came to lunch with the owner, Madeleine Lemaire and her daughter, Suzette. Madeleine Lemaire was a new friend whom Walter had first met two years before at a dinner in Paris. A fellow artist, she was a flower painter, about whom the younger Dumas said, "No one except God has created more roses." (Dumas was the only one of Madeleine's lovers about whom Suzette was certain, as her mother always called him "Monsieur.") Robert de Montesquiou dubbed her "the Empress of roses." She exhibited her pictures in Paris at the same establishment as did Walter, Galerie Georges Petit, and although the Gays liked roses well enough, they preferred the artist to her art: "sad bad pictures of flowers, fruit, and game . . . utterly devoid of taste" was Matilda's frank, accurate assessment. While Lemaire had filled Reveillon with her own pictures, she had wisely retained those of earlier and better talents, such as Jean-Baptiste Oudry and Claude Audran, who had worked there together with the architect Jules Robert de Cotte when the house was redecorated in the eighteenth century.

With "too much sense and too little money to spoil it," she had, by and large, left Reveillon alone, except for the chapel which she converted into a stu-

dio, to the distress of the devout Matilda. "It pained my Catholic soul to see the fine old chapel, with its stately *boiseries,* transformed into an atelier for Madame Madeleine Lemaire's flower pictures. But I imagine there is not much praying done in that household—it is even whispered that Madame Lemaire has never worn a wedding ring! But this does not seem to interfere with her position as an artistic celebrity."

In fact, her celebrity was based more on her skills as a hostess than as a flower painter. Known as "la Patronne," she gave musical evenings on Tuesdays during the season from April to June in her Paris house in the rue de Monceau that attracted all of Paris, "literary, artistic, and *mondain.*" Here she often received her friends while seated at her easel in the salon. During the summer and autumn Reveillon was rarely without guests. Contrary to the Gays' initial impression, life had far from stopped there.

Marcel Proust and the composer Reynaldo Hahn had spent a romantic month together at Reveillon in 1894. Proust loved the house and wrote lyrically about the garden in one of his earliest works, *Les Plaisirs et les jours,* which Lemaire illustrated. In the later novel *Jean Santeuil* he created the fictional Reveillon family. Another frequent guest at Reveillon was Sarah Bernhardt, who came with her tame cheetah and her portraitist friend Jean Clairin.

It was the hearty warmth of Lemaire's welcome that attracted so many, certainly not her peculiar appearance (fig. 102). "Madeleine Lemaire is appalling to behold in her veteran's paint. She has a sort of down on her face that is visible through her paint—like the first beard of a youth," Matilda noted with perhaps more detail than necessary. "But she is very clever, charming, and a delightful hostess."

The September lunch with mother and daughter went well, and Gay was so taken with Reveillon that he asked if he could return there to paint. An open invitation naturally followed, and he made several three-day visits (in October and November of 1907 and again in October 1909), during which he completed four interiors. Two of these are of the "Galerie des Bustes," the long gallery with classical busts against the window walls, which when bathed in strong morning light (fig. 103) had a very different mood than in the late afternoon, when the darkened figures and half-concealed closets created a room of unsettling mystery.

After they got to know the house well, the Gays concluded that Reveillon and the Lemaires were actually not quite right for each other, as Matilda described: "Reveillon is not the frame of the Lemaires. The old château ought to be occupied by some reactionary, pious, and impoverished aristocrat, with

172

shabby clothes and beautiful manners. The place is so distinctly *ancien régime* and the Lemaires are too modern for the surroundings."

Walter and Matilda grew fond of Madeleine Lemaire and often attended her Tuesday evenings in Paris. "There is no house so really hospitable as that of the Lemaires in Paris. They have a warm welcome rare outside of Anglo-Saxon countries." Hospitality notwithstanding, the goal was to escape whenever possible immediately after dinner before the music began. Walter disliked, indeed hated, most music with the peculiar exception of Reynaldo Hahn, who, as it happened, was one of Lemaire's favorites and for whom the Gays would stay. "Reynaldo Hahn sang for us, accompanying himself, as usual. He is a great artist, for his art is so subtle that it gives the illusion of an improvisation. When he sings of flowers, one smells their perfume. When he sings of the East, the colour of the Orient fills the room. He is an extraordinary being, for he is a singer without a voice—and yet more powerful are his effects than those produced by a beautiful vocal organ. Even Walter Gay, who cares nothing about music, is completely carried away by the art of Reynaldo Hahn." Matilda, on the other hand, loved music, went to concerts frequently and was a member of the Société de la Musique de Chambre.

Without Walter, Matilda also attended many of Madeleine Lemaire's teas, including one in honor of Isadora Duncan. "The famous *danseuse* came in Greek costume, her little pupils trooping after her, also in Greek dress and bare legs and feet. Isadora looks much smaller than she does on the stage. Her face is sweet and sympathetic but ordinary, with a very plebeian mouth and hopelessly bad teeth. She smiled vaguely at us, received our compliments with an absent look. I went up to her and said, "I thank you for the beautiful dreams you have given me." She smiled distractedly and looked as if she didn't care. . . . We decided that it was a mistake to know actresses whose talent you admire, for they give you their best before the footlights, which they should never cross."

Madame Lemaire asked Walter Gay (along with fellow artists Paul Besnard, François Flameng, Paul Helleu, Giovanni Boldini, and Henri Gervex) to serve on the committee of honor of her Université des Arts, an atelier for young ladies to be taught the history of art and "the principles of taste." The president of the committee was Gay's old teacher Léon Bonnat, still going strong at seventy-five, who at the inauguration in 1908 sat on the platform next to Lemaire. Matilda, never at a loss for novel matchmaking possibilities, looked at these two rocks of ages and thought how nice it would be if they married. What Walter thought of this grotesque idea is not recorded.

26. Comtesse de Pourtalès

104. Franz Xaver Winterhalter. *Comtesse Edmond de Pourtalès.* Oil on canvas, 38 x 28 ¼". Private collection

Oㅅㅌ OF THE RARE OCCASIONS when Walter Gay was able to combine sport and art was in 1908 at La Robertsau, the grim fortresslike château in Alsace of Comte Edmond de Pourtalès, who had large house parties during the shooting season. Pourtalès and Gay had often shot together and his wife, the famous Mélanie de Bussière, Comtesse de Pourtalès, was well known to both Walter, who liked her, and Matilda, who with good reason did not.

In her heyday during the Second Empire, the countess had been a legendary beauty, which was well captured in a youthful portrait by Franz Xaver Winterhalter (fig. 104) and was still evident in a much later one by Carolus-Duran. Matilda grumbled that both portraits were notable primarily for their "hardly traceable resemblance to the original," and she invariably referred to Madame de Pourtalès as the "ex-empress of beauty."

At a charity party at the Salle Gaveau of *tableaux vivants*, where well-

known paintings were re-created by costumed guests supervised by Walter together with several other artists, Matilda watched Madame de Pourtalès in the audience as Winterhalter's famous picture *Empress Eugénie and Her Court* was presented. "[She] was looking at the representation of her youthful self . . . a very curious historic survival. If the old lady had more nerves and sentiment, it would have been a bitterly sad confrontation of the past and the present." Grudgingly, Matilda acknowledged the presence of "*beaux restes*" and real charm, but Madame de Pourtalès was a "*maîtresse femme* [formidable woman] if there ever was one" with an extremely annoying habit of pursuing, with only infrequent rebuff, other women's husbands. Now aged sixty-nine, the resolute charmer had only recently discontinued this behavior, but Matilda was still wary. "How one can easily believe all the lurid tales one has heard of her! Her life is written on her brow." But Madame de Pourtalès admired Walter Gay's talent, had bought one of his interiors of Reveillon on the opening day of his 1908 exhibition, and now wanted him to paint a room at Robertsau. Matilda could hardly intervene.

He set off from Le Bréau on October 25 and arrived "after a not too fatiguing journey, to find a house full of people—crammed, in fact. . . . I wonder how they managed to find a room for me, but they did, and a most comfortable one," he wrote back to Matilda. "There was a row of people in one of the salons when I arrived, but less stiff than those circles generally are—lots of young people, old people and middle-aged, ending with the hostess, who is perfectly charming and gave me a hearty welcome." To his immense relief, he found several well-furnished, paintable rooms, a welcome contrast to the unattractive exterior.

After the hearty welcome, a familiar problem arose: the room that his hostess wanted him to paint and the room he wanted to paint were not the same room. "The house is better inside than I expected. There are two things that might be done the best. . . . Perhaps I can persuade her. The one I want to paint is a room full of white china, in a big vitrine, also white. I could make something very original out of it. We'll see."

As usual in such cases, the hostess prevailed. The artist set up his easel in the Louis XVI salon hung with a set of Beauvais tapestries and described the resulting picture as "a flattered portrait of the original," or, phrased more plainly in a postcard to Matilda the following day, "*a tour de force* of arrangement to hide the ugly things and bring out the good ones" (fig. 105). The ugly things, whatever they were, were successfully deleted, and Madame de Pourtalès was pleased with the picture's progress. "She couldn't be nicer, and every-

176

body adores her, for she has a sunny nature and no nerves," Walter naively reported.

Under the pressure of a five-day visit with half of each day given over to shooting, he had to paint both day and night "with the result of bloodshot eyes, but I don't mind if I can only finish it; but it is . . . one of the hardest that I have ever tackled. I think I can do all I can on it by Monday night, though it is far from finished, and I leave on Tuesday for Paris." A five-day shooting weekend extended into a ten-day visit to complete the picture, which pleased Matilda about as much as Walter's far-too-enthusiastic account, on his return to Le Bréau, of his charming hostess. The problem, it developed, was not just Madame de Pourtalès's notorious poaching, but also that she didn't particularly like Matilda Gay, who tried to rise above it. "She doesn't care much about me; but then I don't mind that. When people don't notice one much, there is so much more time to study *them*." The following January the countess came to see her finished picture at the Gays' apartment, where she praised their collection, which was more than Matilda did upon seeing the Pourtalès collection ("a so-called Titian, a mediocre Fra Bartolommeo. . .").

After Walter's interior of Robertsau was exhibited in Paris in February, it was delivered to the Pourtalès' handsome house in the rue Tronchet to join his view of Reveillon. Prominent space was made for the two Walter Gays, but not quite as prominent as that reserved for the ex-empress of beauty's portraits by Winterhalter and Carolus-Duran.

The Marquis Boni de Castellane ("I always avoid Boni de Castellane if possible. But he appears not to mind the rebuffs of fate; he is painted, padded, and pert, the very king of Cads"), the former husband of Matilda's friend Anna Gould, gave an account in 1924 of the Comtesse de Pourtalès in his infamous confessions entitled *How I Discovered America*. "The Comtesse Edmond de Pourtalès, whose beauty time was powerless to touch, was one of the most brilliant figures of her day, and she was, literally, the uncrowned Queen of Paris. She had played an important part under the Second Empire, and her friendship with Princess Metternich is almost historic. Nobody was more charming than the Comtesse; she positively exhaled affection; Kings, Emperors, millionaires, statesmen, artists, savants were included in her circle where they hung upon her words, lost in admiration of her wit and fascination." Matilda's sole consolation on reading this description was the author's reputation for unreliability.

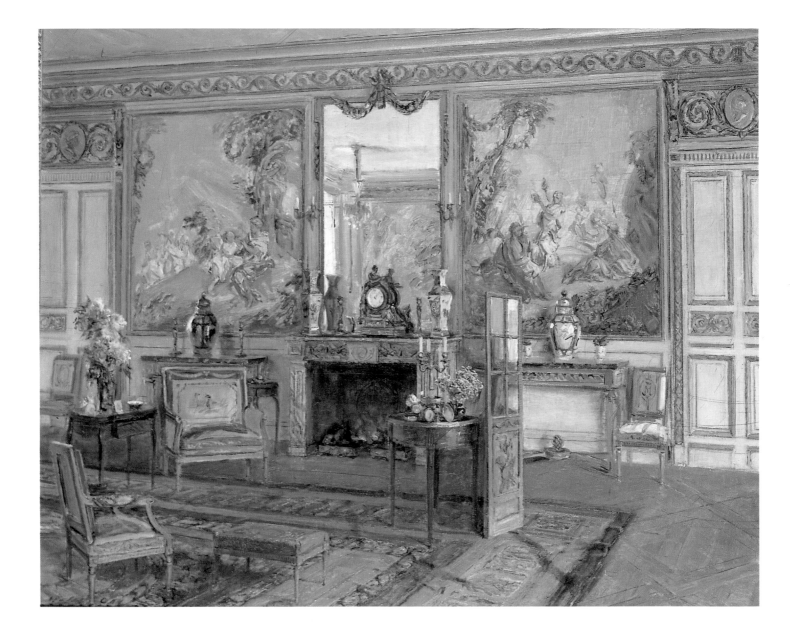

27. Pierre Decourcelle

A MONG THE MANY FRIENDS AND ACQUAINTANCES WHO CAME TO
Walter Gay's opening at the Galerie Georges Petit on April 7, 1908, was
Pierre Decourcelle, who with his wife attended a dinner party that night at the
Gays' apartment. Seated next to Matilda, "M. Decourcelle told me of
the immense difficulties of his profession of dramatic author: the theatrical
manager, the actors, the public, all represented the unknown quantity X, which
might make or mar a piece. Whereas he envied a painter, whose work could
appeal directly to the public, without an intermediary." Despite these com-

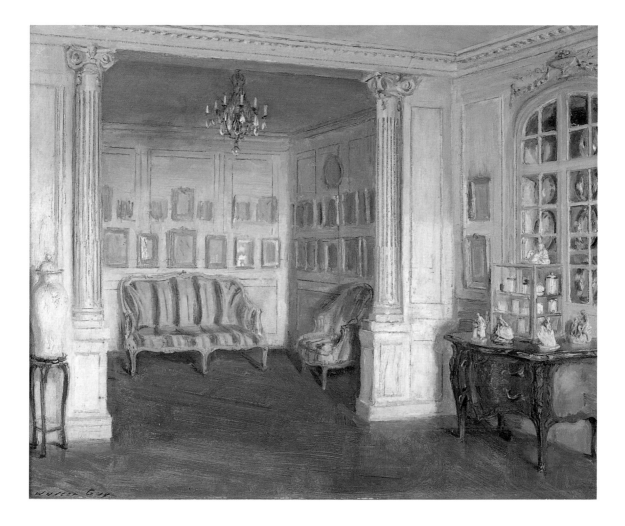

plaints, Decourcelle had enjoyed considerable success in the theater and as a novelist. His plays are little known today but were hugely popular at the time. As an author of *romans-fleuves*, he was prolific, following each book with several sequels. A few of his novels, such as *Gigolette, Les Deux Gosses,* and *Les Deux Frangines* are still read. He was also highly regarded by his peers and was elected president of the Association des Auteurs et Compositeurs, as well as the Société des Gens de Lettres. But Matilda thought there was something slightly bogus about Pierre Decourcelle, as though he were always playing the role of one of his own characters. Still, he could be charming: "an *homme du monde,* very adaptable, with an eye for the ladies."

Two months earlier, Walter had painted two views of the Decourcelle's "delicious little apartment" in the rue Jean-Goujon: "an 18th-century interior of the highest order—and although very full of objects of art, they do not appear to be heaped on one another, but all seem to harmonize," Matilda thought. It had Rococo and Neoclassical *boiserie* of the type that the Gays particularly liked and a refinement absent in many a grand house (fig. 106).

While the objects were in harmony with the apartment, such was not the case with their owners, who "do not fit into their frame," wrote Matilda. And the Decourcelles' friends were a still more discordant note: "the men clever, common, and noisy, the women uninteresting, loud-voiced, and *du faux chic*." Socially it was an apartment to be avoided.

The place did not remain harmoniously furnished for long, as in May 1911, Decourcelle had to sell his collection, which when seen in the cold light of the auction room took on quite a different complexion: "The collection . . . is a coquettish and charming one, all 18th-century. There are really but five or six things of the very first order, but the rather mediocre drawings and pictures are so tastefully presented in their old frames, the collection has been so tremendously advertised, owing to Decourcelle's position as a playwright, that it will sell for two or three times its value. All the connoisseurs, real and make-believe, all the dealers, a number of smart people, *le public des ventes* were there."

Matilda's projection was not far off. Walter came in from Le Bréau for the sale and managed to buy "for a big price" one lot: Gabriel de Saint-Aubin's frontispiece drawing of 1752 for the opera *Eglé*. Walter was pleased with his purchase, but Matilda was irritated by the "exorbitant prices fetched at this sensational sale—the high water-mark of frenzied snobbishness."

28. Nelie Jacquemart André

107. Henri Regnault. *Madame Edouard André.* Black chalk on paper. Institut de France–Musée Jacquemart-André, Abbaye Royale de Chaalis, Senlis

PORTRAIT PAINTING HAS OFTEN LED TO MORE THAN PORTRAITS, AS Nelie Jacquemart was pleased to discover in 1872, when her sitter, the banker Edouard André, proposed marriage. Together they assembled a large collection of works of art in their house designed by the architect Henry Parent on the boulevard Haussmann. "Madame André is one of the celebrities of Paris," Matilda wrote after first meeting her in 1908, "an artist turned *mondaine* with the vagueness of the first and the steel-like hardness of the second—but very amusing, natural, and intelligent." Matilda encountered Nelie again a year later on a morning walk in the Bois and had a "pleasant, disjointed talk with that clever but erratic old lady," who invited Matilda to her next "at home" (fig. 107).

On this initial visit Matilda was particularly impressed by the quality and personal nature of the collection. "To Madame Edouard André's *jour* in her magnificent hotel in the Bld. Haussmann. Madame André, once an artist, afterwards a millionaire, combined knowledge and money to form a splendid collection of pictures, furniture, and porcelain. Her technical experience as a painter guided her purchases and gives her collection a personal note, lacking in that of Mr. Pierpont Morgan, who has been 'personally conducted' by the dealers. The rooms are not too crowded either, which adds immensely to the setting of the pictures, by Greuze, Watteau, Fragonard, Lancret, Pater, Gainsborough, etc. The tapestries are magnificent, as well as the Chinese *potiches*."

After Madame André's death in 1912 and before the house opened to the public as a museum in December of the following year, the new curator, Monsieur Berteaux, and his wife came to see the Gays' collection in the rue de l'Université. Predictably, Matilda preferred him to her. "His wife took an intelligent interest in things, and was dowdy, like all the women of the *intellectuel* set. . . . M. Berteaux was very complimentary to the collection, which it was a pleasure to show to anyone so *passionné*."

He reciprocated with an invitation to Walter to paint the eighteenth-century salon in the soon-to-open Musée Jacquemart-André. Matilda came along and revised somewhat her opinion of the collection: "The house is a great palace; it looks like a section of the Louvre and must have been dreary to live

in. There are rare and beautiful things, and then there are many of second order. The 18th-century sculpture, the busts by Houdon and Coysevox, the tapestries, the tables, are all of a high order. I was rather disappointed in the pictures. There were a number of Madonnas col Bambino, and other pictures which one sees in provincial museums. There is a magnificent fresco by Tiepolo facing the grand staircase . . . also a beautiful frescoed ceiling by Tiepolo in the dining-room."

In Walter's view of one end of the Grand Salon, a black lacquer *bureau*, a gift from Louis XV to the town of Langres, sits on a seventeenth-century Savonnerie carpet (fig. 108). In the corner a portrait of the Marquise d'Antin

108. Walter Gay. *Le Grand Salon, Musée Jacquemart-André*. Oil on canvas, 27³/₈ x 33⁷/₈". The Metropolitan Museum of Art, New York. Gift of Mr. and Mrs. Clarence L. Hay, 1961. 61.9

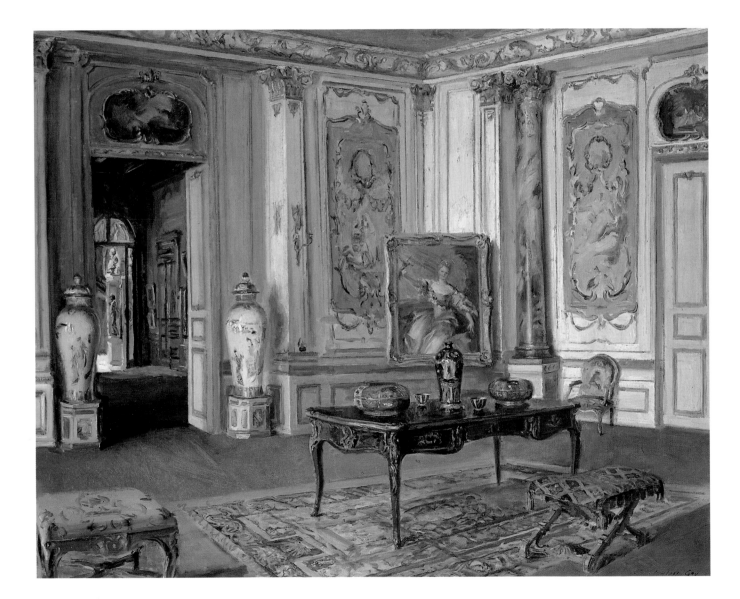

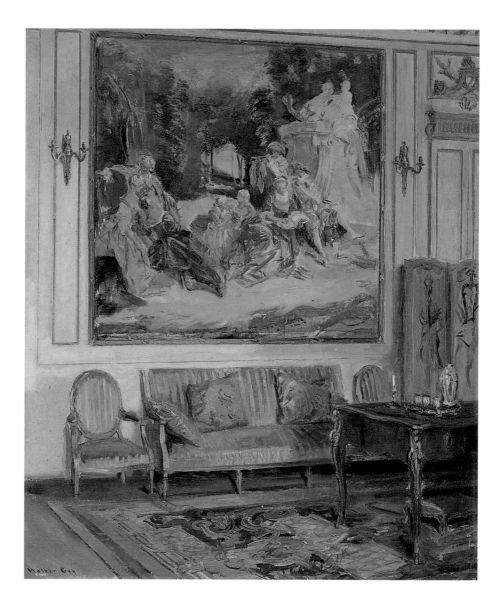

109. Walter Gay. *Boudoir, Château de Chaalis*. Oil on paperboard, 25⅝ x 21¼". National Museum of American Art, Smithsonian Institution, Washington, D.C. Gift of Mrs. Harper Fletcher, in memory of Mr. and Mrs. James Wolcott Wadsworth. 1971.284

by Jean-Marc Nattier levitates rather oddly between two Gobelins tapestries from a set depicting the seasons. Flanking the door are two large eighteenth-century Chinese export vases.

The paint was hardly dry on this picture before Gay sold it to Knoedler & Co. in New York. At the very moment when he was enjoying a successful exhibition at Gimpel & Wildenstein, why he chose their chief rival in New York is as puzzling as his decision to inform René Gimpel that he had done so. Knoedler's sold it as *Large Salon of Edouard André's house, Boulevard Hauss-mann, Paris* (a title that would not have entirely pleased Madame André) for $3,000 in 1917 to the archaeologist Clarence L. Hay, with the offer of exchange

"during five years for full price for any Walter Gay we may have in stock." But Hay had no intention of exchanging the picture and kept it until 1961 when he gave it to the Metropolitan Museum of Art.

Later in 1913, Walter painted a view of the other end of the same salon (now in the Corcoran Gallery of Art in Washington, D.C.), this time altering its proportions and inventing some new details, including an extra tapestry here, an additional column there.

As Walter painted, Matilda was shown through the house, coming finally upon Madame André's bedroom, where her portrait of Edouard André was displayed. "Madame Andre was a talented artist in her day. But when she got the social bee in her bonnet, she blushed for her former career, and would never allude to it. And the aristocracy whom she entertained always looked down upon her, while accepting all that she had to offer," Matilda wrote.

After Edouard André's death in 1884, Nelie bought a country house near Paris, the Château de Chaalis, which she furnished in much the same manner as the palace on the boulevard Haussmann. On her death, both houses were left to the Institut de France as museums with the stipulation that the interior arrangements remain unchanged. (Following several recent years of closure, the Musée Jacquemart-André is now open again, the interior arrangements extensively changed.)

The Château de Chaalis had been built in 1730 as a monastery to replace the conventual buildings of the twelfth-century Abbaye de Chaalis, which had fallen into ruin. Its new curator, appointed by the Institut, was the art writer Louis Gillet, who together with his wife and six children lived in one wing of the château. Hearing about the two pictures that Gay had painted at the boulevard Haussmann, Gillet wrote him a letter oozing flattery ("For fifteen years I have admired your wise and delicate works, your noble talent, your charming appreciation of the beautiful things of my country") and asked him to come and paint at Chaalis. Never entirely indifferent to this kind of praise, Walter was pleased to accept. He wrote to Matilda at Le Bréau: "Chaalis is an ideal place, full of lakes and ruins; the former, it seems, were dug by the monks in the 14th century, in order to put in the fish which they contained, and are now full of wild ducks, which Madame André's frivolous guests used to shoot."

With many rooms to choose from, he selected Madame André's boudoir with a Beauvais tapestry representing Music from a series entitled *Fêtes italiennes* designed by François Boucher, behind a Louis XV *bureau plat* standing on an Aubusson carpet (fig. 109). The Boucher tapestry was, Matilda thought, the best object in the house.

On his return to Paris, Walter was more than usually pleased with the finished picture, as he wrote to Matilda: "I have just returned from Chaalis, dead tired but happy, having accomplished in the two days that I stayed there, as much as I could ordinarily do in as many weeks. . . . I was made most comfortable, and slept in one of Madame André's bed-chambers, with a dressing room, *entrée*, and *salle de bains* all to myself. . . . I have brought back a picture, which is one of my best. How I accomplished it in such a short time is more than I can realize, now that I have got it in a frame. It kills everything in my studio." *Boudoir, Château de Chaalis* was acquired by Matilda's niece in Washington, Mrs. Fletcher Harper, who gave it to the National Museum of American Art. Walter liked it so much that he painted two other versions with small compositional changes.

While working at Chaalis, he grew to like Louis Gillet and his wife and decided to thank them for their hospitality with one of his sketches. "Mons. Gillet came to the apartment this morning . . . and was perfectly astounded at the collection," he wrote to Matilda. "I prevailed on him to accept a sketch, for which he was most grateful, and I wrote a dedication on it for his wife. I picked out one for him myself, and didn't give him a chance to choose, which is by far the best way."

Then there was the usual, tiresome matter of the thank-you letter, which Walter hated to write and often asked Matilda to do for him. "After this present, I don't think it will be necessary for me to write a board and lodging letter, but if you think so, you might write three lines for me; I shall be thankful." Matilda replied that the sketch was sufficient. She also liked Gillet: "a man of rare qualities—modest and erudite—oh! rare combination!" He wrote the introduction for the catalogue of Gay's exhibition in 1923 at the gallery of Jean Charpentier in Paris as well as articles in *Revue de l'Art ancien et moderne* and *L'Illustration*, where Gillet described Walter as the creator of a school of "intimistes," whose pictures were much imitated with little success.

After the war Gillet invited the Gays to return to Chaalis, by which time Matilda had considerably changed her tune about "the eccentric, snobbish, and unloved Madame André. . . . M. Gillet took us into [her] private apartment, which is just as she left it—her bedroom and boudoir were *quelconque* [ordinary] but her bathroom was lined with mirrors. One's imagination pictured that ugly, flabby, yellow old body reflected all over the room—what a spectacle! Happily there were no witnesses, but it could hardly have been a luxury for her to see herself. To use a bathroom like that, one should be sixteen years old, made like a nymph, with the morals of a nymph."

29. Geoffrey Dodge

110. Geoffrey Dodge in 1909.
Reproduced from Yale University,
The History of the Class of 1909

During the war Walter and Matilda met a young American named Geoffrey Dodge, who had "come over here to see if he can be of any assistance to universally beloved France in her hour of need." He was from a New York family, had graduated from Yale in 1909 and joined the Red Cross, in whose uniform Matilda thought he looked very handsome. On the fourth floor of an old house in the rue de Montpensier overlooking the Palais Royal, Dodge arranged "a delightful little bachelor apartment . . . a veritable nest, [where] everything was tasteful and dainty." Personable and amiable, he was soon a frequent visitor at 11 rue de l'Université as well as at Le Bréau where Matilda enjoyed their cozy talks. "It is a pity that anyone who loves the fireside as much as Dodge should be unmarried," Matilda wrote, wondering how she might correct that problem. "He is very much overworked at the Red Cross, and able as he is, shows the strain under which he is living."

After the war, Dodge moved to an apartment almost immediately behind the Gays in the boulevard Saint-Germain "[which he] has fitted up charmingly with taste and comfort, a little *rez-de-chaussée* in an old hotel, which opens out on to a large square garden. There he is happy with his dogs" (fig. 111). He and his friend Russell Greeley enjoyed giving small dinners that often included the Gays and their mutual friends, the Robert Blisses.

After a brief visit back to New York, which he described to Matilda as "six years noisier, vulgarer, and more impossible than it was in 1914," he settled permanently in Paris, where he opened a shop selling antiques and decoration. The shop prospered first in the rue Bayard and later in the place Vendôme.

From time to time Dodge sought Walter's counsel on pictures, as in 1920 when he was interested in a Rembrandt portrait from the Château d'Anet. Walter wrote to congratulate him on finding this portrait of fine quality, one well worth buying, but not for a fantastic price. As the owner of twenty-three

drawings by Rembrandt, Walter felt qualified to comment, although his expertise on this artist was not infallible: the portrait of an *Old Man in Prayer*, which he had advised Boston's Museum of Fine Arts to buy in 1903, has now been downgraded to "Pupil of Rembrandt."

In addition to the view of his apartment, Dodge also acquired an interior of the small study in the rue Ampère that he gave to the Yale University Art Gallery in 1929. Walter thought so highly of Dodge that he gave him the exclusive right to sell his pictures for seven years following his death.

Geoffrey regularly spent Christmas with the Gays at Bréau and continued to see Matilda every week during her last years. To her dismay, he remained a bachelor.

111. Walter Gay. *Salon in the Apartment of Geoffrey Dodge*. Oil on canvas, 21¾ x 18¼". Private collection

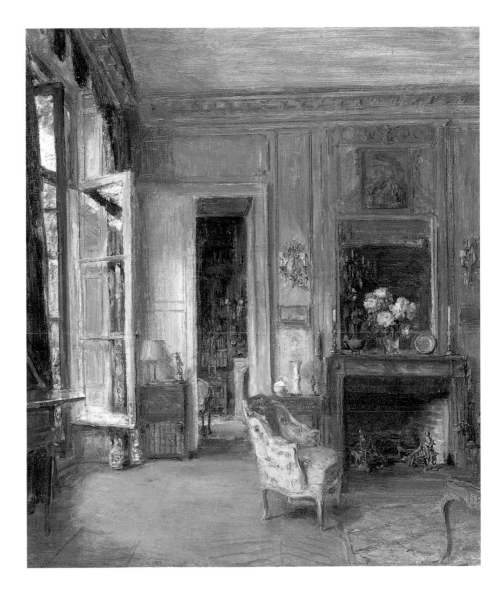

30. Henry Clay Frick and Helen Clay Frick

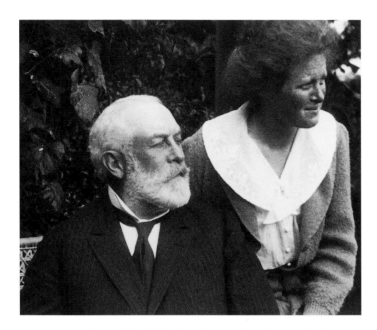

112. Henry Clay Frick with his daughter, Helen Clay Frick. Photo: The Frick Collection

SHORTLY AFTER HELEN CLAY FRICK commissioned Walter Gay in 1928 to paint three rooms in the Frick residence in New York City, she invited the Gays to come for dinner. This was their first visit to the splendid Beaux-Arts palazzo that Helen's father, the coal and coke magnate Henry Clay Frick, had commissioned from the architects Carrere and Hastings. Like everyone else who saw the collection, the Gays were dazzled. "The Frans Hals, the Rembrandts, the Titians in the adjoining room, the Italian room with the beautiful primitives (Miss Frick's favourites), all these treasures are a perfect orgy. And then the splendid commodes in the vestibule—all these are difficult to digest on one evening," Matilda raved. They had in fact seen and admired some of the collection before, in 1911 when it was housed in George W. Vanderbilt's residence at Fifth Avenue and Fifty-first Street, which the Fricks rented until they moved in 1914 to their new mansion at Fifth Avenue and Seventieth Street.

The principal rooms on the main floor were designed by White, Allom & Co. of London in close collaboration with Frick's dealer (and the Gays' friend) Joseph Duveen, who, having given a great deal of attention to the smallest details, such as picture lights so that the paintings he had sold to Frick would show to best advantage, would not have been pleased by Matilda Gay's reaction. "After dinner we visited the Gallery, where we had sat before an open fire before dinner. Miss Frick had arranged a curious lighting system. All the light was extinguished, with the exception of the special lights over the pictures; so that the pictures stared out of the gloom at us. This gave the effect of projections on the screen; the masterpieces therefore lost the quality of painting and looked like ghosts."

The dining room was filled with Gainsboroughs, one of which, the por-

trait of Mrs. Peter William Baker, had come from the drawing room in Ranston House in Dorset, which Walter had painted in 1925. Duveen, as was his custom, had had a copy painted to fill the gap in Dorset when he bought the picture from Sir Randolph Baker and sold it to Frick in 1917. Matilda was amused that Walter "had painted the copy, in the drawing room, making it look like an original; and here we were, dining under the original, in New York."

After dinner, they had a "nice talk with Miss Frick, an excellent, intelligent girl, doing a good educational work in her art library, shouldering the responsibility of her great wealth with courage and good will. But I have the impression that her health is too delicate for such a heavy burden." Although a small and slender woman, Helen Clay Frick in fact bore that burden with grace and modesty for the rest of her very long life. She built, directed, and completely funded the Frick Art Reference Library and was the most influential of the trustees of the Frick Collection, with a strong voice on the works of art that were added to it after her father's death (fig. 112).

But she never really liked New York and preferred to live on her farm in upper Westchester County. As her legal residence, she kept Clayton, the Pittsburgh mansion where she was born in 1888 and where she died in 1984 at the age of ninety-six. When there, she drove about in her father's 1914 Pierce-Arrow, seeing no need to replace it. Her closest friends remained those from her Pittsburgh childhood, who loved the parlor trick of her adored spaniel, which she had trained to play dead when she said "New York" and frolic about frantically on hearing "Pittsburgh."

Helen Clay Frick may have favored the Italian primitives in the collection, but they were not what she engaged Walter Gay to paint. His view of the Fragonard Room captures the effect of the afternoon light on one of the greatest decorative ensembles of the eighteenth century: Jean-Honoré Fragonard's *Progress of Love* (fig. 113), commissioned by Louis XV's mistress Madame du Barry for a pavilion in the garden of her château at Louveciennes. The Gays had seen these pictures before in the London residence of their previous owner, Pierpont Morgan, as well as the copies that had replaced them in the house of Fragonard's cousin in Grasse, where they had been taken by the artist after Madame Du Barry changed her mind and rejected them.

The pictures looked much better in Frick's house than they had in Morgan's, thanks in large part to the paneling and the lighting of the room, which were designed by Sir Charles Allom and executed by the Parisan decorator André Decour. That the room was completed at all, let alone so successfully, was nothing short of a miracle, given the mutual loathing between the

189

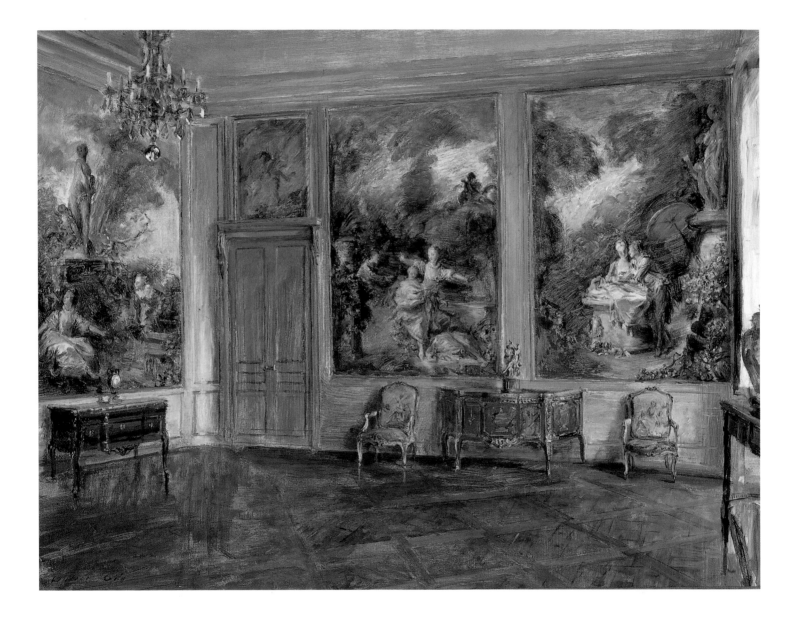

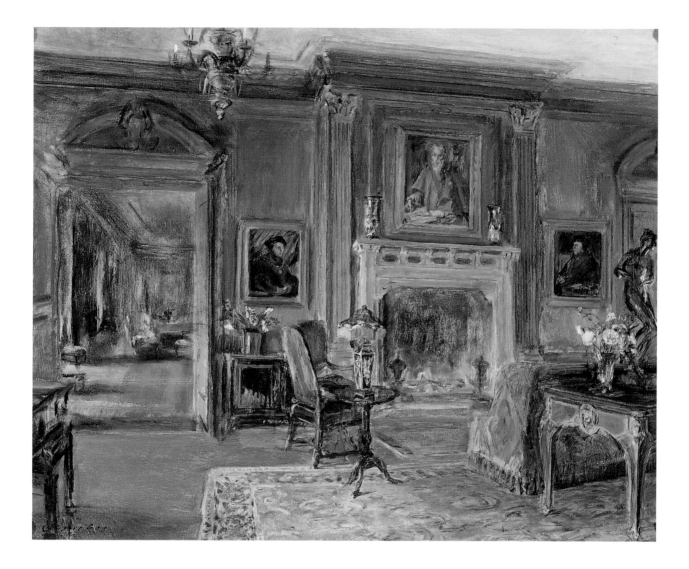

hot-tempered Allom and the difficult Decour, each of whom complained often about the hopeless incompetence of the other. "[Decour] is not a man of good taste," Allom wrote to Duveen. "It is a strange thing that when taste goes wrong, it rarely goes so badly wrong as it does in France."

The adjacent living hall is shown with the doors open to the cavernous library beyond, lit from the tall French windows overlooking Fifth Avenue (fig. 114). Flanking El Greco's portrait of *Saint Jerome* above the chimneypiece are two portraits by Hans Holbein the Younger, *Sir Thomas More* (left) and the man largely responsible for his execution, *Thomas Cromwell* (right), above a pair of cabinets by the Vanrisamburghs with panels of black and gold Japanese lacquer. The Boulle writing table on the right supports the large eighteenth-century bronze *Marine Nymph* after Stoldo Lorenzi and stands on a Persian

sixteenth-century Herat floral carpet. Mercifully the rather alarming green wall-to-wall carpet is no longer in the room.

While the combination of Duveen and White, Allom & Co. was suitable for the imposing rooms on the main floor, the family rooms upstairs needed a lighter touch and for this Frick hired Elsie de Wolfe. Their meeting to discuss her designs, at least as related in her typically self-serving account, has long been the stuff of legend in decorating circles. After examining the drawings carefully and silently, Frick asked to see the alternate set. Long pause. "Mr. Frick," she said sternly, "when I draw up a set of plans there is no second choice. There is only what I show you. The best."

For Mrs. Frick's boudoir she found a series of eight panels representing the Arts and Sciences, painted by François Boucher for Madame de Pompadour's library at her Château de Crécy, near Chartres. These were incorporated into a Louis XV–style *boiserie* room, which Elsie de Wolfe highlighted in the same blue as her drawing room at the Villa Trianon (fig. 115).

Elsie filled the room with French furniture, including the writing table in the center by Jean-Henri Riesener, which she sold to Frick, together with

115. Walter Gay. *The Boucher Room, The Frick Collection*. Oil on canvas, 17½ x 21". The Collection at Clayton, Pittsburgh

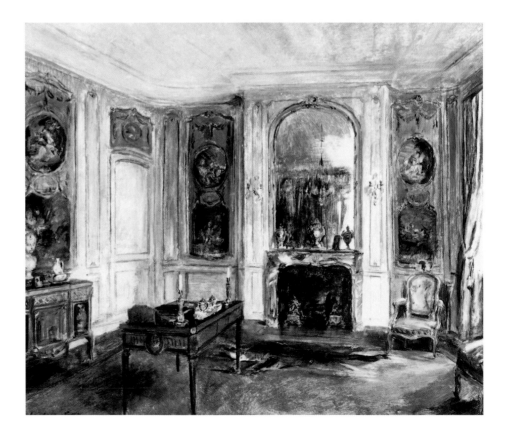

several other pieces in another legendary encounter with her client. The furniture had been part of a famous collection of eighteenth-century French furniture belonging to Sir John Murray Scott, who had inherited it from Sir Richard Wallace, son of the fourth Marquess of Hertford, who created the Wallace Collection in London. Scott bequeathed the furniture to his friend, the extravagant and capricious Victoria, Lady Sackville (mother of Vita Sackville-West), who in turn sold it to the Parisian dealer Jacques Seligmann. Elsie arranged with Seligmann that Frick should have first crack at the collection, still in Scott's Paris apartment, but Frick cancelled the appointment at the last minute to play golf. She persuaded him to delay the game, but only for half an hour, during which he purchased, while periodically checking his watch, the pieces of furniture that she recommended for three million dollars.

That half hour, she admitted, made her a rich woman. "I was also astounded at the revelation that a businessman, so astute and even cold as Mr. Frick was known to be, could spend a fortune with such nonchalance in order to keep a golf appointment," she wrote. Diana Vreeland, in her inimitable way, summed up the transaction: "Elsie was a pretty authoritative big-time dame and she wasn't playing any games about being the clever little woman. If she charged Mr. Frick three million dollars, she had three million dollars' worth of furniture to show him, and he knew it and accepted it. He was in business and she was in business, and there was no kidding around."

Seligmann's son Germain thought that the Riesener table was so important that it should be kept in a special case, but Elsie was not having any nonsense like that. A writing table, no matter how rare, was for writing, so she filled it with writing paraphernalia and candlesticks.

The Boucher Room, as it was called, was moved downstairs to its present location near the entrance hall when the house was converted to a museum after Mrs. Frick's death in 1931. When the Frick Collection opened to the public in 1935, the art critic Lewis Mumford thought that converting a private mansion into a museum had been a mistake. "The paintings are lost in the background. That may have satisfied the tastes of Renaissance princes, or even that of American millionaires during the first part of the present century, but it no longer meets today's standard of presentation," he wrote in *The New Yorker*. He could not have been further off the mark. From the day it opened to the public, this beautiful house filled with a particularly harmonious combination of fine and decorative arts of the highest quality has been one of the most beloved museums in the world. Walter knew from the moment that he began to paint there that it would be his most prestigious New York commission.

193

Part Three.

THE LATER YEARS

31. The Great War

WORLD WAR I CAME TO LE BRÉAU SUDDENLY AND WITHOUT warning. On Saturday the first of August, 1914, the butler took a call from the Préfecture at Melun, rushed from the telephone room into the salon, and announced with an ashen face: "Mobilisation générale!" "In a moment our lives were completely revolutionized," Matilda reported. Every man on the place under the age of forty-six—nine in all, including the gardeners and keepers—had twelve hours to report for duty. "When the last one left, we felt very much alone," Walter wrote. Martial law was imposed on August 3, and the following day Germany declared war against France.

The Gays offered Le Bréau to the French government for a hospital, an offer initially accepted but then rejected when the authorities decided that it was too far from the nearest town. Their friends, most of whom fled to the south, urged them to evacuate, but they decided to remain, not without second thoughts, as by the first of September they were completely isolated without telephone or mail. They awoke on September 5 to the sound of cannon fire and were warned to expect the Germans, then only twenty-four miles distant, at any time, perhaps the next day. But at the famous Battle of the Marne that followed, the enemy was defeated and the front shifted elsewhere. It had been a very close call. "Now that our own personal danger is over, an immense depression has seized hold of me," Matilda wrote. "I hide it as best I may from W. G. for he is so depressed himself."

As American citizens, the Gays were technically neutral and had been provided, as had many American residents in France, with a letter from Ambassador Myron Herrick stating that their property must be respected. "We never used this, fortunately, for the Germans never got to us, but they were very close and we owed much to our Ambassador for his kind thought of us."

With their car and two horses requisitioned ("We never saw our horses again, but our motor was returned to us after the war, five years later," Walter wrote), transportation would have been impossible had not their former chauffeur, an unmobilizable Swiss citizen, appeared one morning with his tumble-down car and was eagerly hired back. The remaining women servants and their children, totaling eleven people, were somehow packed into the car and sent to a safer place near Bourges.

Although gas was nearly impossible to obtain and private vehicles were not allowed on the roads without military permission, Walter managed to get authorization to use the car for only one day to retrieve his collection of drawings from Paris. "The enemy, by this time, had lists of the collections in Paris, and it was said that my drawings were among them. I hated to think that they might end their days in Germany," he wrote in his *Memoirs*.

Precious items were either sealed up in the walls by the mason before he left for the war or were buried. "The most precious thing we buried was the memoirs written by my wife. We unearthed them as soon as the enemy had been repulsed." The Gays graciously offered to store belongings for several of their neighbors: one entire room at Bréau was filled with furniture from the Château de la Rochette. Seven cases of silver belonging to another neighbor were buried.

During the four long years of hostilities, the future of Le Bréau looked far from secure. Matilda's income was greatly reduced and Walter's stopped almost entirely. In 1917, for example, he sold only one picture. This in combination with the rise in taxes made it increasingly difficult to support the expense of a large château, even one with few servants. "Those who have no properties in the country are happier now than the rest—it is not only a question of devouring taxes but also of labour."

A group of officers together with two hundred French reserve troops were scheduled to be billeted at the house in 1915, when Matilda received advice from her well-meaning sister Louisa Wadsworth in Washington: "As for the Bréau, you will of course put away all your nice things, which might be damaged, and I hope the officers *will* sleep in the servants' rooms." Luckily the officers and reservists were deflected by an outbreak of measles and changed plans. Matilda reassured Louisa that they were not in danger and that, with the easing of travel restrictions, they were no longer trapped in the country. "We shall pass ten days here, and then return to Paris, where W. G. is painting and I am interested in war work."

The shortage of servants was an ongoing problem. "We are having great difficulty in getting men servants," she wrote in 1916. "The excellent man who replaced our butler has himself been mobilised, and we are trying various neutrals and reformed wounded soldiers to keep up Le Bréau, for the house cannot be run under three men at the least. For the first time I find it too large. The men servant scarcity will increase as the war goes on, and while women servants can manage in a Paris apartment, they could not do the hard work of Le Bréau, for it is both large and many storied." Somehow they

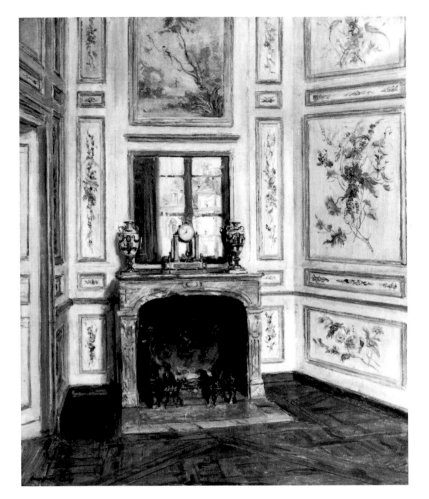

117. Walter Gay. *Antechamber of Marie-Antoinette, Château de Fontainebleau*. Oil on canvas. Private collection

managed to cope with a skeletal staff.

During this period Matilda was concerned with far more than just her house and servants. She was deeply distressed by the deaths of many of her friends and offered sympathy and consolation to many others who lost their sons. She visited wounded soldiers in hospitals and hoped that they did not see the extent of her distress. "I wonder if the comfort I bring to these poor creatures has any correspondence with the pain that their suffering causes me. I wish I could think so. . . . Hospitals will always be nerve-racking to me. But the gratitude of the poor wounded soldiers gives one strength for the ordeal. . . . I never sleep very well after these hospital visits; the ocean of physical suffering one witnesses seems to submerge me. But no one must yield to their nerves at such a moment."

Her diary is a poignant and moving record of the tragedy and devastation of the war. While she deplored the actions of the enemy, she was shocked to learn of some of the equally appalling behavior of the French and American soldiers. It was as though everyone was barbarized by the war. She enrolled in the American Red Cross and became absorbed in her two charities at Versailles for Belgian orphans, Clarisses and Les Ombrages, which required weekly visits.

Walter also did volunteer work, visiting the many hospitals at Melun and Fontainebleau and making lists of their necessities for an organization called the Clearing House. With no commissions, he painted purely for pleasure: views at Le Bréau and at Fontainebleau (fig. 117). On many days Walter and Matilda took long walks in the park.

But they were not without visitors. The famous actress Madame Julia Bartet, one of the leading lights of the Comédie-Française, came to Le Bréau in 1916. "La Divine Bartet," as she was known, had admired Walter's work for

118. Julia Bartet, photographed by Paul Nadar. Caisse nationale des monuments historiques et des sites © Arch. Phot. Paris

many years, and ever since he had painted a view of her salon in 1904, they had remained friends. "Bartet was enchanted with Le Bréau, inside and out, and I was enchanted with Bartet. It is consummate art when an ugly old woman with a bad figure can give the impression of good looks, youth, and grace. Never has *maquillage* been carried to such a point of perfection as on Bartet's face. This great artist, on and off the stage, plays the role of *femme du monde* in a drawing-room with such exquisite finish that the genuine aristocrats seem rough and awkward." She told Matilda that Walter caught *l'âme des choses* [the soul of things] in his painting. "He does," Matilda agreed, "and she gets it in her acting. She has the soul of an artist, this fascinating woman."

For a period of time in 1916 the Gays were obliged to house in the park a group of German prisoners, whom Matilda encountered every morning. "They stare at me in a friendly curious manner, but I look away. They are fine-looking young men, muscular enough to commit any atrocity. They are very well-treated and well-fed." But not always well intentioned, as the head keeper discovered when he caught one of them making an elaborate map of the property with the château and outbuildings all carefully traced. "He snatched the drawing from the prisoner and destroyed it, otherwise it might have been sent back to Germany. I regretted afterwards that he hadn't kept the document to show to me," Walter wrote.

Several friends suggested to Matilda that perhaps the Gays didn't need to maintain the *entire* house during this difficult time, when most châteaux were occupied only partially or shut completely. But she was determined to stay on at full throttle, as she explained to her relative Harriet Harper in America: "Your suggestion of our living on the ground floor, and shutting up the rest of the house . . . is not at all feasible. . . . The pantry and kitchen are in the opposite wing to that of our apartment. We used the old kitchen at the time of the German invasion, but it gives twice the work, and our household staff is reduced to a minimum. In the autumn, when we move over to the south wing, the chapel has to be heated, or we could not keep it open—and this would be too great a deprivation, spiritually and morally. . . . Le Bréau is a house that cannot be shut up in part—it must be occupied wholly or not at all. We could shut up the upper bedroom floor and most of the first floor, but this is a bad economy, for unless a house is aired and dusted, the furniture and hangings go mouldy and go to pieces. So even should we be forced to sell Le Bréau some day . . . we should get a better price for it, as being in good order." Harriet was not convinced.

Despite the war, they were able to see an occasional exhibition. In 1916

they lent a marquetry table and a desk to an exhibition of eighteenth-century furniture held at Jamarin's Gallery on the Champs-Elysées for the benefit of wounded soldiers. "The furniture and bibelots are few in number, of the highest order and beautifully arranged," reported Matilda. Walter painted two interiors of the exhibition for the catalogue. They were even able to shop a few times for art. "Prowled in bric-à-brac shops with W. G., bought two lovely white *porcelaine de Sèvres* vases. It seems almost wicked to indulge in such a luxury when the war is raging at the front."

By May of 1917, they decided that they were better off in Paris. Matilda wrote to Louisa, "We are faced by the problem of coal and of servants for Le Bréau. Our life there has lost much of its charm. With the neighborhood broken up by death and by the war, my rose garden killed by the fierce cold this winter, the lack of essence, and little prospect of being able to have visitors. I have little inclination to go there this summer. We shall do our best to worry through the autumn there, but I would rather make Paris our headquarters and go to Le Bréau for little trips, camping out."

As the Gays' apartment was next door to the Ministry of Marine in the rue de l'Université and near the Ministry of War in the boulevard Saint-Germain, this was not the wisest of decisions. During the Siege of Paris, which began in March of 1918, the Germans aimed their famous gun, Big Bertha, seventy-five miles distant, at the Left Bank and the Gays found themselves once again very close to the action. Although the shells fell near them, once into a house at the end of their garden, they fortunately missed the building at 11, rue de l'Université. As the air raids continued, Matilda grew tired of going to the cellar in the middle of the night with the other disheveled tenants and became fatalistic about the danger. "In air bombardments nothing is safe—neither cellars, nor shelters—I should much prefer being bombed in my own room."

Together with several friends who had supported her orphan charities, including Edith Wharton, Matilda was decorated with the Belgian Order of Queen Elizabeth in October of 1918. "The Belgian minister made a flattering and touching address, after which he presented us each with a little box containing a bronze medal, with the head of the heroic Queen of the Belgians on one side, on the other, a symbolic figure of Belgium. I did not understand why my poor services should bring forth such a flattering recognition. Its chief value in my eyes is that the compliment comes from a heroine. Afterwards we all repaired to the dining-room where champagne and cakes were served. I scoffed at the idea of drinking champagne at four o'clock in the afternoon, and then drank a glass, pledging the little martyred country, its king and queen."

The armistice was signed on November 11, and the next day the Gays came to Paris to watch the celebrations from the balcony of the Hôtel Crillon. "The universal joy was almost delirious. I never saw so many flags in my life. The Place de la Concorde was a compact mass of shouting, gesticulating, flag-waving. Americans were promenading in *camions* [trucks], going very slowly, and waving huge flags. Our own motor car was decorated with the Allied banners."

On December 14, from the Champs-Elysées apartment of their friend Madame de Béarn, the Gays joined a group of friends to watch the victory parade and to cheer President Wilson as he passed. "No sovereign ever had such a reception as was given him," Walter wrote. "He was looked upon by the French as a saviour, not only of France but of the world. . . . I shall never forget his triumphant smile as he greeted everybody and bowed right and left." Matilda was bursting with pride. "At no epoch of the world have human hearts throbbed as have ours today," she wrote.

At a large reception several days later at the American Embassy, Matilda curtsied and said, "'Mr. President, we are very happy to have you with us' to which he replied, with a genial smile, 'I am very happy to be with you'" and shook her hand warmly. "These amiable platitudes mean so little, and yet so much. . . . Mrs. Wilson has a former prettiness, now invaded by fat. The rooms were crowded. All the embassies, the army, the prominent Americans, and some of the pushing ones [were there]."

Walter served on a committee to select a site for a monument to the heroes of the First Battle of the Marne, the battle that had not only saved the Gays and their château, but had also, they felt, saved France and civilization. He went by military car in May 1919 to visit the front and chose a hill at Mondement, the place where Marshal Foch had indicated that the tide had definitely turned against the Germans.

The Gays saw the final victory parade on July 14, 1919, from another apartment on the Champs-Elysées belonging to their friends the Tucks. "The crowds were so great that many poor people spent the night in the street so as to be in time in the morning," Walter reported. "We left home at 5.30 a.m., and were about one hour crossing the Champs Elysées on foot; no carriages being allowed anywhere near the Avenue. When the American troops came by with General Pershing on a gray charger, the emotion was at its height, for our boys had fought the war to a successful finish." They walked home in the dust and crowds, lunched quietly and crawled into bed, completely exhausted. "So endeth the war for us," Matilda gratefully wrote in her diary.

32. The Post-War Years

After the war, the gays felt that the old France they had known, the France of art, intellect, and the imagination was gone. "I fear that 'La belle France' as we knew it is dead," Matilda wrote. "Poetry is crushed out of life by moving machines and flushed away by plumbing." The prospect of industrialization reducing everything to a uniform mediocrity was very real to them. These issues were far more disturbing than the mundane problems such as rising taxes, inflation, decreasing revenues, resolution of the peace negotiations, and the threat of Bolshevism, which, after the more threatening dangers of the war, all seemed to somehow lack dignity and weight. What the Gays did not sense was that their very way of life, based on low taxes and plentiful servants, would never again be quite the same.

As though to show that everything was going to be exactly the same, Matilda lost no time after the armistice in November of 1918 in resuming her busy life as hostess. During the next seven months, while Paris was in the throes of a food crisis, she managed to give twenty lunches at their apartment. In April they hosted a concert for about sixty friends followed by a "thé payant" in aid of the starving musicians of Paris. "Moving men coming up the stairs with piles of gilt chairs on their backs, a piano appears, the furniture of the salons and dining-room is stuffed into the other rooms. . . . It all passed off very well, and I enjoyed it quite as much as our guests." But by the end of June, she felt she had given enough parties for a while. "I prefer now to be entertained, even though our friends do not always understand the gentle art."

One who did understand the gentle art was Emily de Ganay who, however, invited Matilda to the type of party that she absolutely dreaded but could not refuse, a reception in honor of the Queen of Rumania. "The Queen would be pretty in any walk of life. She is very handsome, for a Queen, but getting far too broad," Matilda reported. "We all had to stand up like lackeys while she sat at the tea table and indulged in a copious repast and a comfortable cigarette. Afterwards when I made my curtsey, the Queen said that she knew W. G.'s pictures. It was a royal fib, no doubt, but very gracious. I find crowned heads very uncomfortable acquaintances—they embarrass everyone, and are embarrassed themselves—and we all exchange imbecilities." On another occasion she

summed up the problem: "The inconvenience of royalty is that one must take the attitude of a servant—and this, without wages! I think I prefer social relations with those whom I can address in the second person."

Inflation had brought the cost of living in Paris to alarming levels, and new taxes threatened to engulf half of Matilda's income. Once again the future of Le Bréau was in jeopardy. "I contemplate the probability of being obliged to give up Le Bréau," she wrote to Louisa Wadsworth. "It would make a great change in our lives, especially in W. G.'s, for he adores the place. But when a possession becomes a burden, it ceases to be a satisfaction. I am prepared for any eventuality."

Except, it would seem, economizing, which had never been their strongest suit. Matilda asked their friend Baronne Edouard de Barante which domicile she would give up, were she in their place. She replied sensibly that she would keep both by running them more economically, and then she related an anecdote of their mutual friend, the Duc de Doudeauville, who with three châteaux and a huge house in Paris decided to cut down expenses and reduce his manner of living. "It finally ended in his giving up two swans and a pony!" she recounted, at which Matilda took heart. The Gays didn't even go that far. Some feeble attempts at retrenchment were contemplated but not quite initiated.

On a visit to Le Bréau in the spring of 1919, they were captivated anew by its magic. "The place is so lovely that we must try to hang on to it." And by the summer they realized that selling it was out of the question. Letters to friends and relatives moaning about taxes and wondering how long they could hold on to the place gradually gave way to expressions of their intense pleasure in being there. "It is at Le Bréau that I measure the feverish fatigue of Paris. . . . Spent the morning in the park, sitting on benches, thanking God for the park and the benches." They didn't finally settle in the country for the season that year until the second of July. The war had left a heavy cloud over the house, which together with their sense of time passing elicited a new feeling of melancholy. "A great sadness creeps over me when we first arrive at Le Bréau. The souvenirs of those who have gone, the evanescence of all things earthly, the sense of our own diminishing sojourn, all weigh upon me," Matilda wrote.

Walter received new commissions: in April a house in Saint-Germain belonging to a young couple named Frank ("Madame Frank is very pretty and very smartly dressed. He is superior, but they are both more presentable, and far cleaner than many of the ancient names of France") and in June the Paris salon of their old friend Madame de Gramont, who was much changed by

the war. "She has grown 20 years older, is thin, and has not taken the precaution of supplying her vanished teeth with artificial ones. But she keeps her beautiful eyes and her great distinction. In these large salons, full of priceless objects, where she and her husband entertained all Paris 30 years ago, this white-haired woman dressed in deep mourning, moved noiselessly about like a phantom. She is deeply interested in the picture, and she and W. G. discuss the arrangement of the room amicably. She carries her seclusion to the extent of using only the back entrance of her *hôtel*. She wants to be forgotten by the world, which will forget her altogether, were it not for her large fortune." Madame de Gramont's picture did not proceed so amicably, and it was not until August that it was completed to the satisfaction of both parties.

Their friend Robert Norton, also a close friend of Edith Wharton's, was planning an exhibition of his watercolors of Provence, and he showed them to Walter. "They are charming and dainty like himself," pronounced Matilda with faint praise. Walter agreed to write the preface to the catalogue of the exhibition, which was held at the Galerie Georges Petit in June, but he had Matilda do it instead. At the opening, several people congratulated her on her husband's preface: "signed with W. G.'s name, and written by me. Had they known the real author, they would not have thought it so good."

In April Walter exhibited pictures at his club, the Cercle de l'Epatant ("where they have hung one of his exquisite pictures well, the other buried in a corner") and again in May at the Salon. "They look like little jewels surrounded by awful productions of all kinds," reported his most fervent fan. Walter was at this time preparing for his next exhibition, to be held at Wildenstein's Gallery in New York the following February. The Gays attended the private view on February 16. "The room has been arranged with great taste by M. Wildenstein, who has placed his best 18th-century furniture about, and the pictures have never been shown to such advantage. . . . In all about 60 people came, to be made homesick for France by the interiors." Included were a number of pictures already in American collections that were lent by their owners, both museums (Boston's Museum of Fine Arts, the Art Institute of Chicago, and the Albright Art Gallery in Buffalo) and private collectors (Elsie de Wolfe, Anne Vanderbilt, and Robert Bliss). The response was gratifying, with the pictures selling at the rate of one a day. Relatives as well as friends came to buy. Matilda's nephew Clarence Mackay bought two pictures (fig. 116), one for each daughter. He took the artist off for a week of shooting in North Carolina and on their return he entertained both Walter and Matilda at Harbor Hill, his estate on Long Island.

In the introduction to the catalogue, the art critic, collector, and painter Albert Eugene Gallatin wrote perceptively about Gay's work: "His portraits of rooms—and that is what they are—are portraits full of deeply sympathetic insight. Mr. Gay has been enamoured with the rare beauty of this wonderful epoch, the eighteenth century in France, and the memories suggested and awakened by these old salons, and he has painted them with a heart full of keen appreciation and love." He described the inhabitants of these "empty" rooms as only just out of sight. "It is not necessary for our enjoyment to get a glimpse of the occupants of these rooms, because we can feel their presence. Far are these apartments from being deserted. Someone has only this moment stepped into the adjoining chamber, or out into the blaze of sunshine that comes in at a low French window," an attractive idea that was repeated and elaborated upon by nearly every subsequent writer on Gay's work.

Gallatin was from an old and distinguished family. His great-grandfather had been Secretary of the Treasury under Presidents Jefferson and Madison and then Ambassador to France. He left his family records, extending back to 1248, to the New-York Historical Society, where the Gays went to see them and were fascinated to read the correspondence between Voltaire and the Gallatin of his day. Albert first visited the Gays at Le Bréau in 1913 and was actually a nephew of Matilda's, though one would hardly guess that they were related from her description of him following their lunch in New York in April of 1920: "Mr. Albert Gallatin lunched with us, very pleasant, serious young man, who devotes himself to literature and art criticism." He had established his reputation as an art critic early in the century by writing about Aubrey Beardsley and Whistler. At his house in East Sixty-ninth Street, which the Gays visited ("the house had that atmosphere of refinement which can never be purchased"), he had a collection of drawings by Degas, etchings by Whistler, and several pictures by Walter Gay. Gallatin believed quite correctly that Walter had done some of his best work in watercolor and illustrated one in his book *American Water-colourists*, published in 1922. Gallatin then shifted gears completely and devoted himself to modern abstract painting, which he collected for his own museum called the Museum of Living Art in New York, the contents of which were finally bequeathed to the Philadelphia Museum of Art.

Albert Gallatin was an early exponent of recycling. His catalogue introduction in 1920 was an expanded version of his review of Walter's earlier exhibition at Wildenstein in 1913, which he had repeated in *Art and Progress* and used again with only slight changes in 1916 as a chapter in his book *Certain Contemporaries, A Set of Notes in Art Criticism*. The essay was further ampli-

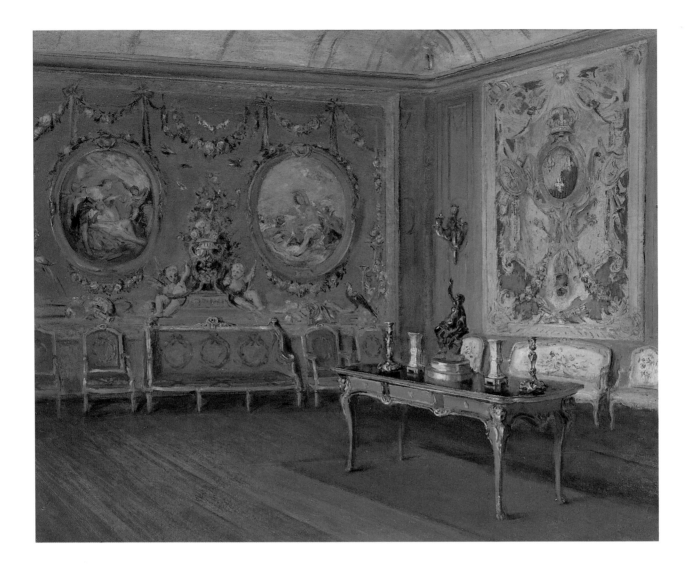

119. Walter Gay. *Tapisseries roses*. Oil on board, 20 x 24¼". Private collection

fied and used for the fifth time as the text of his next book, which appeared later in 1920, *Walter Gay, Paintings of French Interiors*, a luxurious edition of 950 copies printed on specially made paper with fifty full-page intaglio plates accompanied by descriptions of the contents of the rooms. Walter received the book in Paris the following February and was thrilled, writing to Gallatin, "The paper, the printing, the illustrations, and above all the text, all too flattering, perhaps, but sincere. I am really pleased with the success of the effort you have made—all honour to you."

The book was enthusiastically reviewed by the dealer René Gimpel in the American interior-decorating magazine *Arts and Decoration*. Gimpel was particularly impressed by the prominent owners of Gay's work: "Among the names of the collectors we find those famous the world over for the impecca-

bility of their taste." He also hoped that the book would have a positive influence on a style of decorating that he thought had gone astray. "This volume comes at an inspired moment for our education, for it will do much to combat what I term the 'false French' interpretations created by hands strangers to France."

One of the shortcomings of interior decorators was alluded to by Gallatin in his introduction, where he also took a crack at Gay's less-than-distinguished followers: "Mr. Gay has been the virtual founder of a school of painting, and many interiors similar in subject to his are to be found each year in the Paris Salon. None of his followers, however, possess his genius or accomplishment; occasionally, in fact, their pictures remind one a little of the average drawing of the architect or the decorator, devoid of all charm."

As it happened, young architects and decorators were beginning to study Walter's work. Accompanied by their professors, they were a conspicuous presence at the 1920 exhibition. "Now W. G. is looked on as an educational factor—a new and important development," Matilda reported. A development also noted by Gallatin, who thought that his book would be of practical use to the architect and decorator, "not to mention the person contemplating building a French house. I suppose, as a matter of fact, that this will probably be the chief appeal of the book." This educational aspect continued to be emphasized in *Arts and Decoration*, where Walter's pictures came to be seen essentially as illustrations of rooms in good taste. "For two reasons a close study of Walter Gay's room portraits is sure to prove of great value to all who feel more than a merely casual interest in the subject of interior decoration," wrote Costen Fitz-Gibbon in 1926. "A study of Gay's color alone should minister vast encouragement to those who profess to love color, and probably do sincerely love it, but have not the courage of their convictions when the opportunity comes to use it in their own homes. . . . Gay's extraordinary power of singling out a fine grouping . . . and presenting it vividly to the eye at its full composition and color value ought to make even the least sensitive person understand how vitally necessary it is to compose a room by groups." By studying them carefully, the amateur home improver could learn the secrets of successful decorating.

Walter's purpose in exhibiting in New York was not only to sell the pictures that he had painted in France but also to make new clients who would commission more work. One such was Mrs. Oliver Gould Jennings, who walked into Wildenstein in 1920 and bought *Tapisseries roses* (fig. 119), a picture of Gobelins tapestries and Louis XV furniture that had been assembled for an exhibition in Paris during the war. Within a week Mrs. Jennings had Walter

painting views of the library and drawing room of her Fifth Avenue apartment (figs. 120, 121). Matilda was a bit skeptical about the unknown (to her) Mrs. Jennings: "a pleasantish, youngish, prettyish woman, rather brand new, but of such are the kingdom of picture-buyers" and thus predictably critical of Mrs. Jennings's apartment."With W. G. in the afternoon to see the interior he has just finished of Mrs. Jennings—a very *banale* subject, which he has treated most skillfully." The real problem here was more likely to have been Mrs. Jennings rather than her apartment. Mrs. Oliver Gould Jennings was not just "prettyish" but a stunning beauty, and the Louis XV green *boiserie* in her far-from-banal apartment was every bit as good as the very similar *boiserie* in the green salon at Le Bréau (fig. 43), which Matilda did not find banal at all.

If Walter had required his wife's approval of every interior he painted in New York, he would have painted no interiors in New York. Matilda's judgment in such matters was simply not reliable. She had, for example, no objection to the copy of Marie-Antoinette's boudoir at Fontainebleau that Emily Vanderbilt Sloane had installed in her house in Fifty-second Street, except to note that the shape of the room differed slightly from the original and that it lacked the historical setting (i.e., the Château de Fontainebleau). Mrs. Sloane

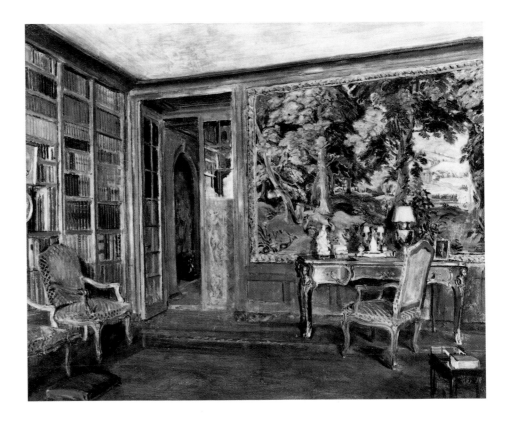

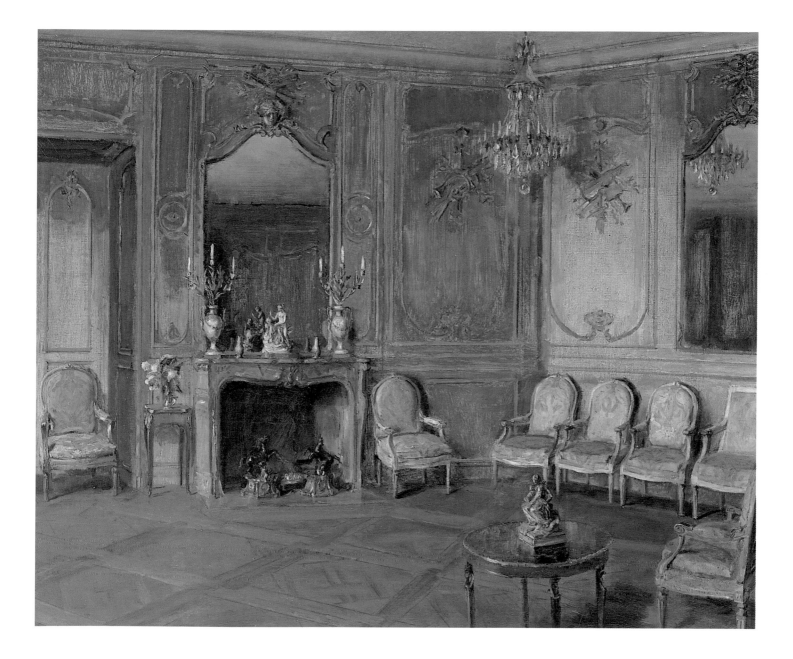

bought Walter's view of the original at the Wildenstein exhibition (fig. 122). But then Emily Sloane was the daughter of William Henry Vanderbilt and an old friend of the Gays, whom she had for dinner while they were in New York. "The hostess, now a widow, keeps up her Sunday dinners of family and friends. We were 32 at table, and the sweet nature of Mrs. Sloane pervades the atmosphere, rendering conflicting elements harmonious."

The Gays' visit to America in 1920 lasted ten weeks and repeated the pattern that had been established on earlier trips and would be followed on later ones. Although these trips were primarily for the benefit of Walter's career, he was never eager to go and had practically to be dragged abroad by Matilda. Pleased though they both were to see their relatives, they had lived so long in France that they felt like foreigners in the United States, particularly in New York, where everything was too new, too loud, and too brash. "The New York pace is too much for me," complained Matilda. While trying their best to be amiable and appreciative of the lavish hospitality, they couldn't wait to get back to Le Bréau. "How curious is the sensation of being a tourist in one's own country. It is the counterpart of being a stranger in France, our adopted home. I leave America without regret; only the affections and the great spectacle interest me." Theirs was the classic dilemma of expatriates: they were, in truth, strangers everywhere.

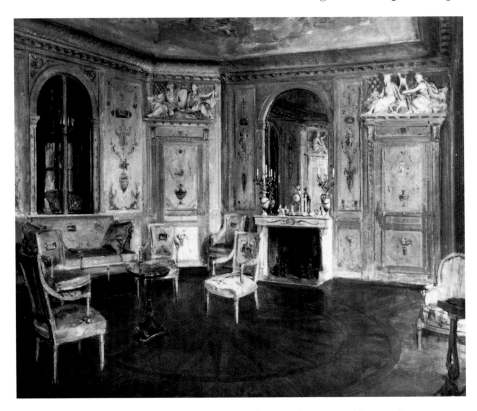

122. Walter Gay. *Boudoir of Marie-Antoinette, Château de Fontainebleau*. Oil on canvas. Private collection

For all of their ambivalence about America, and it wasn't in fact ambivalence so much as distaste, the Gays had a particular penchant for American diplomats and made some of their closest friends as well as best clients through the embassy in Paris, where they were frequent guests, despite the fact that Matilda in general disliked the sour faces of the American community and

especially the rampant bores ("It is their opportunity") who frequented embassy parties. "We found the usual motley crew which gathers at all ambassadorial receptions, but chiefly at the American, the stamping ground of so many o'er-leaping ambitions," was a fairly typical response.

Their favorite ambassador had been the affable, debonair, fox-hunting Henry White, whom Theodore Roosevelt regarded as the most useful man in the entire diplomatic service. White was much missed by the Gays after his departure from Paris in 1909, but he returned after the war to work on the League of Nations, and once again he was a guest at Le Bréau. Matilda adored him: "He is the biggest old darling in the world, with a heart of gold for all friends." After the death of his first wife, the brilliant and beautiful Margaret Rutherfurd, White married Emily Vanderbilt Sloane at the age of seventy.

When Ambassador and Mrs. Myron T. Herrick first arrived in Paris in 1912, they did not make a strong impression on the Gays. "Mr. Herrick is a very intelligent, simple, good-looking man from Ohio. He has a manly straightforwardness, which is very agreeable, but he is not made for the drawing-rooms of old Europe. . . . Mrs. Herrick is excellent, but she has never left Cleveland." He soon showed his skill as a diplomat by keeping the embassy open during the first months of the conflict, when the French government fled to Bordeaux and most of the other embassies in Paris closed. "We were more than ever proud of Ambassador Herrick, who remained at his post," Walter reported. "He had a very great responsibility, for besides looking after all the stranded Americans who found themselves in Paris, unable to get to America, he had the German Embassy to attend to. Their interests had to be in the hands of a neutral power, and Herrick was the only man to do it." During this turbulent time he came to see if the Gays were safe at Le Bréau, a visit they never forgot.

Herrick was recalled in 1914, but he returned to Paris again as ambassador in 1921 and bought for the government a house that served as the first permanent embassy. The large, handsome residence at 2, avenue d'Iéna faced streets on three sides and overlooked the Trocadéro Gardens and the Seine. The two interior views that he commissioned Walter to paint there in 1927 show some of the furniture, tapestries, and pictures that Herrick obtained for the embassy from prominent Americans in Paris, many of whom were friends of the Gays (fig. 123). He also acquired several of Walter's interiors of Le Bréau.

Herrick's counselor at the embassy, Sheldon Whitehouse, and his wife, Mary, also became friends. In 1923 the Whitehouses bought two pictures, a view of a Gobelins tapestry at Fontainebleau depicting Louis XV hunting after

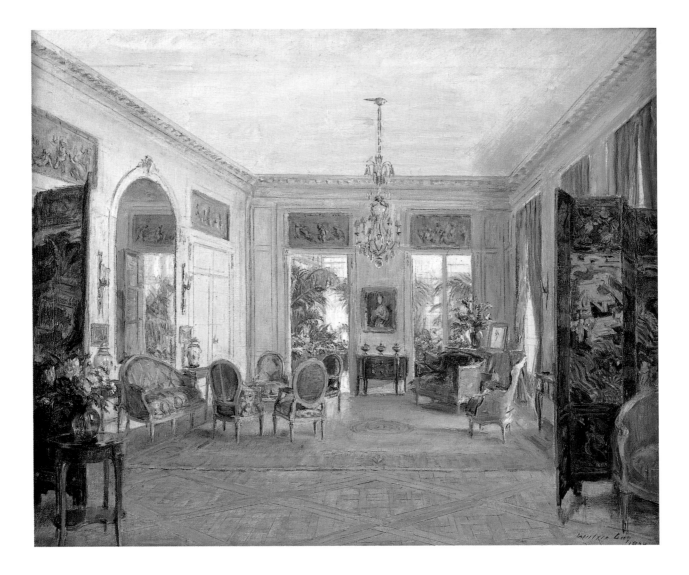

123. Walter Gay. *United States Embassy, Paris.* Watercolor. Private collection

a design by Jean-Baptiste Oudry, which they came to regard as their most cherished possession (fig. 116) and a small watercolor-and-gouache interior of Le Bréau.

The original bills of sale for these pictures survive and show that, while Walter's prices continued to rise in French francs, they did not keep up with the dollar, which quadrupled in value from 6 francs during the war to 26 francs in 1925. In 1923, when the dollar was at 15 francs, Gay was selling small watercolors for 2,000 francs (about $135, the equivalent now of about $2,300) and full-size oils for 8,000 francs (roughly $530, today about $9,000).

Robert Woods Bliss was secretary at the American Embassy in 1913, when he and his wife, Mildred, met the Gays through Edith Wharton (fig. 124).

124. Robert Woods Bliss and Mildred Bliss when he was United States
Minister to Sweden, in court dress. Photo: Harvard University Archives

Matilda liked them both immediately and asked them to Le Bréau for a shooting weekend. "He is . . . very intelligent, pleasant and gentlemanly, with a sense of humour." Matilda wished she had a son like him. Mildred's generous heart was as big as her considerable fortune, and Matilda agreed with Edith that she was "pure bliss." "She has almost every quality—beauty, sweetness, grace, and a supple mind. To crown all, they are happily married." During the war the two couples saw each other frequently. "I am always serene with this rare young couple—so complete in their union, and completing each other." At one point, Mildred set up a convalescent home for nurses next door to Le Bréau at Fortoiseau. The Blisses were serious art collectors and commissioned Walter to bid for them at the sale of Degas's estate in 1918, where they secured *The Song Rehearsal* for 100,000 francs (about $16,700). The next day at the Blisses' apartment, Mildred carried the picture "about the room in her arms like a new toy," while she and Walter studied where to hang it. The Blisses left Paris the following year but continued to see the Gays on their periodic trips back and consulted Walter on acquisitions of paintings as well as suitable frames. Mildred wrote to Walter in 1925, "I often think of you both as two of the most beloved people I know." Walter gave Mildred a pencil portrait of himself by his friend Henri Royer, inscribing it "To Mildred, with affectionate regards" (fig. 125).

On a visit to Le Bréau in 1919 Mildred had admired one of Walter's watercolors, which Robert promptly purchased for her. The Blisses went on to become among his most devoted collectors, buying six of his pictures for their

splendid house in Washington, Dumbarton Oaks, which they gave to Harvard as the Dumbarton Oaks Research Library and Collection, a research center for the study of Byzantine art and landscape architecture, where the pictures still reside. Several of these were acquired after the Blisses visited Le Bréau in 1936, a year before Walter died. Robert Bliss described his affection for Walter in the condolence letter he sent to Matilda: "I am so grateful for the friendship Walter gave me so generously. It made life for me richer and fuller, and added much of happiness and enjoyment to my existence. . . . What happy memories we have of the times we have gone the rounds of the dealers and still happier ones we have spent with him and you at Le Bréau or our delightful tête-à-tête meals at 11, rue de l'Université. It is a rich memory to which Mildred and I hold dearly."

A new patron was Baron Robert de Rothschild, with whom Gay had first dined in 1919 at his house in the avenue Marigny. The three interiors that Walter painted there during the summer of 1921 show the "goût Rothschild" at its most splendid, with an extraordinary collection of French furniture and Dutch pictures. Walter was at the very height of his fame. The periodical *L'Illustration économique et financière* reported in 1923, with only slight exaggeration, that pictures by Walter Gay were to be found in nearly every beautiful residence in Paris.

In 1925 Walter was sixty-nine years old and had until then rarely been ill, but late that year he developed an intestinal hemorrhage that required an operation. His friend Edward Tuck, whose important collection of tapestries and French furniture was left to the nation and is on permanent display at the Petit Palais, wrote a cheerful get-well letter: "What a wonderful thing is modern surgery. An intestinal side-track constructed in a few brief moments to carry for all time with perfect comfort and safety all the traffic of the main line, as though nothing had happened. It beats the first Brooklyn Bridge." But in fact the problem had been very serious. Four years later, Walter encountered an uncomfortable echo of it at the Pavillon Colombe. Edith Wharton's cook was suddenly found lying on the floor in the kitchen and had to be taken by ambulance to the hospital. Edith wrote to a friend the next day: "What is doubly strange is that W. Gay nearly died in exactly the same way several years ago, and was in fact afterward at death's door for months!"

Throughout the 1920s, Walter continued to exhibit his pictures: in 1923 in Paris at Jean Charpentier and at Wildenstein for three exhibitions in 1926, 1928, and 1930, for each of which the Gays went to New York. The first trip was largely a disaster, as Matilda had shingles and hardly left their hotel

room for seven weeks. The second went smoothly, although not without her compiling a list of the sacrifices incurred: "Holy Week services in Paris; Easter Sunday at Le Bréau; sea-sickness; enormous expense; leaving our little pups." She reported, as usual, that the exhibition was a great success, particularly the recent gouache pictures: "His admirers are astounded at the new departure of night effects in his later works." She brought to New York two of her young Wadsworth relatives, who especially wanted the pictures that had already been sold. The 1930 show did even better: "an astounding success: his gouaches and water colours are greatly admired, and acquired."

125. Henri Royer. *Walter Gay*. Pencil on paper, 11¾ x 9". Inscribed: "To Mildred, with affectionate regards, Walter Gay." Photo courtesy Dumbarton Oaks, Washington, D.C.

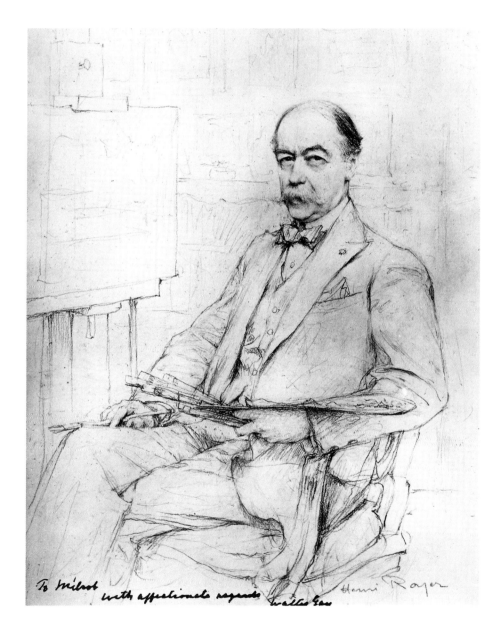

33. Memoirs of Walter Gay

After reading his wife's diary for so many years, Walter finally decided to write his own memoirs. He finished the manuscript at Le Bréau in September of 1929 and sent it off to Albert Gallatin in New York to oversee the private publication. After correcting the proofs in January, he sent Gallatin a check for $945 to cover the costs and soon received 150 handsomely printed copies of the *Memoirs of Walter Gay*.

Written in an engagingly direct and modest manner, the book describes Walter's teenage trip to Nebraska, his early years in Paris, his marriage to Matilda, and their life at Le Bréau during the war. The brevity of his seventy-six-page text is in marked contrast to Matilda's encyclopedic diary. Most of his friends who received the slim volume wished it had been longer. Several noted similarities with his pictures.

Their friend of many years and Edith Wharton's former lover, the journalist Morton Fullerton, responded: "The delightful 'measure' of your *Memoirs* is one with the distinguished delicacy of your immortal interpretations of 'the spirit of empty rooms.' . . . Your manner is delightful in its taste . . . a model for any gentleman minded to write about himself."

Edith Wharton was in the process of writing her own memoirs and was rather taken aback that Walter had beaten her to it. "What a surprise!" she wrote. "And what a march you have stolen on me. Here have I been pegging away in a desultory fashion at my reminiscences for the last year, and out comes your little volume, complete and rounded off, and reading as if it had cost you no more trouble than if your pen had been a brush. All my congratulations in having set down these memories of so happy and successful a life. I wonder how many of us could say that we have never repented the chief decisions of our lives? I am glad that you have been singled out by Fate as one of the few, for you and Matilda have given back a hundredfold to your friends the kindness you have received from the Gods. Thank you so much for sending me this charming little book."

Which indeed it is, but it is also a book as revealing for its exclusions as its inclusions. The chapters on his teenage year in the West and on life at Le Bréau during the war are vividly written and fascinating. But this was not the

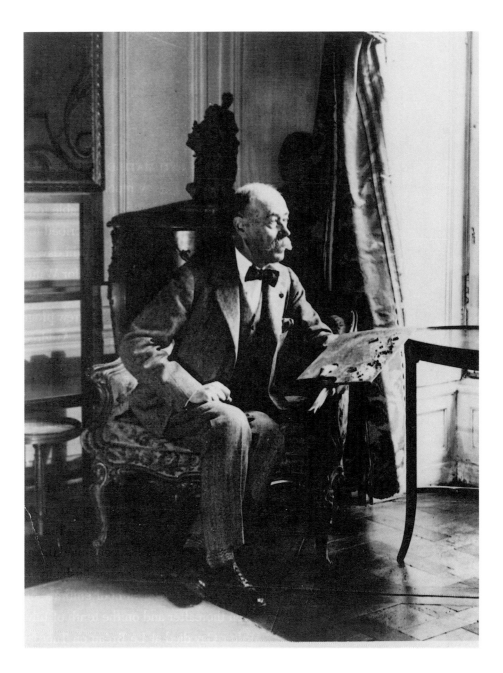

126. Walter Gay, c. 1930.
Photograph: Collection
Arthur T. Garrity, Jr.

type of book nor was Walter Gay the type of man who would write anything that might discomfort Matilda. The topic of their failure to have the children she so strongly wanted was obviously off-limits, but there were many other safer subjects—family, friends, and the rewards and frustrations of life in France about which he was almost totally silent. Written with uncommon discretion, these are the memoirs of a reserved and mild-mannered artist *"doublé d'un gentilhomme."*

217

34. The Last Years

BY 1932 WALTER AND MATILDA WERE BOTH ON THE DECLINE. THEIR friend Berthe de Ganay reported to Edith Wharton at Easter that they were "rather shaky." But they were still able to do week-long sightseeing trips in France, which Matilda, as usual, described in detail: 1933 (eight days, thirteen churches, two museums); 1934 (eight days, seven churches, one château). It was, however, increasingly too much for Walter, who had at times to stay in the car.

After their last trip in 1934, he grew progressively weaker. Matilda gave an account of his deteriorating health to Mildred and Robert Bliss on Christmas Eve 1936: "Walter Gay is very feeble, more so even since last summer. The doctors diagnose it as atrophy of the muscles of the thighs, also of the arms. He cannot walk without assistance, nor can he paint much. He is very patient under these privations. His friends are very kind to him, and come often to see him." The implicit message in her closing sentence was clear: "We shall look forward to seeing you next year—but don't put it off too long!"

Years earlier a friend had asked Matilda if Walter showed any "leanings" toward the church. "No," she replied, "but he admires it immensely and detests all other religions." Thinking that this was probably as good as it was likely to get, Matilda nonetheless continued the prayers that she had been making ever since their wedding for her husband's conversion, prayers that were finally answered in his eleventh-hour embrace of Catholicism. General paralysis set in soon thereafter and on the tenth of July he lost consciousness.

Walter Gay died at Le Bréau on Tuesday, July 13, 1937, at the age of eighty-one. The simple funeral was held the following Saturday in the tiny fifteenth-century Gothic Church of Saint-Aspais at Melun, which was draped in black curtains, the coffin resting in the center surrounded by hundreds of lighted candles. "There were no speeches or invocations, but for almost an hour the singing of the . . . choir rang through the church," Matilda recorded. "A few prayers, delivered by the priest, were answered by the choir."

Geoffrey Dodge reported to Mildred Bliss, "I am just back from Walter Gay's funeral. . . . Matilda of course is very broken and is aged years and looks horribly feeble, but of course is bearing up as she would. I have a feeling that

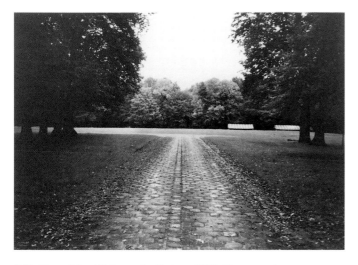

127. Site of the Château du Bréau, 1998. Photo: author

she can't last long. . . . She is exhausted now and has gone back to Le Bréau."

Walter was buried in the plot they had chosen together in the cemetery of Saint-Germain. Although far from ideal, it was, they thought, probably the best that could be found under the circumstances. "We had, years ago, bought a tiny plot at Hingham, near the old Gay burial plot," Matilda wrote. "But the difficulties and painfulness of the voyage back, useless turning of the knife in the wound, caused by the post-mortem patriotism of so many Americans who can't bear to live in their country and yet yearn to be laid there to rest, has decided us to this step. Like all continental cemeteries, this, at St. Germain, is defaced by the tributes to the departed. Grief takes such gruesome and unlovely forms in Latin countries. There is nothing of the sweet peace of the English graveyard, or of the tidy taste of an American cemetery. The artificial flowers and beaded wreaths, looking like bonnet frames, the utterly tasteless tombs, and general bleakness rob the sacred spot of all dignity and charm."

The obituaries in the *New York Times* and *New York Herald Tribune* announced the death of the "Dean of American Painters in France" and listed his numerous honors, societies, and clubs. The award that had pleased him the most was given in 1927: Commander of the Legion of Honor. The anonymous writer of the entry in *The National Cyclopaedia of American Biography* the following year must have known him well: "He had a gentle nature, always looked for the good in everyone, was a keen observer and a man of strong attachments."

Among the many condolence letters Matilda received was one from Edith Wharton, who had been at the funeral. "I am sending you this line by Elisina [Tyler], to tell you how sorry I am not to be able to go with her to see you this afternoon. I should have been quite willing to risk the fatigue, but Elisina & my maid behaved so awfully about it that I had no alternative [but to] go on snoozing on the sofa; so I send you instead my best love & deepest sympathy by Elisina. How often in passing your gate, I have said to myself, 'I must stop & give a hug to dear Walter Gay'—& I am happy to say that I have always done it until today, when, alas, it only half matters. This brings you my best love, & many many thoughts of my beloved W. G. under whose mauve poppies,

given to me 18 years ago, I am now lying" (see fig. 76). It was the last letter Edith Wharton ever wrote, for a week later she died as well. On August 14 Matilda attended her funeral service in the village of Saint-Brice and the burial at the Cimetière des Gonards in Versailles, a cemetery that seemed just as bleak as that at Saint-Germain.

By the end of the year, Matilda was feeling much stronger, as Geoffrey Dodge reported to Mildred Bliss: "She is really splendid, is taking an interest in everything and has people all the time for lunch, goes to all the Exhibitions and is really keeping up splendidly. She is going to keep Le Bréau and be there next summer, and seems in good health. I lunch there about once a week, so keep in close touch with her."

She wanted to sell Walter's pictures to American museums, and she asked Dodge to help. He wrote to Mildred, "I had a long talk with Mrs. Gay the other day about selling the pictures that she has by Walter. . . . She said she did not wish at the present moment to sell to private individuals, but was delighted with my suggestion that he, being such an outstanding American painter, should be represented in all American museums. . . . I am sure that you will agree with me that all American museums should have a Walter Gay." But not all American museums shared that belief, and his efforts were unsuccessful. The museums that did not already have a Walter Gay were apparently not, in 1937, interested in buying one. Matilda was also ready to sell Walter's collection of antique frames, which Dodge offered to the Blisses for 400,000 francs ($80,000).

At this point money was clearly a problem. Because the Gays had remained American citizens, the gift of their collection to an American museum would have resulted in a considerable tax benefit, but there was no financial advantage in giving it to the Louvre. Foreseeing that she might need to raise capital to pay for death duties, Matilda had retained some of their drawings, the best of which, Fragonard's *La Fête de Saint-Cloud,* she placed in 1938 with the Paris dealer André Weil to sell. Whether he succeeded in selling it is not clear. The drawing was stolen by the Germans during the war and recovered by the French in 1946, when it was shown in Paris in an exhibition entitled "Les chefs-d'oeuvre de collections françaises retrouvés en Allemagne." The drawing was later acquired by the famous banker Robert Lehman, who gave it, together with his extraordinary collection of old-master paintings and drawings, to the Metropolitan Museum of Art.

The Metropolitan Museum of Art held a memorial exhibition of Walter Gay's paintings in 1938, consisting entirely of interior views from American

collections, many lent by his prominent friends and patrons (Mrs. Vincent Astor, the Blisses, Helen Clay Frick, Albert Gallatin, Clarence L. Hay, Mrs. Oliver Gould Jennings, James Speyer, and Mrs. Herbert N. Straus). In reviewing the exhibition, Gallatin wrote, "Walter Gay had a most beguiling personality, gentle, exquisitely courteous, as though there lived again in him the tradition of that period of culture to which he was devoted. Traversing this exhibition I have been moved by the beauty with which the pictures in it reproduce interiors I have known. At the same time I have been conscious of the beautiful nature out of which they proceeded, the man who was as lovable as the artist."

Many years before Matilda had written, "How I dread being the 'last leaf on the tree!' It is such a lonely fate." This, of course, is exactly what transpired, but not in her worst nightmares could she have envisioned just how grotesque that fate was to be. In the midst of another war that she thought she would never live to see, she became a "guest" at Le Bréau, now occupied by jack-booted German officers, stomping about on the parquet floors, plotting the destruction of the country where she had lived most of her life. "After half a century in France, one can live nowhere else," she had once explained to a friend. In her bedroom on the second floor, she listened to the tinkling of the crystal Louis XV chandeliers and looked out at the now desolate gardens.

On her death in 1943, she left Walter's unsold pictures and her diary to her favorite niece, Sophie Gay Griscom, who had stayed with them for two years in the early 1920s. It seemed fitting that Le Bréau should go to her favorite nephew, James Wadsworth, whose family would surely enjoy the place that had given the Gays and their friends such pleasure for so many years.

But that was not to be for long. After Wadsworth's death in 1952, Le Bréau was sold and eventually became the property of the local commune, that wanted to use it as a school but soon discovered that it failed to meet the necessary building codes. The château was demolished in 1971. Today the site is a *centre des loisirs* [recreation center], with one of the two stable blocks restored for that purpose. The walled gardens are empty. In the French garden there remains only a semicircle of stone pedestals, which once supported ornamental vases in front of the chestnut trees. The moat and ponds have been filled in and the drive now ends at a large field of grass (fig. 127).

Across the road from the château that was filled with the Gays' passion for the *parfum du passé*, in the field where they liked to sit among the wheat sheaves at sunset gazing at their beloved Bréau bathed in golden light, there now looms an enormous and indescribably hideous shopping center.

Notes

The following abbreviations are used:

AAA: Archives of American Art, Smithsonian Institution, Washington, D.C. Walter Gay's papers were given to the Archives of American Art by his niece Mrs. Sophie Gay Griscom and nephew John Gay. Included are scrapbooks containing letters, sketches and sketchbooks, photographs and printed material. They are microfilmed on reels 2137–2139 and 2802.

MG: Matilda Gay

MGD: Matilda Gay's diary, unpublished, collection Arthur T. Garrity, Jr. Cited in the notes only when required to clarify dates.

WG: Walter Gay

WGM: *Memoirs of Walter Gay*, New York, privately printed, 1930.

Introduction
Page

6 "The pictures . . . cultivated epoch." Albert E. Gallatin, introduction in *A Memorial Exhibition of Paintings by Walter Gay*. November 28–December 22, 1945, Wildenstein, New York.

Prologue. May 1945
Page

9 "Aunt Tillie's . . . pillow cases." Stuart Symington, Jr., to author, June 17, 1998.

13 "During Mr. Travers's. . . lively succession." Mrs John King Van Rensselaer, *Newport, Our Social Capital* (Philadelphia/London, 1905), p.91.

Chapter 1. Matilda Travers and Walter Gay
Page

14 "Besides . . . family of London. WGM, p. 57.

14 "This wise form of gift . . . and friends," WGM, pp. 57–58.

Chapter 2. Walter Gay, Genre Painter
Page

17 "[My uncle] had gone . . . after life." WGM, p. 12.

17 "I grew up . . . about art." WGM, p. 12.

17 "I jumped at the chance . . . go aboard." WGM, p. 13.

17 "Walter Gay . . . they are now." Unidentified newspaper clipping, scrapbook, Gay Papers, AAA.

18 "who had known . . . the past." WGM, p. 43.

18 "stressed simplicity . . . own work." Julius Kaplan, "Léon Bonnat," *The Dictionary of Art*, vol. IV (London, 1996), p. 329.

18–19 "The usual way . . . louder than ever." Barclay Day, l'Atelier Bonnat," *The Magazine of Art* 5 (1882), pp. 138–40.

19 "I went to his studio . . . few years." WGM, p. 44.

20 "I remember . . . any money." WGM, p. 44.

20 "Bonnat . . . all art." WGM, p. 48.

20 "On this . . . to go home." WGM, pp. 52–53.

20–21 "The surprise . . . great progress." undated newspaper clipping, scrapbook, Gay Papers, AAA.

21 "The large and spacious . . . art debut." unidentified newspaper clipping, Gay Papers, AAA.

21–22 "We went over . . . lawn tennis." "Two Americans in Paris—1885," *Archives of American Art Journal* 12, no. 4 (1972), pp. 23–24.

22 "symphony . . . meagre meal" "American Artists at the Paris Exhibition," *Harpers New Monthly Magazine* 79 (September 1889), pp. 511–12.

22 "My pictures . . . receiving medals." WGM, p. 56.

Chapter 3. Walter Gay, Painter of Interiors
Page

24 "Medals and honours . . . to me." WGM, p. 60.

24 "It was a little . . . paintable," WGM, pp. 59–60.

24 "I painted . . . to do." WGM, p. 60.

24 "Walter had exquisite . . . is due." Mrs. Winthrop Chanler, *Autumn in the Valley* (Boston, 1936), p. 115.

26 "Invitations were sent . . . the inauguration," MGD, March 3, 1905.

28 "I've had . . . of thing." WG–MG, undated [July 1907], AAA, no. 61.

29 "I must send . . . you both." Edith Wharton–WG, undated [1908], AAA, no. 71.

30–31 "In the afternoon . . . has been." MGD, April 15, 1908.

31 "This makes his fifth . . . happy artist." MGD, April 13, 1910.

33 "understood that inanimate . . . a glimpse." Henri Lavedan,

"Walter Gay" in *Exhibition of Paintings and Water Colors by Walter Gay at the Galleries of E. Gimpel and Wildenstein*, New York, March 4–April 4, 1913.

33 "Miss Wolfe is a . . . of taste." WG–Wildenstein, March 23, 1913, AAA.

33–34 "The quality of reserved . . . delighted me." J. T. Coolidge–WG, March 21, 1913, AAA, no. 110.

34 "Your exhibition . . . to notice." Mary Cadwalader Jones–WG, March 10, 1913, AAA, no. 108.

34 "Mr. Gay's exhibition . . . courtyard." Mrs. Peixotto–MG, March 11, 1913, AAA, no. 107.

34 "I must take a minute . . . of affliction." Edward Robinson–WG, March 6, 1913, AAA, no. 105.

Chapter 6. The Country
Page

55–56 "The memory . . . and complete." Margaret Terry Chanler–MG, December 21, 1905, AAA, no. 203.

56 "Enfin Le Bréau . . . des rêves!" Gabriel de Mun–MG, undated, 1913, AAA, no. 112.

56 "An old high-roofed house . . . dim embroidery." Edith Wharton, *The Reef* (New York, 1912; reprint ed. 1965), pp. 83, 109.

59–60 "The sofas and chairs . . . color." WG–MG, May 31, 1914, AAA, no. 123.

64 "They are perfectly killing . . . exactly right," WG–MG, May 31, 1914, AAA, no. 123.

65 "The chapel . . . changing it." *Autumn in the Valley*, p. 117.

69 "We have lived . . . the neighbours," WGM, p. 87.

69 "I went to Maples . . . less lonely." WG–MG, undated [1913], AAA, no. 116.

71 "Le Bréau was more . . . the pace." Henry Adams–Elizabeth Cameron, June 25, 1907, *The Letters of Henry Adams*, vol. VI (Cambridge / London, 1988), p. 74.

73 "I haven't bought . . . good things." WG–MG, May 31, 1914, AAA, no. 123.

73 "In the day time . . . of it." WG–MG, June 2, 1914, AAA, no. 124.

73 "The last event . . . and lamps." WG–Mildred Bliss, Dec. 11, 1920, Dumbarton Oaks Archives, Washington D.C.

74 "The mécanicien . . . shined up." MG–WG, July 5, 1910, AAA, no. 88.

74 "Les automobiles . . . la prudence." Comtesse Robert de Fitz-James–MG, September, 1916, AAA, p. 21.

75 "Everything is going . . . you arrive." WG–MG, May 31, 1914, AAA, no. 123.

76 "Peggy also begins . . . the motor." WG–MG, May 31, 1914, AAA, no. 123.

76 "I therefore got rid . . . is today." WGM, p. 63.

Chapter 7. Travel
Page

78 "Before 1895 . . . *commis-voyageurs*." WGM, p. 58.

82 "A lady occupying . . . at 10 p.m." MGD, July 25, 1921.

86 "My own confidence . . . above suspicion." Eben Howard Gay quoted in John Griffen, "Chippendales are withdrawn," undated newspaper article, Museum of Fine Arts Archives, Boston.

88 "How I long . . . of them." WG–MG, June 13, 1908, AAA, no. 77.

88 "fairly kept me awake with terror." Edith Wharton–Bernard Berenson, May 23, 1920, quoted in R. W. B. Lewis and Nancy Lewis, *The Letters of Edith Wharton* (New York, 1988), p. 432.

Chapter 8. The Gays as Collectors
Page

89–90 "Very early in Walter . . . one another." *Autumn in the Valley*, p.116.

95 "It certainly is a great gesture . . . magnificent gift," Geoffrey Dodge–Mr. and Mrs. Bliss, January 8, 1938, Dumbarton Oaks Archives.

Chapter 9. Edward Robinson
Page

98 "I told [Bonnat] . . . a mission," WG–MG, undated, 1903, AAA.

98 "Robinson is a . . . to sell." WG–MG, undated, 1903, AAA, no. 174.

98–99 "Wasn't it nice . . . Robinson says." WG–MG, undated [1903], AAA.

99 "There is plenty . . . unknown hand'" WG–MG, May 11, 1905, AAA, no. 201.

100 "My last interview . . . this world." WG in E. R. and J. Pennell, *The Life of James McNeill Whistler* (Philadelphia, 1908), p. 155.

100 "One of the well known . . . of it." WG–Edward Robinson, Feb. 28, 1906, Metropolitan Museum of Art Archives, quoted in Natalie Spassky, *American Paintings*

in the Metropolitan Museum of Art, vol. II (New York, 1985), p. 372.

100 "On arriving from Italy . . . no hurry." WG–Edward Robinson, April 27, 1906, *American Paintings in the Metropolitan Museum of Art*, vol. II, p. 372.

101 "perhaps the most beautiful . . . were conducted." *Bulletin of the Metropolitan Museum of Art* 1, no. 7, (June 1906), p. 105.

101 "[The cracks] must have . . . the cracks." WG–Edward Robinson, Nov. 13, 1906, *American Paintings in the Metropolitan Museum of Art*, vol. II, p. 372.

101 "In the short visit . . . our house," WG–Edward Robinson, May 1906, Metropolitan Museum of Art Archives.

101 "Mr. and Mrs. Roger Fry . . . appalling dowdiness." MGD, May 27, 1906.

102–3 "Mr. Morgan . . . his glass." MGD, March 12, 1908.

Chapter 10. Ralph Curtis
Page

105 "I find Ralph . . . happy here." WG–MG, undated [1906], AAA, no. 205.

105 "Mrs. Ralph is charming . . . is dangerous." Henry Adams–Elizabeth Cameron, September 18, 1899, *The Letters of Henry Adams*, vol. V, p. 40.

106 "It's all about me . . . all parties." Henry Adams–Elizabeth Cameron, June 9, 1908, *The Letters of Henry Adams*, vol. VI, p. 152.

106 "all the luxury . . . their crowd." Ernest Samuels, *Bernard Berenson* (Cambridge / London, 1987), p. 120.

106–7 "in the high florid rooms . . . figured concavity." Henry James, *The Wings of the Dove* (New York, 1909), p. 132.

Chapter 11. John Singer Sargent
Page

110 "[Sargent] was then . . . his art." WGM, p. 40.

110 "At Sargent's . . . of course." WG–MG, undated [July 1907], AAA, no. 61.

110–11 "In the afternoon . . . everyone else." MGD, July 15, 1904.

Chapter 12. Lord Ribblesdale and Lady de Grey
Page

114 "I haven't got . . . this attention." WG–MG, June 1905, AAA, no. 202.

Chapter 13. Elsie de Wolfe, Bessie Marbury, and Anne Morgan
Page

115–16 "I went to the Marbury . . . their world." Henry Adams–Elizabeth Cameron, January 28, 1901, *The Letters of Henry Adams*, vol. V, p. 189.

116 "a brilliant coterie . . . good talk." Elsie de Wolfe, *After All* (New York, 1935), p. 107.

116 "the flutter of Sapphic society." *Bernard Berenson*, p. 62.

116 "into the very lap . . . luxury." *Bernard Berenson*, p. 64.

116 "[They] were international . . . good time." *After All*, p. 162.

116–17 "Miss de Wolfe kindly . . . on Sunday." WG–MG, May 31, 1914, AAA, no. 123.

117 "Those two women . . . they were." Edith Wharton–Mary Cadwalader Jones, April 15, 1916, quoted in Alan Price, *The End of the Age of Innocence* (New York, 1996), p. 81.

117 "Edith Wharton, as I remember her . . . of manner." *After All*, p. 107.

117 "She simply cleared . . . twentieth century." Diana Vreeland in Jane S. Smith, *Elsie de Wolfe* (New York, 1982), p. xv.

117 "I believe in plenty of optimism . . . all rooms." Elsie de Wolfe, *The House in Good Taste* (New York, 1913), p. 48.

118 "The Morgan wing . . . will do." WG–MG, May 31, 1914, AAA, no. 123.

118 "I am not one of those . . . the original." *The House in Good Taste*, pp. 261, 257.

118 "The note of the interior . . . *objets d'art*." *The House in Good Taste*, p. 294.

119 "The house itself was enchanting . . . and small." Diana Vreeland in *Elsie de Wolfe*, p. 76.

119–20 "There was a marble mantel . . . the fireplace." *After All*, p. 128.

122 "The house is narrow . . . have had." *The House in Good Taste*, pp. 47–48.

Chapter 14. Edith Wharton
Page

124 "It is copied from Belton . . . our own." MGD, June 16, 1905.

126 "No press of business . . . Poilu went." Edith Wharton–MG, May 19, 1924, AAA, p. 81.

127 "My thirteen years of Paris life . . . happy years." Edith Wharton, *A Backward Glance* (New York & London, 1936), p. 258.

129 "a kind of continuous earthquake . . . one's door." Edith Wharton–Bernard Berenson, quoted in R. W. B. Lewis, *Edith Wharton* (New York, 1985), pp. 419–20.

129 "in motoring out . . . of 1918." *A Backward Glance*, p. 362.

130 "As soon as I was settled . . . into my life." *A Backward Glance*, p. 363.

130 "To St. Brice . . . main point." MGD, August 19, 1919.

132 "The big salon at Mrs. Wharton's . . . help her." Ogden Codman letter to unknown, filed with letter to "Tom," August 10, 1931, Boston Athenaeum.

132–33 "Here was such a high goal . . . faculties." quoted in *Edith Wharton*, p. 454.

Chapter 15. Henry James
Page

139 "The Walter Gays gave me . . . massive gold!" Henry James–Mary Cadwalader Jones, January 31, 1913, quoted in Millicent Bell, *Edith Wharton & Henry James* (New York, 1965), p. 187.

139–40 "I send my most affectionate love . . . their immortality." Henry James–Edith Wharton, October 13, 1914, Lyall H. Powers, ed., *Henry James and Edith Wharton: Letters: 1900–1915* (New York, 1990), p. 308.

140 "Posted here in London . . . some days." Henry James–Edith Wharton, October 17, 1914, *Henry James and Edith Wharton: Letters*, p. 310.

140 "I had with me . . . little pair" Henry James–Edith Wharton, October 20, 1914, *Henry James and Edith Wharton: Letters*, p. 312.

140 "It's splendid of you . . . Henry James." Henry James–Walter and Matilda Gay, August 1, 1915, AAA, no. 151.

Chapter 16. Jacques-Emile Blanche
Page

141 "Blanche took us up . . . medallion face." MGD, January 31, 1909.

Chapter 17. Egerton Winthrop
Page

143 "the lover of books . . . to see." *A Backward Glance*, p. 94.

144 "the first in New York . . . designed setting." *A Backward Glance*, p. 92.

144 "Few apartments . . . particular era." George William Sheldon, *Artistic Houses*, vol. I (New York, reprint 1971), p. 135.

144 "When, at night . . . than described." *Artistic Houses*, p. 137.

Chapter 18. Henry Adams
Page

146 "These artists . . . an artist!" Henry Adams–Elizabeth Cameron, August 21, 1899, *The Letters of Henry Adams*, vol. V, p. 17.

146 "I passed Sunday . . . or discuss." Henry Adams–Elizabeth Cameron, August 14, 1899, *The Letters of Henry Adams*, vol. V, p. 9.

146 "Walter Gay, whom I asked . . . was cheap. " Henry Adams–Elizabeth Cameron, October 16, 1899, *The Letters of Henry Adams*, vol. V, p. 47.

146 "My meals grew . . . St. Simon," *The Letters of Henry Adams*, vol. V, p. 46.

148 "My visit to Le Bréau . . . cat-fight." Henry Adams–Elizabeth Cameron, September 21, 1909, *The Letters of Henry Adams*, vol. VI, p. 278.

Chapter 19. Alfred Sommier
Page

150 "ran over to Vaux . . . within bounds." Henry Adams–Elizabeth Cameron, July 31, 1908, *The Letters of Henry Adams*, vol. VI, p. 167.

153 "this picture which is . . . your brush." Alfred Sommier–WG, September 8, 1908, AAA, no. 83.

154–55 "I said to him . . . our naughtiness." MGD, March 14, 1908.

Chapter 20. Comte de Vogüé
Page

157 "famous plane tree . . . are doomed," MGD, September 1, 1910.

Chapter 21. Comtesse Robert de Fitz-James
Page

158 "[She] was a small thin . . . in Paris." *A Backward Glance*, p. 265.

205 "His portraits of rooms . . . French window." Albert Eugene Gallatin, introduction in *An Exhibition of Paintings and Water Colors by Walter Gay*, February 17th to March 6th, 1920, E. Gimpel & Wildenstein, New York.

206 "The paper . . . to you." WG–A. E. Gallatin, February 1921, Gallatin Collection, New-York Historical Society.

206–7 "Among the names . . . to France." Rene Gimpel, "Walter Gay, Paintings of French Interiors," *Arts and Decoration*, 15, no. 2 (June 1921), p. 93.

207 "Mr. Gay has been . . . all charm." Albert Eugene Gallatin, *Walter Gay, Paintings of French Interiors* (New York, 1920), p. 3.

207 "not to mention . . . chief appeal." *Walter Gay, Paintings of French Interiors*, p. 6.

207 "For two reasons . . . by groups." Costen Fitz-Gibbon, "Room Portraits by Walter Gay," *Arts & Decoration* 25, no. 4 (August 1926), p. 30.

211 "We were more than ever proud . . . do it." WGM, p. 65.

213 "I often think of you both . . . I know." Mildred Bliss–WG, February 10, 1925, AAA, p. 83.

214 "I am so grateful . . . hold dearly." Robert Bliss–MG, July 28, 1937, collection Arthur T. Garrity, Jr.

214 "What a wonderful thing . . . Brooklyn Bridge!" Edward Tuck–WG, February 5, 1926, AAA, p. 89.

214 "What is doubly strange . . . for months!" Edith Wharton–Gaillard Lapsley, August 8, 1930, *The Letters of Edith Wharton*, p. 528.

Chapter 33. *Memoirs of Walter Gay*

Page

216 "The delightful 'measure' . . . about himself." Morton Fullerton–WG, May 3, 1930, AAA, p. 111.

216 "What a surprise! . . . little book." Edith Wharton–WG, May 4, 1930, AAA, p. 108.

Chapter 34. The Last Years

Page

218 "Walter Gay is very feeble . . . too long!" MG–Mildred & Robert Bliss, Christmas card dated December 24, 1936, collection Arthur T. Garrity, Jr.

218–19 "I am just back . . . Le Bréau." Geoffrey Dodge–Mildred Bliss, July 19, 1937, Dumbarton Oaks Archives.

219 "He had a gentle nature . . . strong attachments." *The National Cyclopaedia of American Biography*, vol. XXVII, p. 37.

219–20 "I am sending you . . . now lying." Edith Wharton–MG, August 4, 1937, *The Letters of Edith Wharton*, p. 607.

220 "She is really splendid . . . with her." Geoffrey Dodge–Mr. and Mrs. Bliss, January 8, 1938, Dumbarton Oaks Archives.

220 "I had a long talk . . . Walter Gay." Geoffrey Dodge–Mildred Bliss, September 30, 1937, Dumbarton Oaks Archives.

220 *La fête de Saint-Cloud*, see Metropolitan Museum of Art, *The Robert Lehman Collection, VII, Fifteenth- to Eighteenth-Century European Drawings, Central Europe, The Netherlands, France, England*, 1999, no. 121, pp. 337–39.

221 "Walter Gay . . . the artist." In "Walter Gay, A Memorial Exhibition at the Metropolitan Museum of Art." Collection Arthur T. Garrity, Jr.

Selected Bibliography

Books, catalogues, and articles

Allen, Josephine L. "A Memorial Exhibition of Paintings by Walter Gay," *Metropolitan Museum Bulletin* 33 (April 1938), pp. 100–102.

Baschet, Jacques. "Le Château du Bréau: Peintures et aquarelles de Walter Gay," *L'Illustration* (August 14, 1928), pp. 124–28.

Bazin, Germain. "Expositions à l'Orangerie: La Collection Walter Gay au Musée du Louvre," *L'Amour de l'art* 29, no. 1 (February 1938), pp. 25–30.

Bouyer, Raymond. "Les Expositions: Walter Gay," *Revue de l'art* 43, (March 1923), pp. 229–31.

Burke, Doreen Bolger. *American Paintings in the Metropolitan Museum of Art*, vol. III. New York, 1980, pp. 292–98.

Cortissoz, Royal. "Walter Gay," *Commemorative Tributes of the American Academy of Arts and Letters, 1905–1941*. New York, 1942, pp. 359–62.

"Distinguished Paintings of Old French Interiors by Walter Gay," *Arts and Decoration* 34, no. 5 (March 1931), pp. 40–41.

Fitz-Gibbon, Costen. "Paintings of French Interiors by Walter Gay," *Arts and Decoration Quarterly* 1, no. 2 (Summer 1929), pp. 16–19, 100.

Fitz-Gibbon, Costen. "Room Portraits by Walter Gay," *Arts and Decoration* 25, no. 4 (August 1926), pp. 29–30.

Gallatin, A. E. *American Water-colourists*. New York, 1922, p. 15, fig. 28.

Gallatin, A. E. *Certain Contemporaries; a Set of Notes in Art Criticism*. New York, 1916.

Gallatin, A. E. "Mr. Walter Gay's Interiors," *Art and Progress* 4, no. 9 (July 1913), pp. 1023–27.

Gallatin, A. E. *Walter Gay: Paintings of French Interiors*. New York, 1920.

Gay, Walter. *Memoirs of Walter Gay*. New York, 1930.

Gillet, Louis. "Walter Gay," *Revue de l'art ancien et moderne* 39 (January 1921), pp. 32–44.

Gillet, Louis. "Walter Gay: Peintre d'intérieurs," *L'Illustration* (December 5, 1923).

Gimpel, René. "Walter Gay, Paintings of French Interiors," *Arts and Decoration*, 25, no. 2 (June 1921), p. 93.

Huyghe, René. "La Donation Walter Gay au Musée du Louvre," *Bulletin des Musées de France* 10, no. 1 (January–February 1938), pp. 6–8.

Jaffrenou, M. E. "Catalogue des dessins de la collection Walter Gay conservés au Cabinet des Dessins du Louvre (Écoles françaises et anglaises)" (dissertation), École du Louvre, Paris, 1984.

Jewell, Edward Alden. "A Walter Gay Memorial," *New York Times*, April 10, 1938, p. 7.

Lane, James. "Walter Gay," *Art in America* 26, no. 1 (January 1938), pp. 24–28.

Lane, James. "Walter Gay Interiors," *Art News* (January 21, 1939), p. 11.

"Memorial to Gay: Painter of Empty Rooms," *Art Digest*, 12, no. 15 (May 1, 1938), p. 13 [Review of Metropolitan Museum exhibition].

Musée d'Orsay. *Catalogue sommaire illustré des peintures,* vol. I. Paris, 1990, pp. 208–9.

Orr, Lynn Federle. "Walter Gay," in Katherine Harper Mead (ed.), *The Preston Morton Collection of American Art, Santa Barbara Museum of Art.* Santa Barbara, Calif. 1981, pp. 176–78.

Quick, Michael. *"American Expatriate Painters of the Late Nineteenth Century* (exhibition catalogue). Dayton, Ohio, 1976, p. 100, fig. 8, no. 16, and bibliography.

Reynolds, Gary A. "The Spirit of Empty Rooms: Walter Gay's Paintings of Interiors," *Antiques* 137 (March 1990), pp. 677–87.

Reynolds, Gary A. "Walter Gay," in *The Dictionary of Art*, vol. XII. New York, 1996, pp. 212–13.

Reynolds, Gary A. *Walter Gay: A Retrospective* (exhibition catalogue). Grey Art Gallery, New York, 1980.

Scott, Barbara. "Dancing Sunbeams," *Country Life* (April 20, 1995), pp. 82–85.

"Walter Gay Dies," *Art Digest* 11, no. 19 (August 1, 1937), p. 25.

"Walter Gay Dies in France at 81; A Noted Painter," *New York Herald Tribune*, July 15, 1937.

"Walter Gay, 81: American Painter," *New York Times*, July 15, 1937, p. 19.

"Walter Gay, 81; Famous Artist, Born in Mass.," *Boston Transcript*, July 15, 1937.

Wolf, Ben. "Rooms with Souls," *Art Digest* 20, no. 5 (December 1945), p. 17.

Additional bibliography in Michael Quick, 1976, and Gary A. Reynolds, 1980.

Walter Gay Exhibitions

1905, Paris. Galerie Georges Petit, *Exposition des tableaux par Walter Gay*, March 3–15, 1905

1908, Paris. Galerie Georges Petit, *Exposition Walter Gay*, April 1–15, 1908. Catalogue introduction by Henri Lavedan

1913, New York. E. Gimpel & Wildenstein, *Paintings and Water Colors by Walter Gay*, March 4–April 4, 1913. Catalogue introduction by Henri Lavedan

1913, Buffalo. Buffalo Fine Arts Academy, *Oil Paintings and Water Colors by Walter Gay*, July 1913

1914, Chicago. The Art Institute of Chicago. *Paintings and Water Colors by Walter Gay*, March 24–April 6, 1914

1920, New York. E. Gimpel & Wildenstein, *Paintings and Water Colors by Walter Gay*, February 17–March 6, 1920. Catalogue introduction by A. E. Gallatin

1923, Paris. Jean Charpentier, *Peintures, aquarelles et gouaches de Walter Gay*, February 8–22, 1923. Catalogue introduction by Louis Gilbert

1926, New York. Wildenstein & Co., *Paintings and Water Colors by Walter Gay*, April 1926. Catalogue introduction by A. E. Gallatin

1928, New York. Wildenstein & Co., *Paintings and Water Colors by Walter Gay*

1930, New York. Wildenstein & Co., *Paintings and Water Colors by Walter Gay*

1933, Paris. Jean Charpentier, *Exposition Walter Gay (quelques oeuvres récentes)*, February 25–March 10, 1933

1936, Paris. Jean Charpentier, *Peintures et aquarelles de Walter Gay*, March 11–25, 1936

1938, New York. Metropolitan Museum of Art, *Memorial Exhibition of Paintings by Walter Gay*, April 9–May 30, 1938

1939, New York. Wildenstein & Co., *Paintings & Water Colors by Walter Gay*, January 1939

1945, New York. Wildenstein & Co., *Memorial Exhibition of Paintings by Walter Gay*, November 28–December 22, 1945. Catalogue introduction by A. E. Gallatin

1974, New York. Graham Gallery, *Walter Gay*, January 5–February 2, 1974. Catalogue introduction by Stuart Preston

1980, New York. Grey Art Gallery and Study Center, New York University, *Walter Gay: A Retrospective*, September 16–November 1, 1980. Catalogue by Gary A. Reynolds

Acknowledgments

I HAD BEEN THINKING FOR SOME TIME ABOUT DOING A BOOK ON Walter Gay when I received a call in the summer of 1997 from Arthur T. Garrity, Jr., of Hingham, Massachusetts, who told me about his long-standing interest in this artist. He had assembled a large amount of material relating to Gay, including a diary kept by Walter's wife, Matilda, and he asked whether I might be interested in seeing it. Shortly thereafter I went to Hingham and sat down to read the diary. After only a few pages I realized that no book on Walter Gay could possibly be written without this document and that the book that called out to be written was far more interesting: a biography of Walter and Matilda Gay. Mr. Garrity generously allowed me to borrow the diary and other documents to use for this book. He is the kind of angel, and that day was the sort of day, that every scholar-curator hopes at one point in life to encounter and almost never does. My gratitude to him is limitless. As we share the belief that this diary is one of the most interesting and lively accounts of the period, we are looking forward to its publication. The diary is from the archives of historic documents and related materials of Walter and Matilda Gay, in the collection of A. T. Garrity, Jr., Hingham, Massachusetts, and excerpts are quoted in this book with his permission.

This project would not have been possible without support from the Metropolitan Museum of Art, particularly from Philippe de Montebello, Director, and Olga Raggio, Chairman of the Department of European Sculpture and Decorative Arts, who indulged my enthusiasm for a book that is at best tangential to my curatorial responsibilities and provided me with both time and support for the necessary photography. My colleague Barbara Weinberg in the Department of American Paintings and Sculpture has been exceptionally generous in many ways. I know of no other curator who would have done what she did by making all the information on Walter Gay in her files available to an interloper with no knowledge of American painting. The interest of Barbara Burn, who was in the Editorial Department at the Metropolitan Museum when I began this book and is now at Abrams, meant a great deal to me. I could not have hoped for a better editor. Others at the museum who have greatly helped are Bob Kaufmann in the Watson Library, Deanna Cross in the Photograph and Slide Library, and Josephine Freeman in the Photograph Studio. The very talented Bruce Schwarz in the Metropolitan Photograph Studio photographed many Walter Gays in private New York collections for this book. Stephanie Post in the Department of European Sculpture and Decorative Arts was endlessly patient and kind in shepherding far too many revisions of the manuscript through the mysterious (to me) circuits of word processing.

Many colleagues from other museums kindly showed me pictures by Walter Gay in their collections or shared important information, particularly Odile Cavalier at the Musée Calvet, Avignon; Anne Dopffer at the Musée National de la Coopération Franco-Américaine, Château de Blérancourt; Janet Caney, Jeffrey Munger, and George Shackelford at the Museum of Fine Arts, Boston; Daisy Stroud at the Albright-Knox Art Gallery, Buffalo; Robert-Henri Bautier at the Musée Jacquemart-André, Abbaye Royale de Chaalis; Susan Rossen and Sandy Thayer at the Art Institute of Chicago; Stephanie Copeland at the Edith Wharton Restoration, The Mount, Lenox; Janet S. Dickson at the Yale University Art Gallery, New Haven; Edgar Munhall and Bill Stout at the Frick Collection, New York; Odile Berthy and Anne Distel at the Musée d'Orsay, Paris; Barbara Katus at the Museum of American Art, Pennsylvania Academy of the Fine Arts, Philadelphia; Dick McIntosh at the Frick Art and Historical Center, Pittsburgh; Danette Smart at the Portland Museum of Art; Elizabeth Leuthner at the Museum of Art, Rhode Island School of Design, Providence; Michael Milkovich at the Museum of Fine Arts, St. Petersburg, Florida; Timothy Burgard at the Fine Arts Museums of San Francisco; Christian Baulez at the Musée National des Châteaux de Versailles et de Trianon; Joe Tallone at the Archives of American Art, Washington, D.C.; and James N. Carder at Dumbarton Oaks, Washington, D.C. I especially want to thank Hutton Wilkinson at the Elsie de Wolfe Foundation for having the foundation's pictures by Walter Gay cleaned and photographed.

Debra Force and Jane Egan at Beacon Hill Fine Art and Eileen Dadey at James Graham & Sons in New York have been extremely generous with transparencies and information on Walter Gay. I also want to thank Michael Grogan at Grogan & Co., Dedham, Massachusetts; Lanto Synge at Mallett, London; Alan Hobart at the Pyms Gallery, London; Guillermo de Osma at the Guillermo de Osma Galeria, Madrid; in New York: Warren Adelson at Adelson Galleries; Gerald Bland at the Gerald Bland Gallery; Debra Wieder at Hirschl & Adler Galleries; Alasdair Nichol at Phillips; Simon Parkes at Simon Parkes Art Conservation; Alex Raydon at the Raydon Gallery; Peter Rathbone at Sotheby's; Eliot Rowlands at Wildenstein; and Richard York at the Richard York Gallery; René Gimpel at Gimpel Fils, Paris; Alexandre Pradère at Sotheby's, Paris; and Christopher Addison at Addison/Ripley Fine Art in Washington, D.C.

Among the many people who share my enthusiasm for this artist and who have helped in numerous and various ways are the following: Lady Jane Abdy, Mr. and Mrs. William S. Abell, Mr. and Mrs. Armin Allen, Baronne Bernard d'Anglejan-Chatillon, Louis Auchincloss, Reinier Baarsen, Mr. and Mrs. Marvin Barrett, Mrs. Robert Blake, Bill Blass, Jay Cantor, Edward Lee Cave, Lynn Chase, Mrs. Diane Cousins, Mrs. Sheila Donaldson, Jeffrey Drummond, Mrs. Justin East, Monte Freeman, the Marquise de Ganay, Cynthia T. Gay, John Gay, Linda Gillies, Alexis Gregory, Rufus K. Griscom, Mrs.

Louise Grunwald, Peggy Guggenheim, Duane and the late Mark Hampton, Nina Herrick, Mr. and Mrs. Alexander Irving, William Iselin, Beverly Jacoby, Mrs. Wadsworth Larson, Richard Lawson, Mr. and Mrs. Jean LeCorbeiller, Julius Lewis, Kinsey Marable, Pauline Metcalf, Howard Monroe, Elizabeth and the late Alton Peters, Stuart Preston, Remack Ramsay, the Honorable Joseph V. Reed, Lynn Springer Roberts, the late Marie Bonne de Viel Castel Roberts, Robert M. Rubin, Harold W. Sands, Bill Schwind, Barbara Scott, Mr. and Mrs. Edward Sherretts, Jr., William Kelly Simpson, Mr. and Mrs. James Symington, Stuart Symington, Jr., Hugh Tennant, Comte Patrice de Vogüé, Michael Wager, Olimpia and the late Paul Annik Weiller, Mr. and Mrs. Charles Whitehouse, Graham Williford, and Melissa Wyndham.

Index

NOTE: Page references to illustrations are in *italics*.